SUZIE ZUZEK

FOR

LILLY PULITZER

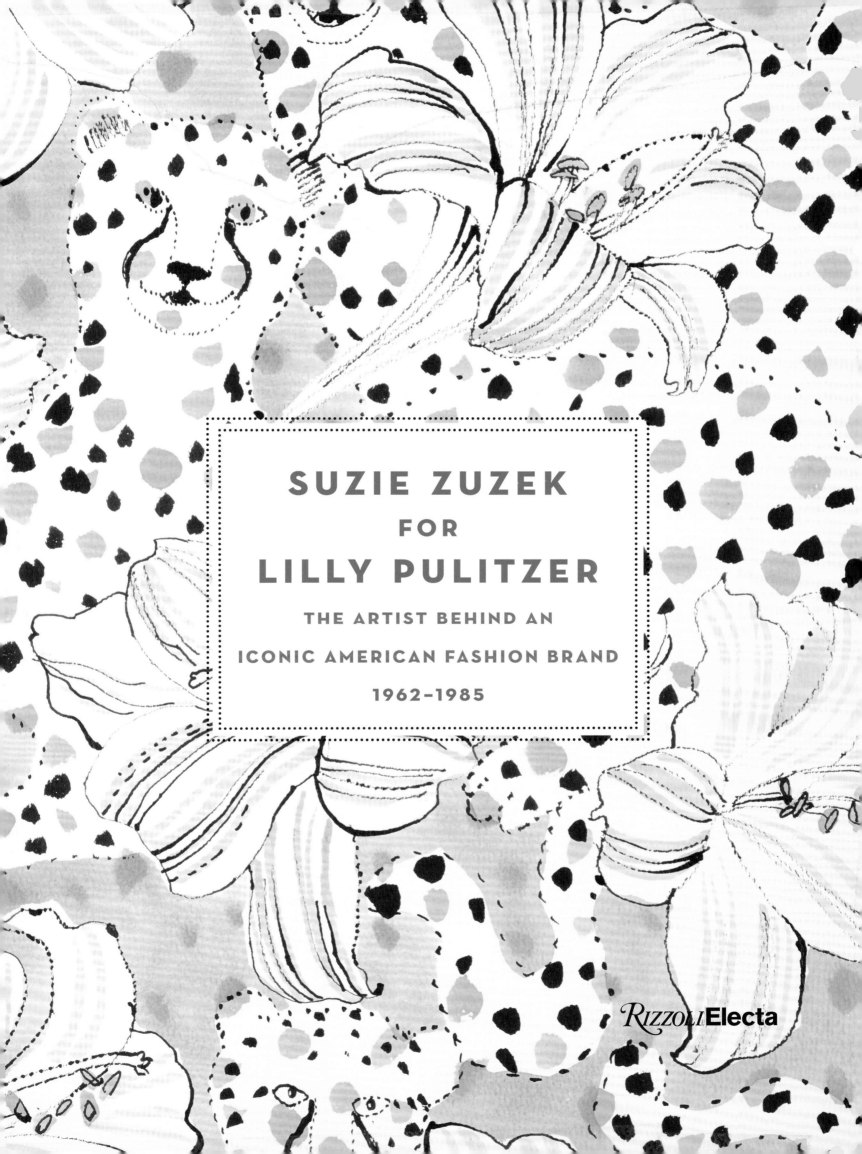

SUZIE ZUZEK
FOR
LILLY PULITZER

THE ARTIST BEHIND AN
ICONIC AMERICAN FASHION BRAND
1962–1985

RIZZOLIElecta

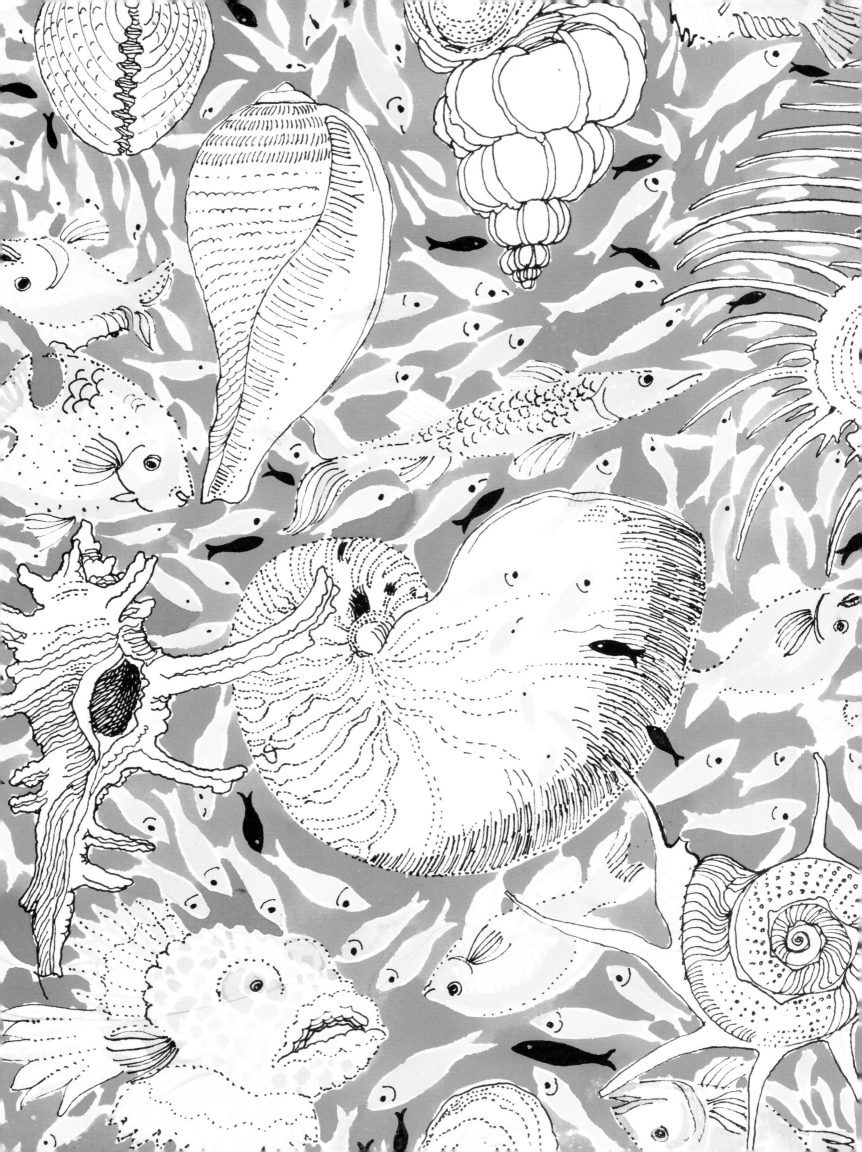

CONTENTS

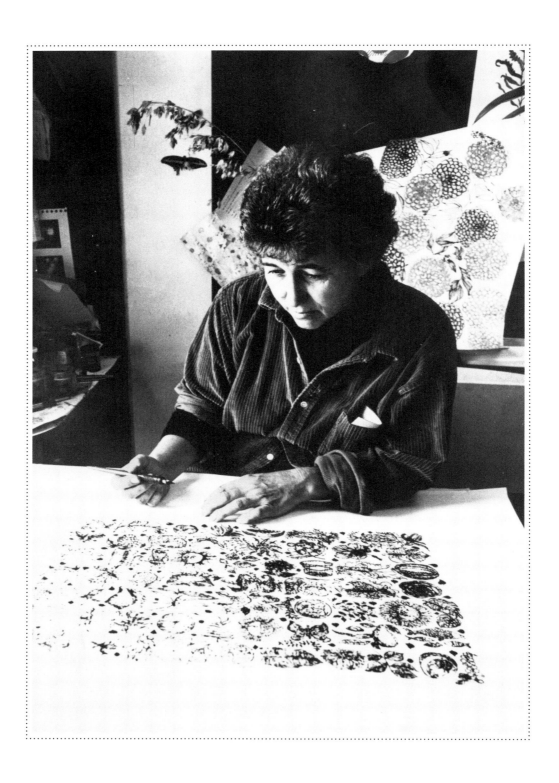

ABOVE Suzie Zuzek, drawing *All Florida II*, at her desk in the
second-floor studio of Key West Hand Print Fabrics, late 1960s.
Behind the artist is her drawing *Double Glow*, 1969.

OPPOSITE (BACKGROUND) Suzie Zuzek, *All Florida II*, 1969.

The fabulous success of
the "Lilly Look" would not have
been possible without Suzie's
whimsical and magical creations.
She constantly amused me,
not only by the genius of her art
but also by the sheer numbers
of designs she created. I couldn't
wait to see what came next.

—LILLY PULITZER ROUSSEAU, 2012

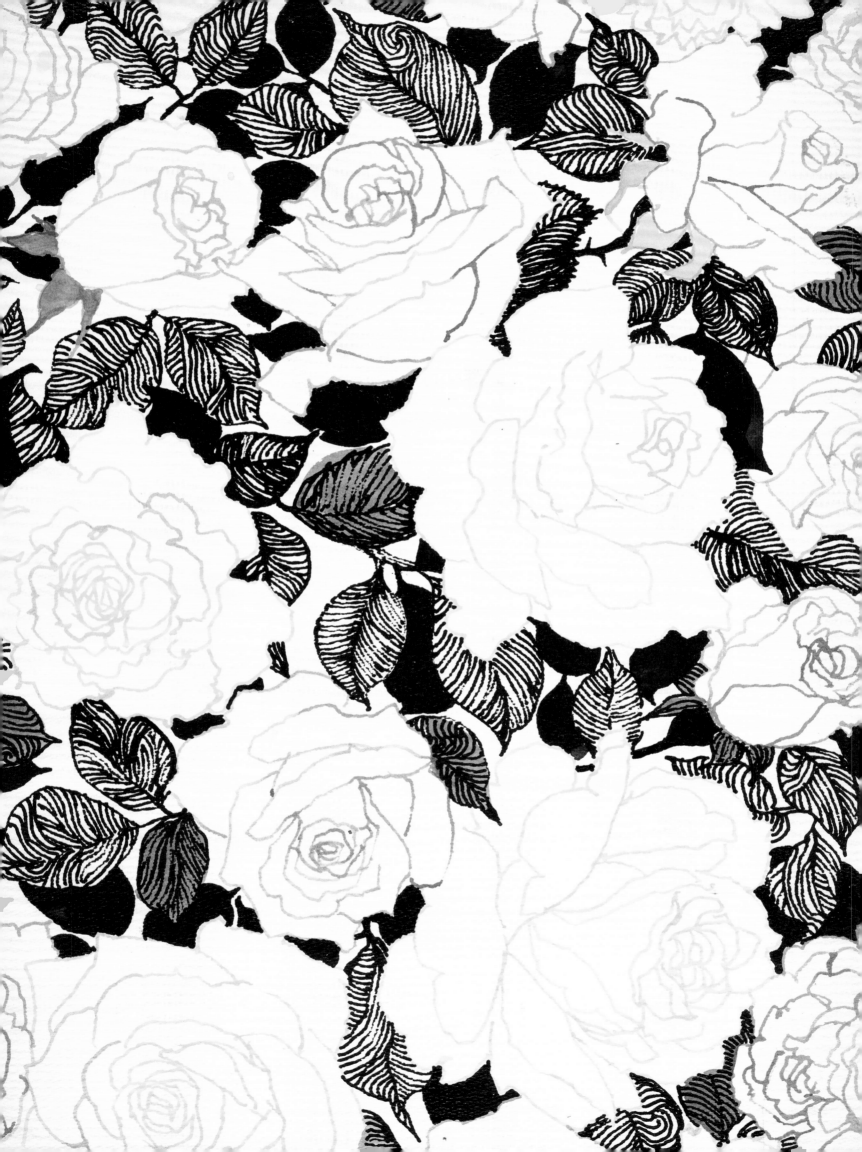

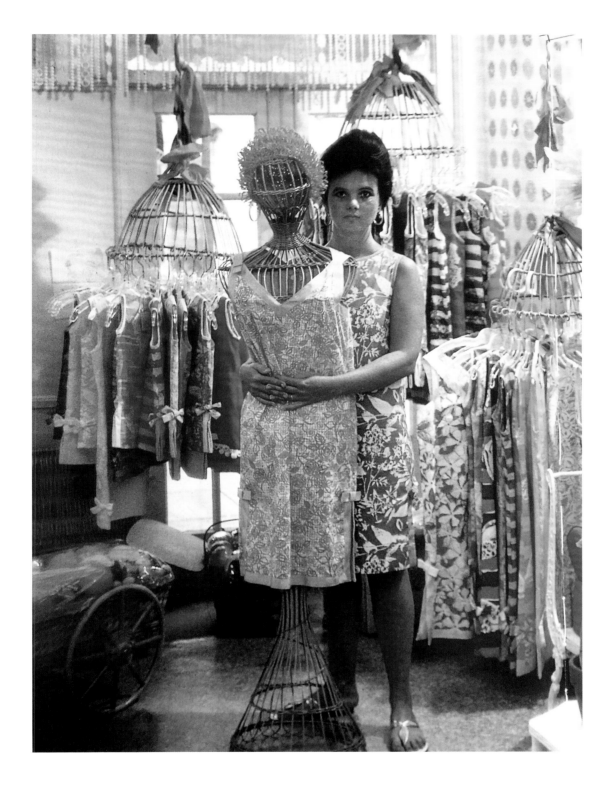

OPPOSITE Suzie Zuzek, *Suzie's Roses*, 1968.

ABOVE Lilly Pulitzer in her Palm Beach shop on Via Mizner (off of Worth Avenue), with mannequin dressed in a shift in a Zuzek design, 1962. Photographed by Howell Conant.

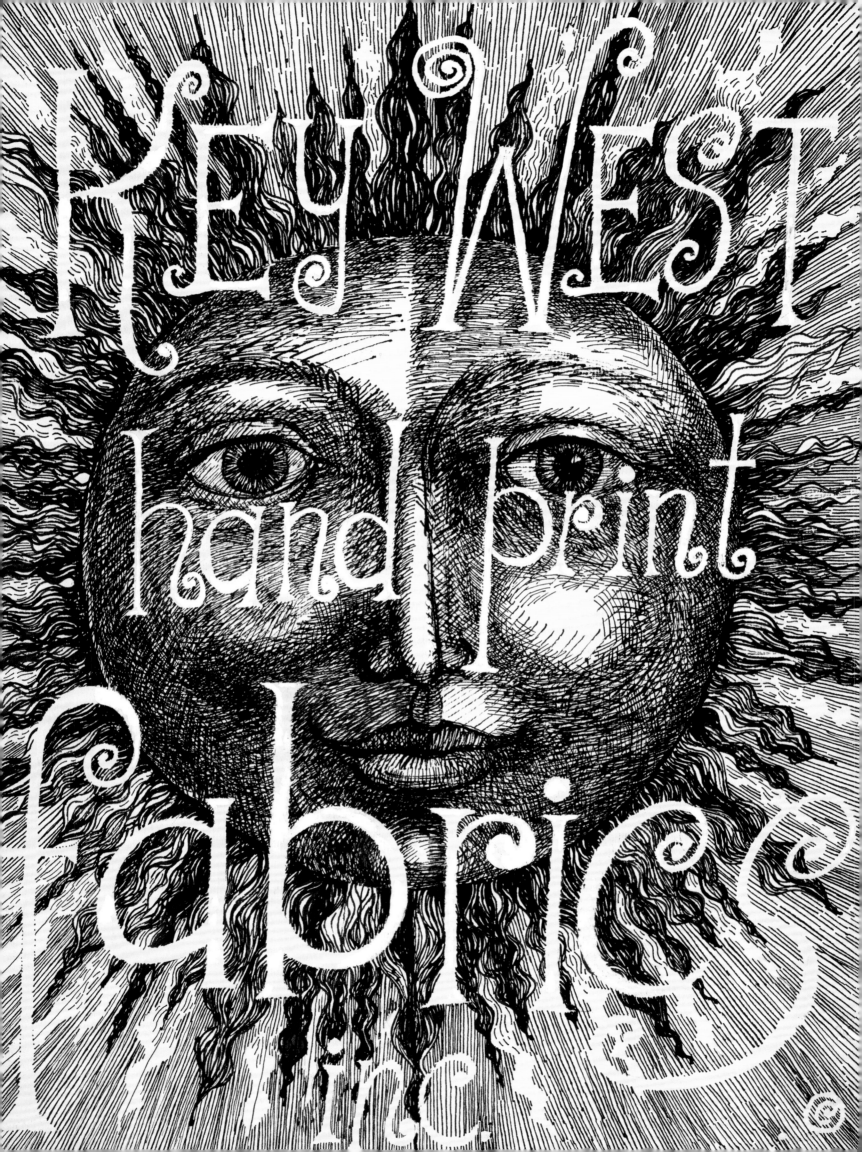

INTRODUCING SUZIE ZUZEK

FOR DECADES SUZIE ZUZEK'S brilliant textile designs hid in plain sight—splashed across the bodies of enthusiasts of the Lilly Pulitzer brand. Although unattributed, Zuzek's signature style was easily recognized, much adored, and avidly collected as customers purchased multiples of single silhouettes. Indubitably it was Zuzek's prints that cemented the success and appeal of the original Lilly Pulitzer brand from 1962 to 1985. Without her engaging prints the Lilly shift might have fizzled out after a few seasons, remaining a fad rather than growing into an entire genre of fashion. As enlivened by Zuzek's imagination, the "Lilly Look" soared. With the recent discovery of the archive of her textile designs, Zuzek's achievements can come fully to light. This book and a related exhibition at the Cooper Hewitt, Smithsonian Design Museum in New York City seek to celebrate an artist, her never-before-seen oeuvre of original watercolor drawings, and their notable impact on American fashion.

Suzie Zuzek (1920–2011) was the most accomplished and prolific textile designer at Key West Hand Print Fabrics, a silkscreen-printing company founded in its namesake Florida town in 1961. Almost immediately, the fledgling company attracted its first major client in Lilly Pulitzer, the socialite-turned-household-name-dress-designer from Palm Beach. By coincidence both the firms of Key West Hand Print Fabrics and Lilly Pulitzer had been founded almost by accident by amateurs. The only trained professional and proven talent in the mix was Suzie Zuzek de Poo, who had studied textile design and illustration at the Pratt Institute in Brooklyn, New

OPPOSITE Suzie Zuzek, *KWHPF, INC. 1543*, early 1960s. Zuzek's whimsically portrayed sun faces were a motif to which she repeatedly returned. The artist created sun-face designs for textiles and for Key West Hand Print Fabrics promotional materials throughout the 1960s and '70s.

RIGHT Suzie Zuzek, *Klips*, 1975.

York, graduating at the top of her class, and who had worked for three years designing fabrics for interiors and fashion in New York.

Marriage to a Key West native took her to Florida, where she was in the right place at the right time to accept a job at the newly established Key West Hand Print Fabrics concern. Around the same time that Lilly Pulitzer incorporated her own business (in 1962), she checked out Key West Hand Print Fabrics, was enchanted by the Zuzek designs she discovered there, and began buying the textiles there for her shift dresses and other styles.

Key West Hand Print's most significant client, the Lilly Pulitzer company eventually bought 51 percent of the company. Zuzek, Key West Hand Print Fabrics, and Lilly Pulitzer would be closely entwined from 1962 until bankruptcy closed the original Lilly Pulitzer company in 1985. Bankruptcy resulted in Lilly Pulitzer, Inc. separating the design archive from Lilly Pulitzer's trademarked name. The extensive working archive of prints—the vast majority by Zuzek—was sold off in December 1985. Years later Lilly Pulitzer, Inc. sold the LILLY PULITZER trademark and trade name to a different company. The archive that is the subject of this book and exhibition has remained intact. It was recently rediscovered and purchased by a private group intent on saving and celebrating Zuzek's legacy and her iconic American look.

That Zuzek's work for Lilly Pulitzer was anonymous reflects a standard that has been historically customary throughout the fashion world, where unsung artisans abound. Producers of fabric are of course integral to producers of fashion, and in most cases a fabric house originates a group of materials that are then offered—sometimes exclusively, sometimes not—to a single fashion designer, who then builds a one-time collection around the designs. Some fabric houses work quite closely with the designers, devising new textiles inspired by their style and technique. However, in the case of Lilly Pulitzer, it was one designer, Suzie Zuzek, who over the course of a quarter of a century created the overwhelming majority of prints that defined the Lilly Pulitzer brand.

Rarely is the original author of a design known by name, although it has been a selling point when fabric houses commissioned designs by fine artists such as Raoul Dufy, whose creations were produced beginning in 1912 by French textile house Bianchini-Ferier from which they were then used in designs by Paul Poiret (and more recently Christian Lacroix and Geoffrey Beene) or, in New York beginning in the 1940s, by Wesley Simpson, whose fabrics featured prints from Salvador Dalí and Joan Miró, which made their way into clothes by designers such as Claire McCardell. The same system of anonymous talent behind the scenes extended to other "furnishers" of fashion. The famed embroidery house Lesage has, since the early twentieth century, collaborated with the greatest couture houses—from Madeleine Vionnet and Schiaparelli to Yves Saint Laurent and Valentino—resulting in embroideries that are both instantly recognizable as the work of the couturier and also, given the quality and visual style of the technique, by Lesage. Similar to the case of Lesage, Zuzek's work was recognizable as her own. Customers were buying a Zuzek-designed fabric because they liked the artistry of her work.

Consciously or unconsciously, people collected Zuzek's designs, attracted by the verve, wit, palette, and technique evident throughout her work. Despite being primarily anonymous, Zuzek has been one of the most avidly collected American textile artists of the second half of the twentieth century, attesting to her importance in fashion history. ❋

OPPOSITE, CLOCKWISE FROM TOP LEFT *Kifaru*, 1970; *Gerald*, 1977; *Rescue Me Lilly*, 1968; and *Pescador*, 1972. All drawings by Suzie Zuzek. Many of the artist's designs pair an overall abstract pattern with a finely detailed drawing, allowing the patterns to be perceived differently up close and from a distance.

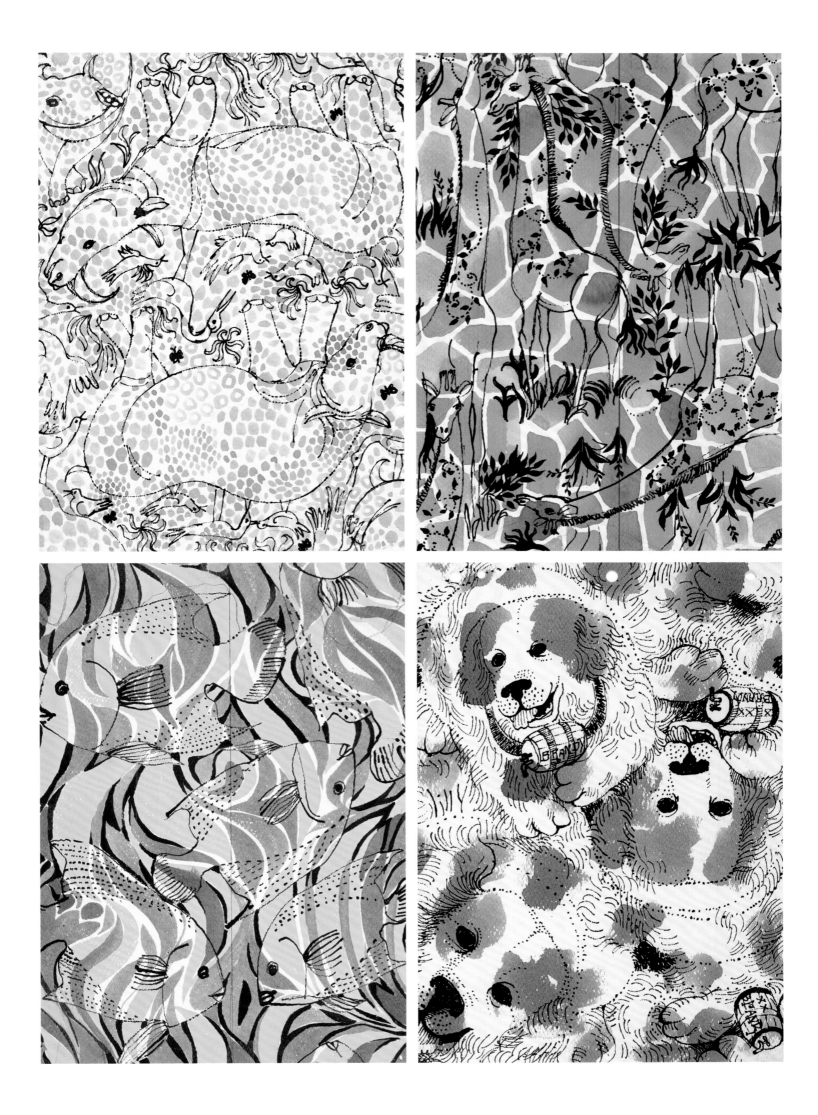

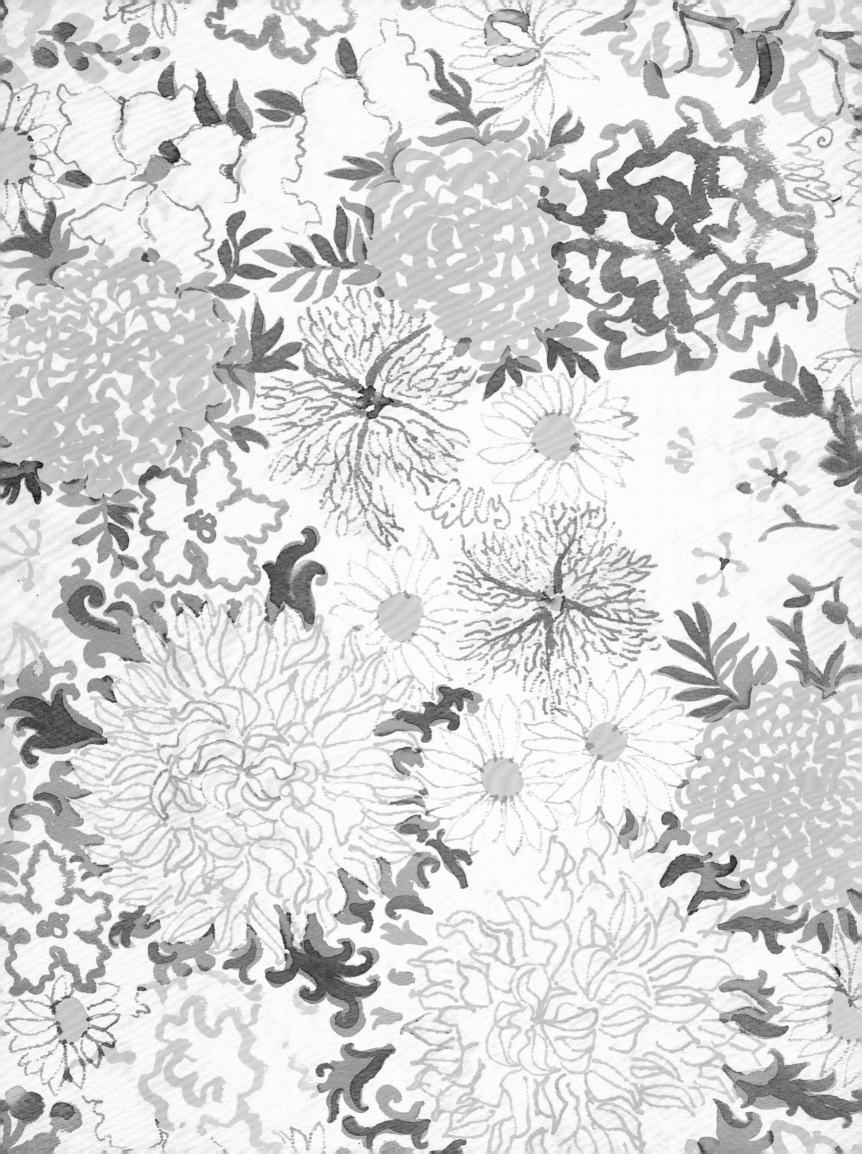

WILDNESS

SUZIE ZUZEK'S PRINT DESIGNS

SUSAN BROWN

Associate Curator, Cooper Hewitt, Smithsonian Design Museum

THE COLORFUL, ECLECTIC, AND WHIMSICAL prints that adorned Lilly Pulitzer's simple shift dresses in the 1960s and 1970s earned an immediate and devoted following, one that has endured for generations. Yet few people, other than serious vintage Lilly Pulitzer collectors and a handful of Key West residents, know that many of those prints were created by artist Suzie Zuzek (Agnes Helen Zuzek de Poo, 1920–2011). Zuzek was the lead designer for Key West Hand Print Fabrics, Inc., where Pulitzer sourced most of her fabrics—and all of her prints—from 1962 to 1985, when the Lilly Pulitzer company was owned and overseen by Lilly Pulitzer herself.

Zuzek's designs were arguably the secret behind Pulitzer's runaway success. Lilly Pulitzer fashions are rarely mentioned without a nod to the fabulous fabrics that made them unique. "The legend of Lilly, after all, is anchored in the wild, colorful prints of her original sundresses and shifts."[1] Suzie Zuzek, however, has remained largely unknown. It was common then, as it is now, for individual designers' work to go unrecognized in the name of building a strong brand identity. Zuzek's story will resonate with many designers toiling away anonymously today. What is unusual in this case is that the "Lilly Look"

OPPOSITE Suzie Zuzek, *Lilly Garden*, 1967.

ABOVE Model (standing) wearing a one-sleeved Lilly Pulitzer dress in Zuzek's *Lilly Garden*. Photographed by James Moore for the June 1968 issue of *Harper's Bazaar*.

RIGHT Suzie Zuzek, *Wildness* textile, 1972.

was so closely identified with the prints, and the prints were so overwhelmingly the product of one woman's imagination: Suzie Zuzek's.

Soon after launching her business, Lilly Pulitzer explained her fabric situation quite frankly: "We were awfully lucky to find four boys in Key West who do their own silk screening. . . . It's lucky because I can't draw a thing. I'll say, 'I want something in a wild orange with yellow'. . . and they'll turn out beautiful prints for me."[2] Peter Pell, Jim Russell, Bill Johnson, and Walter Starcke were Pulitzer's "four boys." They were the unlikely founders of Key West Hand Print Fabrics.

Key West Hand Print Fabrics was the locus of a creative encounter between fashion designer Lilly Pulitzer and textile designer Suzie Zuzek—one that created an immediate sensation in the fashion world and made a lasting impact on American style. The wildly successful pairing lasted twenty-four years, but the story of how they came together is one of unlikely encounters and unexpected twists.

Peter Pell was a stage manager and sometime performer who had been the personal manager for Tallulah Bankhead for six years.[3] Jim Russell was a dancer/choreographer and Pell's partner. Pell and Russell fell into screen printing almost as casually as Pulitzer did the fashion business. In 1960, while working on a production of *On the Town* at the Coconut Grove Playhouse, the couple visited Key West to go diving and fishing with Walter Starcke, a former Broadway producer whom Russell knew from New York. Starcke was on the board of the Old Island Restoration Foundation, which had been founded that same year to preserve and restore significant examples of Key West architecture. He had recently purchased Harbor House, a historic downtown building that had housed Key West's first bank.[4] There, he had established a small screen-printing business with a single, thirty-foot screen-printing table.[5] Russell shared Starcke's enthusiasm for historic architecture and design, and was intrigued by his redevelopment efforts. Whether to escape the rat race of New York for the gay-friendly culture of Key West, or simply because they were seduced by the island's laid-back charm, Pell and Russell soon found themselves part owners of the screen-printing studio.

Russell and Pell had no experience whatsoever in textile design or manufacturing and not surprisingly, they were soon struggling with the business. Angus Smith, Starcke's original designer at Key West Hand Print Fabrics, lasted only about three months in the position. After his departure, Pell took over designing

the fabrics while Russell set up the retail shop. Having only a rudimentary printing set-up, they were carrying the freshly printed yardage across the street to the Fountain Launderette to heat-set the inks in the dryers there. The Fountain's owner, Bill Johnson, began by giving the pair accounting advice, and ended by becoming their business partner. Another New York theater expatriate, costume designer Virginia Pierce, also joined the Key West Hand Print Fabrics team. She had retired to Key West with her husband but after his death, she wanted the distraction of work. She designed a line of clothing and accessories for Key West Hand Print Fabrics under the name Vanda, a combination of her first initial and her husband Albert's. Starcke was a friend of local artist Suzie Zuzek de Poo, and collected her work. He knew that she had a background in textile design; he suggested that Russell and Pell contact her.[6]

❋ ❋ ❋

Suzie Zuzek was born Agnes Helen Zuzek, the youngest of five children of Yugoslavian immigrant parents, in 1920. She was raised on a dairy farm in Gowanda, New York, just south of Buffalo. From early childhood, Aggie, as the family called her, loved to draw, and her family indulged her interest. "When I was very young, I had a warm place behind the kitchen stove where I could draw," she said. "My sisters gave me pieces of paper."[7]

After her father died when she was twelve years old, she and her siblings had to work the farm. There was little possibility that she would go to college, much less to art school. But, as with many young men and women of her generation, Zuzek's world opened up when she enlisted to serve in the Second World War in 1943. It's also where she got the nickname Suzie, a riff on her last name. After serving in the Women's Army Auxiliary Corps (WAACs) at Camp Beale in California, she was eligible for tuition benefits under the G.I. Bill. She enrolled at the Pratt Institute in Brooklyn, New York, to study commercial illustration. At Pratt, she was encouraged to study textile design, graduating at the top of her class in that field in 1949. She also attended classes at the Art Students' League, where she studied drawing with the famous illustrator and caricaturist Peggy Bacon.

Through her teachers at Pratt, Zuzek immediately got work designing fabrics for New York textile firm Herman Blanc, where she spent three years creating both drapery and dress fabrics. During that period, she met and married John de Poo, and gave birth to two daughters, Kathryn and Amy. De Poo was a native of Key West, Florida, and the young couple relocated there in 1955. Soon a third daughter, Martha, was born. Zuzek continued designing textiles on a freelance basis, sending designs back to New York and traveling there occasionally to keep her hand in the business, and also to earn the income she very much needed after she and de Poo separated and she became a single mother.

When Pell and Russell called, Zuzek agreed to work for them and continued to do so for the next twenty-four years. And she was prolific. She became the company's principal textile designer, with her unique style soon setting the tone for the company's products. As the Florida Development Commission put it: "The beautiful designs and colors that the talented artist turned out soon were attracting the attention of all who came to the shop."[8]

Key West Hand Print Fabrics consisted of the screen-printing studio and a retail shop. Harbor House, at 423 Front Street in the oldest part of the city, was a mid-nineteenth-century brick building with "iron lace" grillwork and a New Orleans feel. The owners salvaged the original bar from the Old Cuban Club on Duval Street and installed it as the counter in the shop. Their chandeliers were made from shrimp pots.[9] When the shop first opened, they had only a few rolls of printed

OPPOSITE Suzie Zuzek, *Sea Fantasy*, 1972. Fish, turtles, and lobsters all serve as canvases for additional patterns.

ABOVE Suzie Zuzek, self-portrait, New York, late 1940s.

fabric, but soon expanded into a variety of items geared toward the tourist trade: yardage goods featuring Zuzek's imaginative takes on Key West flora, fauna, and architecture; tea towels with recipes for local specialties such as key lime pie and conch stew; table linens; beach bags; hats and scarves. Visitors to the shop were invited to watch the screen-printing process, giving the feeling of being immersed in the joyful, colorful world of Zuzek's prints. Vanda had a boutique within the shop, where she would see private clients for whom she would design custom Vanda Exclusives featuring Key West Hand Print Fabrics designs on silk chiffon, wool jersey, or linen, instead of the polyester-cotton broadcloth from which most of the ready-to-wear items were made.

The arrival of Palm Beach socialite Lilly Pulitzer on the scene in February 1962 has the mutability of a tall tale often told.[10] Her mother and sister Memsie happened across the Key West Hand Print Fabrics shop while yachting in the area, or while waiting for repairs to their yacht, and sent some samples to Lilly, who had recently started making dresses from dime-store fabrics. After seeing the samples, Pulitzer either flew in by seaplane to have a look, or came on vacation with her business partner Laura Robbins.[11] Robert McKenzie, who later ran the decorator fabrics line for Key West Hand Print Fabrics, said that the notoriously salty Lilly "marched in with a Gristedes bag, dumped it on the counter, and said 'Is this your shit?'"[12] Two consistent points to the tale are that Pulitzer was barefoot, and that she ordered three hundred yards on the spot, increasing her order to three thousand yards as soon as she got back to Palm Beach.[13]

Russell, who usually managed the retail shop, called Pell down to talk to her. Pulitzer and Pell came from the same social milieu. He was the cousin of Rhode Island Senator Claiborne Pell,[14] whose *New York Times* obituary stated, "Mr. Pell, whose ancestors were the original lords of the manor in Pelham Manor, N.Y., lived among the old-money families in Newport."[15] Russell, by contrast, came from a working-class family. He was raised in the Bronx by his mother, Minerva Rousseau, who worked for years at Ohrbach's, a moderately priced department store.[16] Zuzek, a shy farm girl and first-generation American, was even further removed from Pulitzer's world. Pell and Pulitzer became close friends, speaking by phone almost daily. Pell remained the social lubricant in the company's dealings with Pulitzer.[17]

Overnight, Pulitzer became Key West Hand Print Fabrics' largest wholesale customer. She used the company's fabrics almost exclusively. Referring to Key West, she said, "I still use some ginghams and piqué, but the big thing is here."[18] The unique quality of Zuzek's prints made Pulitzer's shifts collectible. "It's sort of become a cult to own one . . . Some of our customers collect the different fabric designs as though it were a hobby. They get one of every new design we turn out," said Bill Tracey, manager of the Key West Hand Print Fabrics store in Coconut Grove.[19]

❋ ❋ ❋

The company's leadership was typically presented in the press as a triumvirate with Pell as the creative head, Russell as the retail mastermind, and Johnson as the money man. Zuzek, however, was their secret weapon. She was a prodigiously talented designer. "The three-sided combination, held together by a loyal and talented staff including the inspired original designs of Suzy DePoo [*sic*] (Zuzek, her trade name) is nearly impossible to beat."[20] According to McKenzie, Pell didn't do much designing after Zuzek was hired. "Peter's designs were concise and close," he said. "With Suzie, whoom! Their designs opened

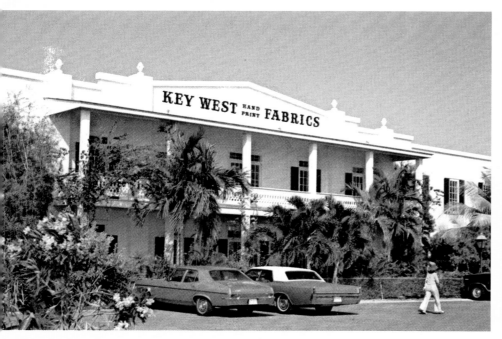

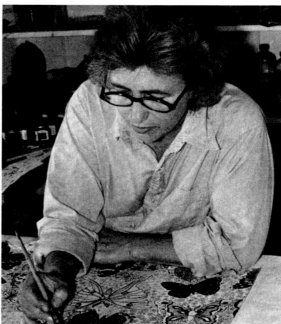

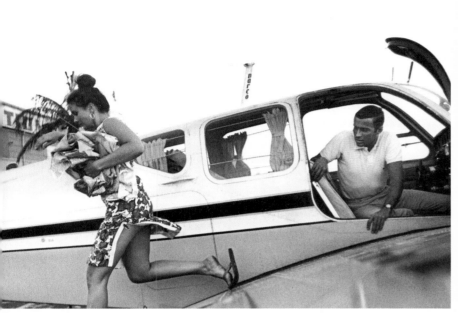

up, they were free, they were what I would call happy. That may sound crazy, but you know what I mean—you look at them and you can't help but smile."[21]

Although Zuzek was a quiet person who was most often seen in a chambray shirt and white Keds, riding her bicycle or combing the beach for driftwood and sea glass for her artwork, she produced designs of incredible vitality. Her style was perfectly suited to screen printing: big, loose designs in which minor mis-registrations were not apparent. Today, Pulitzer is often dismissed as a purveyor of pink and green florals, but those original prints were beloved for a reason: Zuzek's designs were wonderful and strange, and far more diverse than just florals. A newcomer to island life, she was freshly fascinated by the sea. She created patterns with traditional elements like shells and seagulls, but more unexpectedly shrimp pots and fishnets, sea glass bottles, turtles and crabs, sandpipers, and pelicans. Inland, she turned her creativity on the city's iron grillwork, weathervanes, and wicker furniture. The sun face was a recurring theme, appearing in Key West Hand Print Fabrics' line continuously and in many variations for ten years.[22] It also served as the company's logo—in addition to designing fabrics, Zuzek contributed illustrations to most of the company's graphic design. Some of her own favorite designs were based on vegetables such as beets, cabbage, squash, and sweet corn. "There's really nothing different in this world," she said. "It's just the different twist you give a thing."[23] The twist that she gave things was uniquely her own: fish wearing crowns, lounging lions strumming guitars, monkeys sipping martinis.

Zuzek loved animals and loved to draw them. She kept a house full of them—cats, dogs, peacocks, rabbits, goats, even a monkey named Trinket, who had the run of the island. She drew familiar animals—cats and mice, raccoons and owls, cows and sheep—as well as exotic ones such as rhinoceros, hippopotamuses, zebras, giraffes, and cheetahs, which she never saw in the wild but studied in books. Her animals were characters with expressive faces and attitudes, which may reflect her early interest in commercial illustration. Pulitzer loved them too. "Suzie's animal prints—that's what Lilly went for. They were fabulous," said June Klausing, who started in sales at Key West Hand Print Fabrics in 1975 and eventually became general manager of retail operations.[24]

There were florals—many florals!—ranging from impressionistic splotches of color to drawings of near-botanical precision. Later in life, Zuzek reminisced about picking wildflowers in the woods with her sister. She created many prints based on the flowers that she loved as a child: daisies, poppies, cosmos, and Queen Anne's lace. "I still like northern flowers better,"

OPPOSITE, LEFT Key West Hand Print Fabrics building, Front Street, Key West, Florida. 1970s.

OPPOSITE, RIGHT Suzie Zuzek drawing *Pretty Butters* (1974) in Key West Hand Print Fabrics second-floor art studio.

ABOVE, LEFT Lilly Pulitzer steps out of husband Peter's plane with arms full of Key West Hand Print Fabrics samples, 1963.

ABOVE, RIGHT Key West Hand Print Fabrics co-owner Jimmy Russell (far left) with KWHPF employees including Clyde Taylor and Dan Sheehy—in prints designed by Suzie Zuzek.

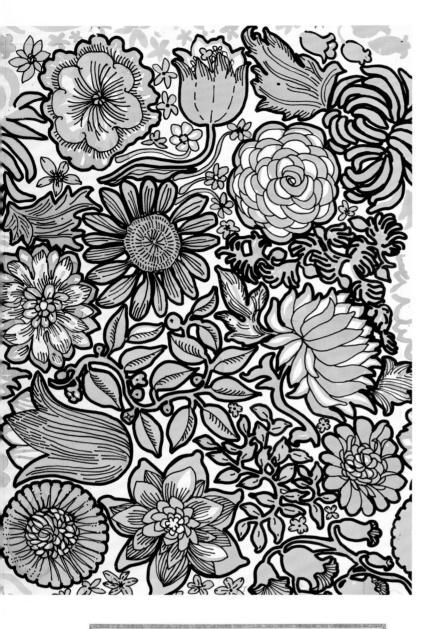

she professed, although that did not prevent her from creating stunning designs from such tropical species as hibiscus, azalea, bougainvillea, and even a night-blooming cactus that grew in her backyard.[25]

Zuzek was a generous designer who rewarded those who looked closely. In addition to being a delightful artist, she had a deep mastery of pattern design. She understood that her designs would be viewed from a distance as an overall pattern and be enjoyed up close in all their idiosyncratic detail. A design that might, from a distance, appear to be a traditional polka-dot pattern would be revealed up close to be composed of bears frolicking with balls, or owls with blue-ringed eyes. Paisleys might turn out to be penguins or walruses on closer inspection. A delicate study of butterflies, in repeat, becomes a bold diagonal stripe, ideally suited to the A-line maxi skirts and dresses of the 1970s.

Her compositions filled every inch of the page. She was inspired by the Unicorn Tapestries, and the term *millefleurs*, or thousand flowers, used to describe tapestries with an all-over floral background, would certainly apply to many Zuzek designs.[26] And, as in traditional Indian paisleys, she filled every internal space in the design with yet more pattern: flowering vines, leaves, and tiny flowers. In a design like *Sea Fantasy*, some fish have scales, whereas others have swirling patterns or polka dots, and the shells of turtles and lobsters are covered with flowers. Rhinoceros' hides are adorned with roses in another pattern. Zuzek sometimes kept fragments of decorated porcelain she found on the beach if they had pretty patterns that she might use to fill the interstitial spaces in her designs.

In spite of her incredible range, Zuzek had a distinctive style. Key West Hand Print Fabrics always carried both men's and women's clothing, and Lilly Pulitzer quickly diversified first into children's and then men's apparel. They did not create separate fabric lines for men, women, and children; the same humorous, whimsical designs served for all. Pulitzer strongly favored Zuzek's animal patterns for her Men's Stuff collection. For the most part, Zuzek was given free rein to design what she liked, although she occasionally responded to special requests. Pulitzer introduced a line of Ivy League sport coats, for example, and Zuzek created designs based on the schools' mascots—Princeton Tigers, Yale Bulldogs, and so on. When Pulitzer launched her golf togs, Zuzek created a few golf-themed patterns featuring tees and flags.

More than anything, Zuzek loved to draw. Many of her original designs were drawn in India ink with a Speedball B6 nib. For the most part, she used naturalistic colors, especially for the animals. Her original colorations were often offered as one colorway in the printed fabrics,

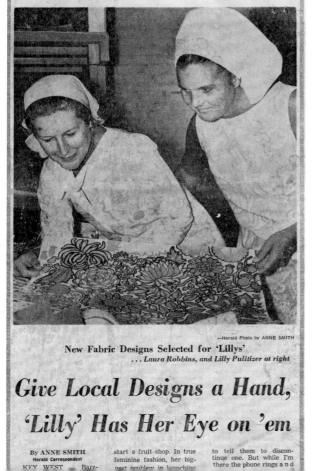

—Herald Photo by ANNE SMITH

New Fabric Designs Selected for 'Lillys'
. . . *Laura Robbins, and Lilly Pulitzer at right*

Give Local Designs a Hand, 'Lilly' Has Her Eye on 'em

By ANNE SMITH
Herald Correspondent
KEY WEST — Bare- start a fruit shop. In true to tell them to discon-
 feminine fashion, her big- tinue one. But while I'm
 gest problem in launching there the phone rings a n d

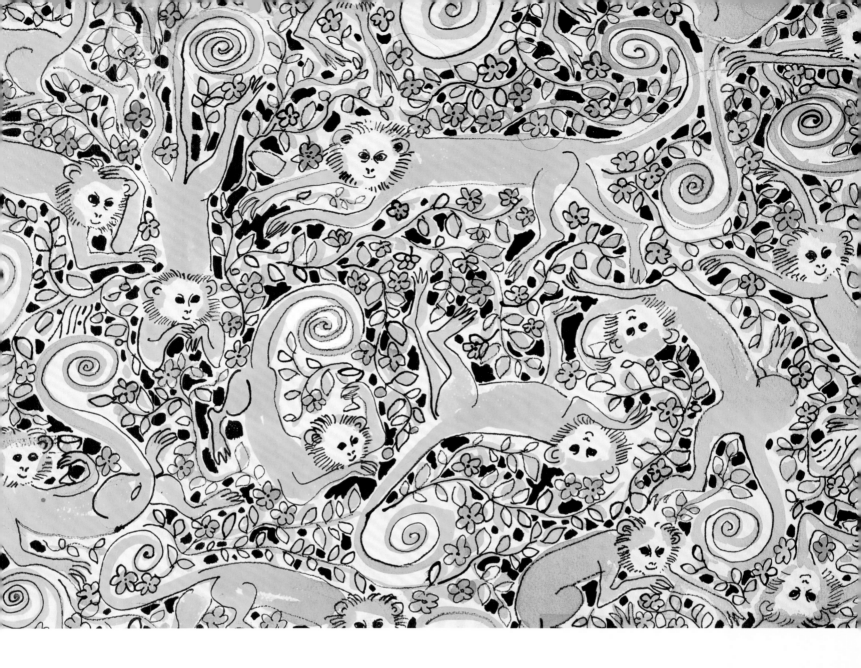

with Pell choosing the alternate colorways. His beyond-bright, tropical colors came to be identified with the "Lilly Look." Neither Lilly Pulitzer nor Key West Hand Print Fabrics conformed to the seasonal color palettes that the fashion industry as a whole followed. "Lilly Follows the Sun" was a long-running ad campaign for the Pulitzer brand, and both companies espoused the theory that it was always "the season" somewhere. The sun-bleached look of the fabrics was part of their endless-summer appeal.

The florescent colors sometimes obscured Zuzek's beautiful line work; at other times, her virtuosic skill with pen and ink was showcased. The cover of the August 1, 1969, issue of *Vogue* featured a young Jacqueline Bisset wearing a tunic printed with Zuzek's *Lilly's Creatures* design in black on tawny suede. Men's sport coats were also offered in printed suede. Black backgrounds became popular for floral prints in the early 1970s, and Zuzek's black-ground florals are some of her most richly detailed designs.

Another of Pulitzer's particular demands was that they avoid fall-on, or areas where two inks are deliberately overlapped to create additional colors. Zuzek painted her designs with Dr. Ph. Martin's concentrated watercolors, which she could overlay to create brilliant blended colors, maximizing the design impact while using the smallest number of screens (and keeping costs down). *Wonderworld*, for example, is a seven-color design printed with just four screens: yellow, pink, red, and turquoise, with turquoise over pink to

OPPOSITE, TOP Suzie Zuzek, *Lotsa Flowers*, 1966.

OPPOSITE, BOTTOM Lilly Pulitzer and business partner Laura Robbins reviewing original drawings by Suzie Zuzek at Key West Hand Print Fabrics. Zuzek's drawing *Lotsa Flowers* is in the foreground. Photographed by Annie Smith for the April 28, 1966 edition of the *Miami Herald*.

ABOVE Suzie Zuzek, *Trinket*, 1971. Zuzek's pet monkey, Trinket, turned up all over Key West, as well as in many of her textile designs.

make the purple, and turquoise over yellow to make the green. Pell's lack of design training, along with a resistance to incurring the expense of doing strike-offs of every colorway, sometimes resulted in unattractive shades in the fall-on, leading Pulitzer to declare, "No more fall-on!"[27] That limited Zuzek's toolbox as a designer, but she deployed a variety of other techniques to create depth and complexity. She used the full repertoire of drawing techniques, including hatching, cross-hatching, and stippling, to shade her figures. In a sort of reverse stippling, she would sometimes ask the technicians to leave open dots in the color separations. The resulting white speckles in the solid color areas created the illusion of a color gradation. She used rubber cement as a frisket, or resist. This could be used to reserve the color of the ground fabrics, or could be printed in white pigment on a brilliantly colored ground, creating highlights in a manner similar to the way white chalk is used on a charcoal drawing.

She also created depth by layering abstract patterns under or over highly detailed ones. Some functioned almost like camouflage, creating a moment of happy surprise when the hidden figure became apparent. In *Pescador*, a bold pattern of waves conceals delicately drawn fish. The zebras in *El Morocco* almost elude detection behind gray blade-leaf grasses. Even in *Wildness*, where the animal and floral elements are of equal scale, the barely-there outlines make the cheetahs hide in plain sight. Leigh Martin Hooten, a young textile designer who came to Key West Hand Print Fabrics as an intern in 1978 and never left, described Zuzek as a wonderful mentor: "She was always so encouraging, and gave great criticism. You always knew exactly what you had to do, and she was always right."[28]

In 1963, just a year after Pulitzer first arrived at Key West Hand Print Fabrics, the vivacious prints on her shift dresses were already so sought after that they were being copied. Key West Hand Print Fabrics sued Miami dress firm Serbin Inc. for copyright infringement on two Zuzek designs that were used by Lilly Pulitzer, Inc. Key West Hand Print Fabrics won the lawsuit.[29] After this early lesson, Johnson ensured that all the company's future designs were copyrighted to Key West Hand Print Fabrics, Inc., listing the designer in the title of each work on the application.[30] The designer's name also appeared in the selvedge of the yardage. Pulitzer, for her part, began to require that the name "Lilly" be incorporated directly into the design of the fabrics used by her. According to former Key West Hand Print Fabrics employees, Pulitzer showed a clear preference for Zuzek's prints. As Key West Hand Print Fabrics' biggest customer, Pulitzer always got first choice among all the new designs. Once she had selected among the pile of drawings presented to her on each visit to the factory, Lilly's name would often be incorporated into the design, either on the original drawing or added in the printing process on the line work acetate.[31]

In southern Florida, Zuzek was a well-known painter and sculptor. In the local press, her contribution to Key West Hand Print Fabrics' success was often noted. But as the Lilly Pulitzer brand became synonymous in the public's mind with those wild, wonderful prints, the messaging shifted to suggest that Pulitzer designed the fabrics herself, or "in collaboration with" her partners in Key West.[32] In fact, not one of the 2,109 designs copyrighted by Key West Hand Print Fabrics between 1962 and 1985 listed Lilly Pulitzer as creator. Zuzek was by far the most prolific creator of the Key West Hand Print Fabrics designs, with her name appearing in the title of more than 1,550 designs.[33]

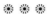

Through the 1960s, Key West Hand Print Fabrics expanded rapidly, primarily to meet Lilly Pulitzer, Inc.'s increasing demand for fabrics. By 1966, they were supplying Pulitzer with over five thousand yards per week.[34] The partners quickly expanded production at Harbor House, adding two additional printing tables and instituting shift work to keep the tables in operation twenty-four hours a day. "It's a story of beanstalk growth in the first four years since the fabric operation was originated," the *Key West Citizen* reported.[35]

In 1967, Key West Hand Print Fabrics opened a new, custom-built factory designed by local architect Dan Stirrup. The building was situated at 529 Front Street, in the oldest part of the city. The team worked with the Old Island Restoration Foundation to create a design in keeping with the conch style of local vernacular architecture. In that spirit, they preserved, at considerable cost and effort, a strangler fig tree whose limbs and roots grew through the brick wall of the pineapple processing plant that had previously occupied the site.[36] In Zuzek's hands, the tree became the symbol of Key West Hand Print Fabrics. It was used in both fabric designs and advertising.[37]

The new factory had five sixty-yard tables and two seventy-yard tables—a dramatic increase from Harbor House. "We'll be able to start with five times more production capacity than we've had before, and it'll be possible to go to eight times the capacity," Johnson

OPPOSITE, CLOCKWISE FROM TOP LEFT *Polka Puma*, 1970; *Bear Balls*, 1974; *Leopard Lilly*, 1966; and *Spot*, 1972. All drawings by Suzie Zuzek.

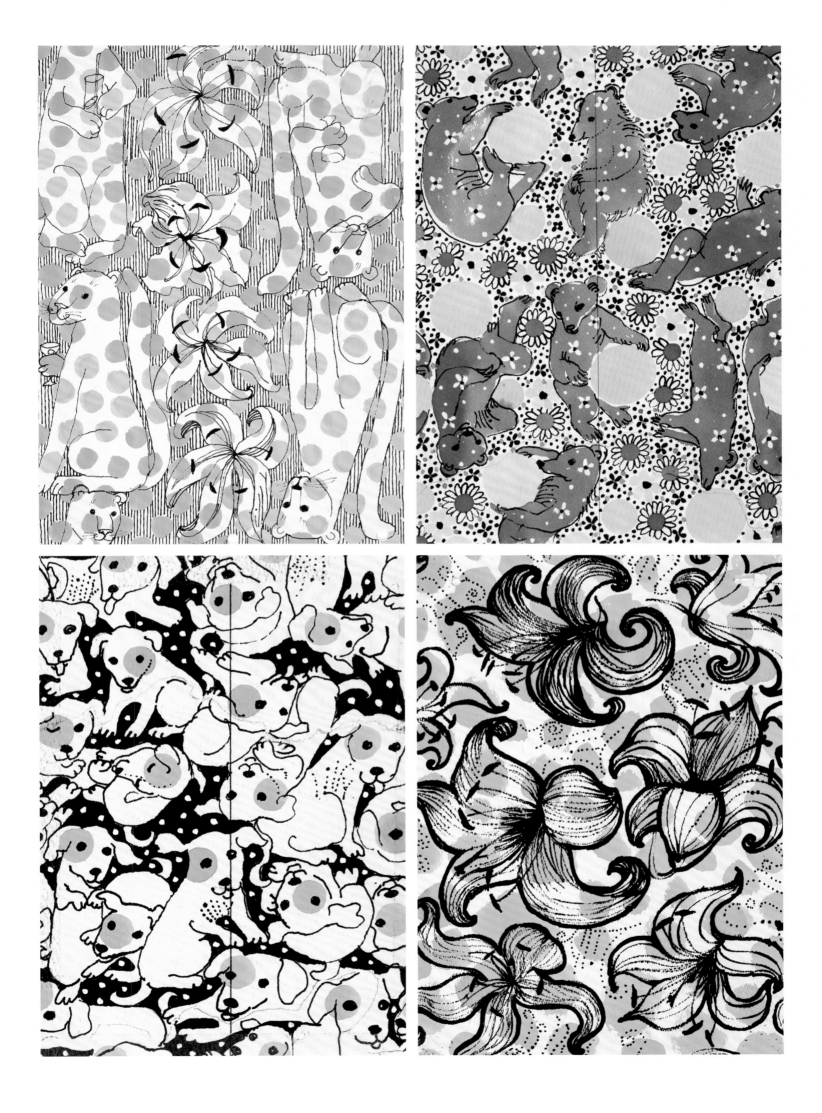

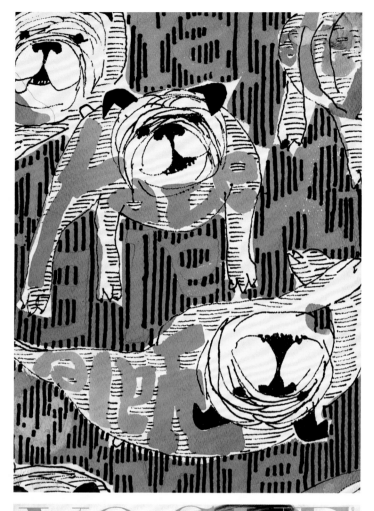

stated.[38] The art department, which included Pell's office, Zuzek's studio, and the area where the color separations were done, was on the second floor. The first-floor shop had a large picture window looking out over the printing tables. Visitors were also welcome to walk around back to watch the printing process up close. The gala opening of the new factory on March 17, 1967, brought together Key West politicians with such jet setters as the Pulitzers and Peter and Cheray Duchin, society columnist Suzy Knickerbocker, and other Key West notables including sometime-resident Tennessee Williams.[39]

The building was erected on city land, a benefit to both the city and the company. By 1970, the factory was converting more than a million yards of fabric per year and was the largest employer in Key West. Key West Hand Print Fabrics was recognized as one of the city's major tourist attractions, welcoming as many as two thousand visitors a day to tour the factory floor.[40] The company's retail footprint was also expanding. New stores opened around Florida, first in Coconut Grove, Marathon, Fort Lauderdale, St. Petersburg, Silver Springs, Daytona Beach, Vero Beach, and Winter Park, and later in Nantucket, Houston, Gatlinburg, Baltimore, Washington, Annapolis, and Hilton Head. Lilly Pulitzer and Key West Hand Print Fabrics had an unwritten agreement that they would not open stores in the same town, so if Lilly Pulitzer had Newport, Key West Hand Print Fabrics had Nantucket, and if Lilly Pulitzer had a shop in Nassau, Key West Hand Print Fabrics opened one in San Juan. When the Nantucket store opened, the *Key West Citizen* reported, "Key West Hand Print Fabrics has a foot in the door through their prime and treasured customer, Lilly Pulitzer—and another well-respected family in that neighborhood whose name is Kennedy."[41] Many of those who summered on Nantucket were winter residents of Key West.

Russell specified product for the shops and designed all of the stores, maintaining the emporium feeling of Harbor House in all of the additional stores. Initially, some were franchises that were operated by Johnson's relatives, but later all the stores were fully owned and

LEFT, TOP Suzie Zuzek, *Yale University*, 1969.

LEFT, BOTTOM Actress Jacqueline Bisset in a Lilly Pulitzer suede tunic printed with *Lilly's Creatures* (1968) by Zuzek, on the August 1, 1969, cover of *Vogue*.

OPPOSITE Fisheye view of Lilly Pulitzer fashions, including a long sleeveless dress (on left) in Zuzek's *Paulette's Posies* (1968) and orange-pink-and-blue men's pants (on right) in Zuzek's *Lilly's Llamas* (1967). Photographed by Frank Zagarino for the November 25, 1968 issue of *Newsweek*.

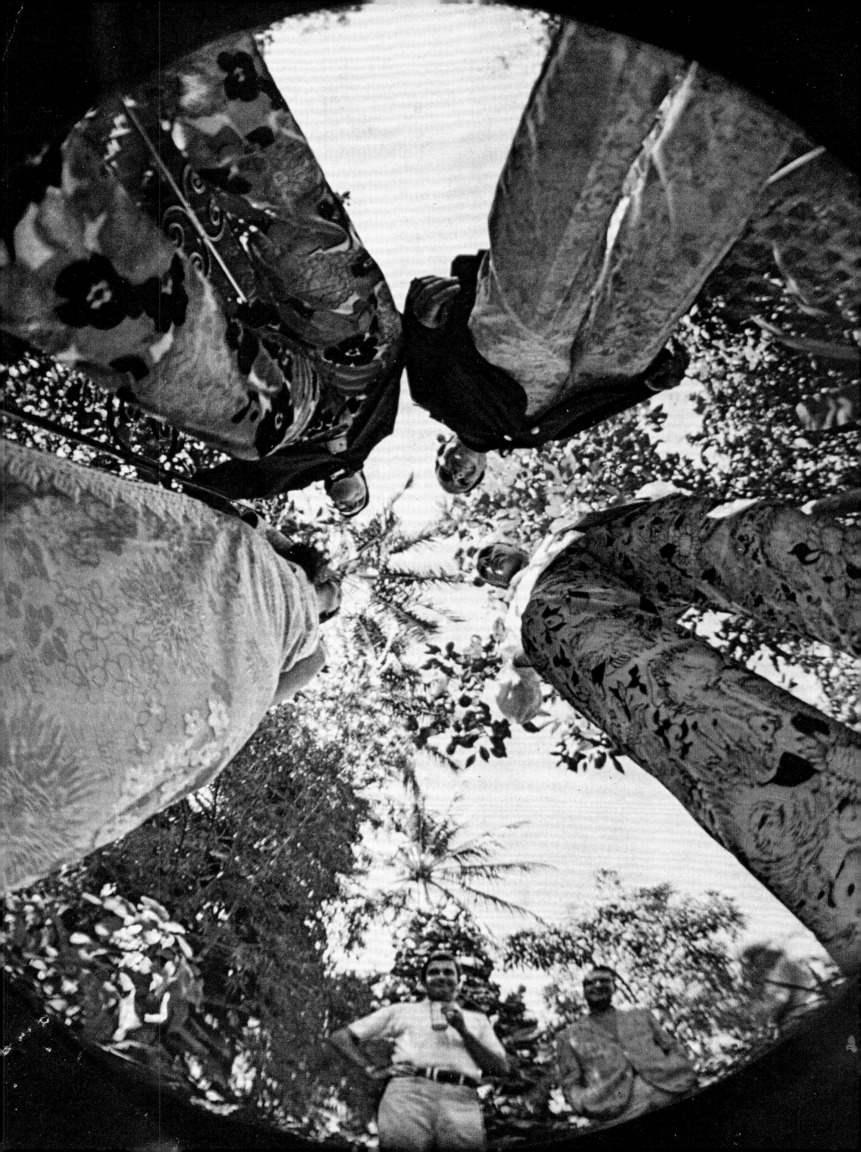

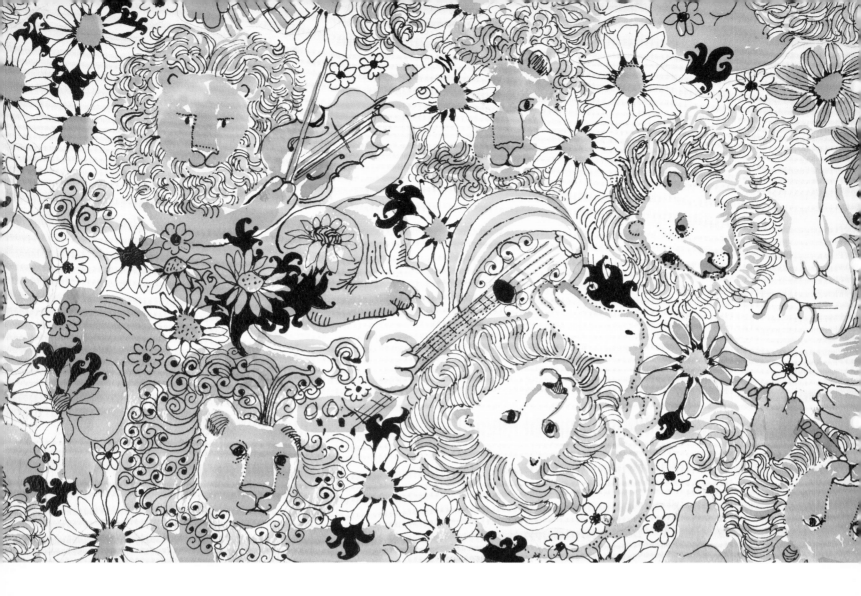

controlled by Key West Hand Print Fabrics.[42] At their peak in the late 1970s, Key West Hand Print Fabrics had twenty-two retail stores, and Lilly Pulitzer had thirty-three.[43] The Lilly Pulitzer boutiques carried only Lilly Pulitzer apparel, while the Key West Hand Print Fabrics shops carried both "Lillys" and "Vandas," marketing them side by side. According to Klausing, they did not perceive Lilly Pulitzer as a competitor. "Vanda," she said, "designed classic fashions for the mature woman," whereas Lilly Pulitzer was considered a youth-oriented brand.[44] Both targeted a similar price point (about $30 to $75), but Vanda Exclusives sold for $100 to $250.[45] Home sewers who purchased Key West Hand Print Fabrics wares to make their own "Lillys" would receive a Key West Hand Print Fabrics label with the yardage.

Key West Hand Print Fabrics also branched out into decorator fabrics, which were distributed to the trade through showrooms in New York and across the country. Although bright colors and tropical themes were popular for Florida homes, they were a harder sell in the northeast. Zuzek adapted with sparser, more abstract designs such as *Key West Plaid*, *Winter* (a design of leafless trees), and *Bamboo II*, and Pell developed more subtle color palettes. Lilly Pulitzer's

home line, created for Lord & Taylor, also used Zuzek prints, including *Seawake*, inspired by a boat's wake. Pulitzer's housewares, bedding, and yard goods for upholstery and drapery were as print-driven as her fashions. The June 1969 issue of *House & Garden* proclaimed, "This year, domestically bent, [Lilly Pulitzer] has designed a collection of decorative fabrics and accessories calculated to do for the house what her clothes do for winter-weary ladies and gentlemen: send spirits soaring."[46] Zuzek's enchanting animals appeared on placemats, beach towels, tote bags, and pillows: "Customers grab them up for children's

ABOVE Suzie Zuzek, *Hep Cats*, 1969.

OPPOSITE, TOP Suzie Zuzek, *Sea-Lilly*, 1969.

OPPOSITE, MIDDLE Pulitzer Jeans in Zuzek's *Sand Fiddlers*, photographed by Peter Barlow for the October 1968 issue of *Rudder Magazine*. The magazine caption reads, "If you're a serious racer, don't let your crew wear [Pulitzer Jeans]—they attract girls like crazy."

OPPOSITE, BOTTOM Suzie Zuzek, *Sand Fiddlers* textile, 1968. This design was available in a remarkable forty-seven colorways, including "Yes Yes Yellow" and "Outstanding Orange."

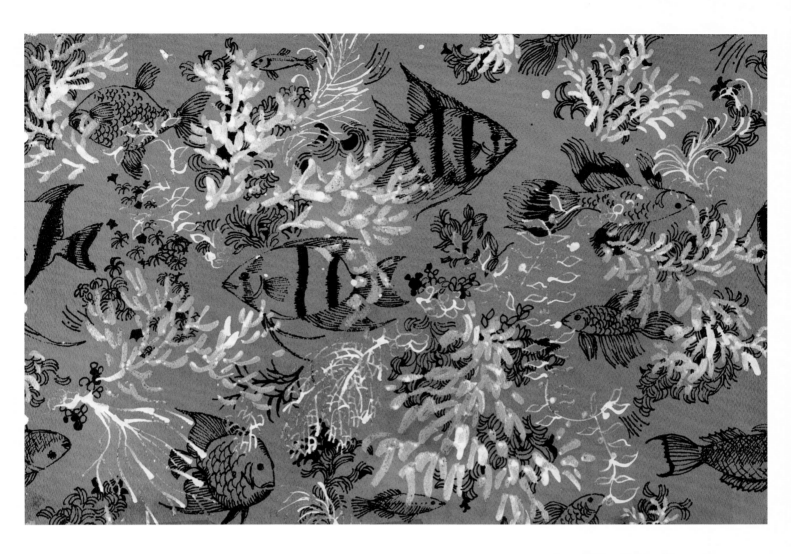

bedrooms and family rooms," reported *Home Furnishings Daily*.[47] Lord & Taylor's Fifth Avenue flagship store devoted its entire bank of windows to promoting the line, replacing its traditional awnings with colorful textiles from Key West Hand Print Fabrics.

<p style="text-align:center">❀ ❀ ❀</p>

When Key West Hand Print Fabrics first opened in 1961, downtown Key West was a very different place from the bustling tourist destination that it is today. As local newsman Bud Jacobson so noirishly put it, "The neighborhood was dim, poorly lighted, an area favored by sailors and shrimpers looking for a strip joint, a cheap beer, a night prowl among some of the seediest barrooms the town had to offer."[48] The economy was largely dominated by the Navy installation, and there were only two bars—Sloppy Joe's and Captain Tony's—plus the Old Town Trolley and the aquarium. From the late 1950s, there were intimations that the Navy might pull back its presence there, and that tourism was going to be key to the future economic success of the region. Starcke may have originally conceived of Key West Hand Print Fabrics as a tourist shop, but with the rapid expansion of the wholesale business to match Lilly Pulitzer, Inc.'s explosive growth,

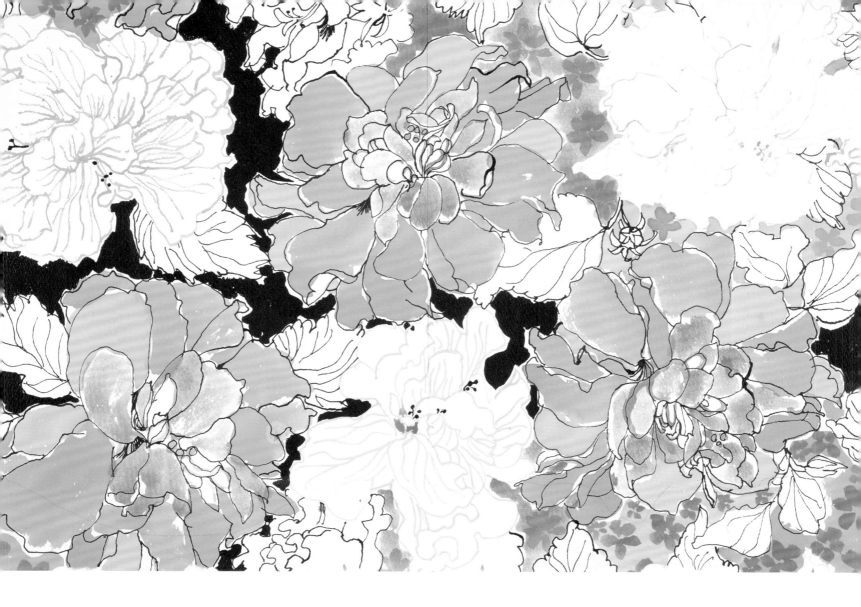

TOP Suzie Zuzek, *Tennessee's Hibiscus*, 1973.

ABOVE Zuzek with playwright and Key West resident Tennessee Williams at a Key West Hand Print Fabrics party, circa 1968.

OPPOSITE Key West Hand Print Fabrics workroom with three sixty-yard tables for hand-screen printing, 1960s. Fabric production at the factory was reported in miles, not yards.

it took a direction that he could not have imagined. Key West Hand Print Fabrics came to occupy a unique position as both a full-blown industry that employed more than one hundred fifty people in skilled work and a major tourist attraction. That winning combination, together with a visually exciting product created by local artist Suzie Zuzek, made Key West Hand Print Fabrics a darling of the Florida Development Corporation.

The upstart company was invited to represent Florida in the 1964 World's Fair in New York. Russell's mother, Minerva Rousseau, was appointed manager of the shop, and Zuzek created special designs for the presentation.[49] The *Key West Citizen* reported, "The only real direct representation of Key West at the New York World's Fair this past summer was appropriately done by its fastest growing small industry, and one of the nationally known leaders in the fashion field—Key West Hand Print Fabrics."[50]

In 1968, Zuzek's design was chosen from among hundreds of entries to be the official Key West flag, a version of which is still in use today. The design features a conch shell in the center of a radiating sun on a blue ground, with the northern and southern constellations

and 1828, the year the city was chartered.[51] Fittingly, the flags were printed at Key West Hand Print Fabrics.

In 1970, the Florida Department of Commerce called on the company to design uniforms for its Welcome Station hostesses at the state's official tourist greeting centers. Zuzek created a custom design called *All Florida II*, featuring conch shells, spoonbills, sand dollars, starfish, shrimp pots, turtles, and butterflies. The uniforms, which were initially shirtwaist dresses and later pantsuits, were printed in "Gulf Stream Blue," "Key Lime Green," and "Florida Orange" colorways.[52] The designs were also worn by Department of Commerce employees when promoting Florida tourism at national and international events. A Zuzek design made an appearance at the Florida governor's mansion in Tallahassee when First Lady Adele Graham requested a custom design incorporating hibiscus and mockingbirds, Florida's state bird. The fabric was used to create table linens for the Governor's Ball, a fundraiser to benefit restoration of the historic mansion.[53]

The theatrical bent of the company's founders showed in its promotional events. When the first cruise ship docked at Key West in 1965, Russell wrote a musical, *Cayo Hueso*, to entertain the passengers on board the *Yarmouth Castle*.[54] During the 1970 and 1971 cruise seasons, Johnson pressed his sailboat, the *Marquesa*, into service to promote the company's fabrics, sailing out to greet the arriving cruise ships. The *Key West Citizen* reported, "Flying brightly colored pennants and crewed by handsome young men wearing Key West Hand Print *lavalavas*, and beautiful girls wearing *pareas* of the firm's brightest prints, the gallant vessel was one of the city's most appreciated welcoming committees."[55] Johnson took advantage of events like regattas and the annual Fort Lauderdale–Key West race to show off the company's wares. Zuzek created several jumbo-sized patterns, including *Sun Sail* and *Sail Birds*, which were printed on sails of the competing boats. In 1973, Johnson outfitted the thirty-eight-foot *Marquesa* with floral-print sails. Zuzek created an oversized hibiscus pattern, which was printed in shades of pink and green at the factory on regulation canvas, and constructed into a "roller-furling Genoa headsail" by Hood Sailmakers of Marblehead, Massachusetts.[56] On an eleven-day voyage from Vero Beach to Key West, the boat docked at yacht clubs and waterfront restaurants in six ports of call. Models sporting spring fashions in Zuzek's colorful patterns disembarked down a shocking pink gangplank and gave a brief runway show before returning to the boat and sailing off.[57]

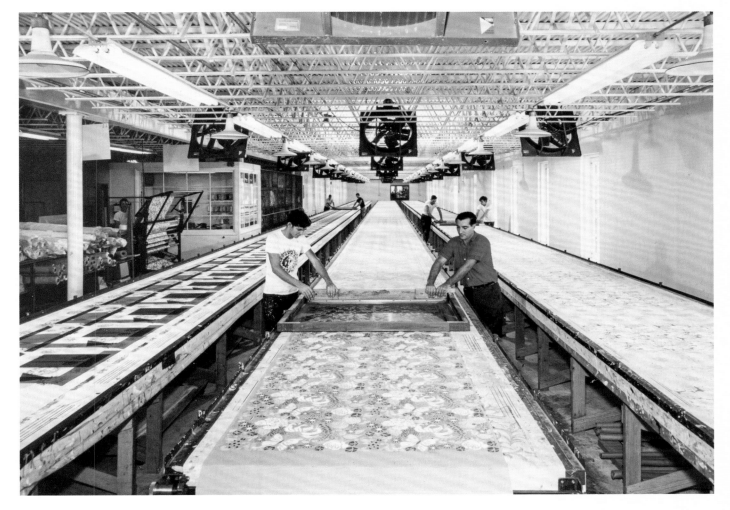

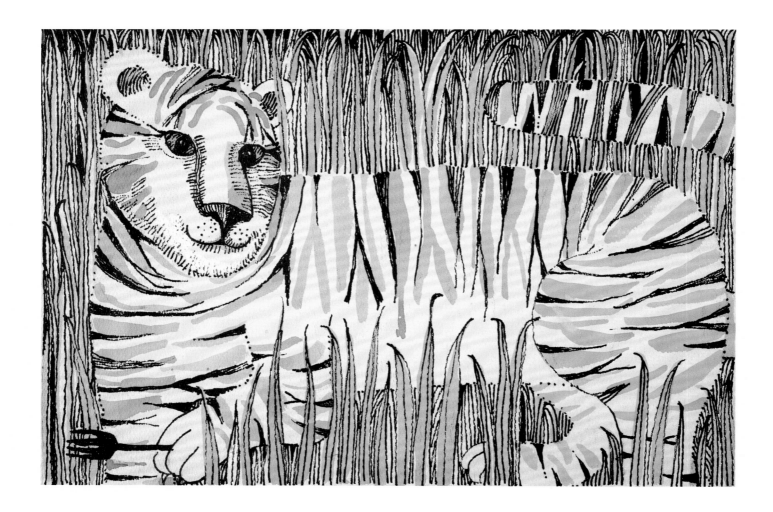

There was always something fun going on, several former employees reported. Pell and Russell had clearly created something special—a company that continued to feel small even as it grew. "They created an environment where all these wonderful things could happen," Klausing said. "I enjoyed every day at Key West Hand Print."[58]

<p style="text-align:center">❁ ❁ ❁</p>

For more than twenty years, the odd-couple pairing of Suzie Zuzek's wild patterns with Lilly Pulitzer's classic silhouettes brought mutual success and growth to both Lilly Pulitzer, Inc. and Key West Hand Print Fabrics. As Zuzek herself put it, "They made her, and she made them."[59] Early on, Lilly Pulitzer purchased the factory that produced her clothing and retailed her products through her own shops, but she was completely dependent on Key West Hand Print Fabrics and Suzie Zuzek for the fabulous prints that were the signature of her brand. Although Key West Hand Print Fabrics was more fully vertically integrated with textile design and production, garment design and production, and merchandising all in-house, the company was financially dependent on its largest wholesale client: Lilly Pulitzer, Inc.

In the early 1980s, things took a sudden downward turn. First, there was a radical shift in leadership at Key West Hand Print Fabrics. In 1980, Bill Johnson decided to retire, selling his shares to Lilly Pulitzer, Inc., ceding a controlling interest in the company.[60] In 1981, Peter Pell died suddenly in a choking accident. His shares in the company passed to his lifelong partner, Jim Russell.

In 1984, Lilly Pulitzer, Inc. filed for Chapter 11 bankruptcy. In a surprising next move, the company designed a collection, *New Directions*, which included just one print, in shades of gray. "Updated styles with uncharacteristically formal purples, reds, and greens have replaced the pink-and-green flower print dresses made famous by Kennedy in the '60s," the *Miami Herald* reported.[61] Fashion critics explained the company's failure in a variety of ways, but from the point of view of Key West Hand Print Fabrics employees, it was all about the prints, or lack thereof. "How ironical," the firm's PR spokesperson stated, "when in the year that fashion dictates prints, the company that designed and printed the fabrics for fashion-famous Lilly Pulitzer Resort Wear is now being liquidated by Lilly Pulitzer, Inc."[62]

Russell was optimistic that Key West Hand Print Fabrics could successfully reorganize. He began

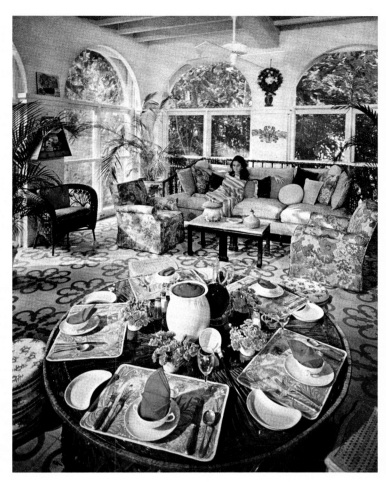

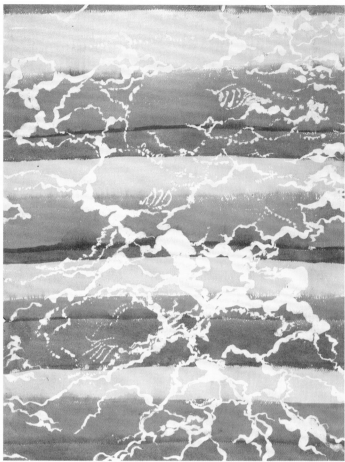

plans, together with the staff, to reorganize production around the needs of its own shops. The final blow to the company was one that affected creative industries around the world: the AIDS crisis. By that time, Russell was quite ill; he died in 1985. He and Pell had fostered an inclusive, gay-friendly environment at the company, and the epidemic took the lives of many staff members in the ensuing years.[63]

In 1985, Lilly Pulitzer, Inc. sold off Key West Hand Print Fabrics, the company's largest asset, retaining only her trademarked name.[64] Key West Hand Print Fabrics, together with all of the textile designs and the underlying copyrights, was purchased by a group of Key West businessmen, who did not want to lose the city's major employer and downtown attraction.[65] The *Key West Citizen* reported, "The financially troubled Key West company closed its doors in July, laying off many skilled employees. But not for long, as businessmen Ed Swift, Chris Belland, Moe Mosher, and Greg Curry put their heads together and came up with a plan to save one of the island's landmark tourist attractions."[66] Key West Hand Print Fabrics did reorganize, but without Lilly Pulitzer or Suzie Zuzek, it never attained the national prominence that it previously had.

Zuzek decided to retire from textile design to focus on her art full-time. She sculpted in tin and glass, painted ceramic tiles, completed commissioned public artworks, ran a gallery, and mentored and supported younger artists. She was honored with a retrospective exhibition of her work at the Key West Art and Historical Society in 2001. But she never knew what happened to the extraordinary body of work that she created for Key West Hand Print Fabrics. In 1993, Lilly Pulitzer licensed and subsequently sold her trademark to a company that began

OPPOSITE Suzie Zuzek, *KWHPF, INC. 1433*, 1968. Zuzek had a keen and sly sense of humor that is evident throughout her work. Here, a lion hidden in tall grass holds a fork as if waiting for dinner—an appropriate motif for a placemat.

ABOVE, LEFT Zuzek designed all of the prints used by Lilly Pulitzer for her home collections, including *Multiflora* (1965) shown on the club chairs in Pulitzer's Palm Beach house. Photographed by William Grigsby for the June 1969 issue of *House & Garden*.

ABOVE, RIGHT Suzie Zuzek, *Seafoam*, 1968. This evocative pattern was used for both fashion and interiors fabrics. Pulitzer used the design for a tablecloth in her own Palm Beach house.

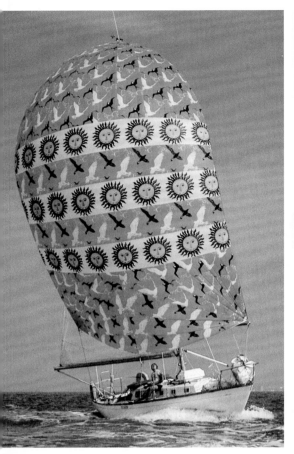

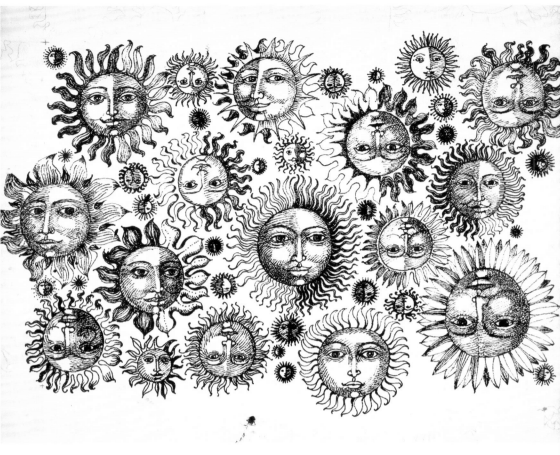

producing a line of clothing under the Lilly Pulitzer name.[67] In 2008, the *New York Times* reported that Pulitzer had thrown out most of the archive in 1984, and for those not familiar with the details of the bankruptcy proceedings, it seemed Zuzek's original textile designs were lost.[68]

A 2014 exhibition about Key West Hand Print Fabrics at the Key West Art and Historical Society, which included a handful of Zuzek's original design drawings, revealed that perhaps all was not lost.[69] Further investigation by Becky Smith, who developed a close friendship with Zuzek after meeting her in 2007, soon revealed that the contents of the Key West Hand Print Fabrics factory—more than 2,500 original design drawings, together with the acetate color separations, swatch books with colorways and production information—remained largely untouched in storage in Key West. In 2016, Smith and Meg Shinkle, backed by a small group of St. Louis investors, purchased most of the assets of the

Key West Hand Print Fabrics, including the design archive. They catalogued, photographed, conserved, and archivally housed the archive in an art storage facility to ensure its long-term preservation.[70] This book and the exhibition that accompanies it are hopefully the first of many opportunities to explore Zuzek's limitless imagination.[71]

❋ ❋ ❋

Suzie Zuzek's artistic contribution to a fashion look that became an icon of American style is a fascinating, previously untold story. It is also an important addition to the history of American fashion, and perhaps a corrective to the invisibility of textile designers in the fashion industry more broadly. Lilly Pulitzer herself said, "The fabulous success of the 'Lilly Look' would not have been possible without Suzie's whimsical and magical creations. She constantly amused me, not only by the genius of her art but also the sheer numbers of designs she created. I couldn't wait to see what came next."[72] Zuzek's wild, wonderful designs are what made Pulitzer's fashions so unique and so beloved. Through Lilly Pulitzer's widespread popularity in the 1960s and '70s, and the enduring legacy of those original fashions, Suzie Zuzek's imaginative designs have found their way into the hearts of millions. ❋

ABOVE, LEFT *Elysium* won the award for best spinnaker in the 1978 Fort Lauderdale to Key West Race, sporting two Suzie Zuzek designs: *Sun Sail* and *Sail Birds*, 1970s.

ABOVE, RIGHT Suzie Zuzek, *Suzie's Sons*, 1965.

OPPOSITE Suzie Zuzek, *For Mariners Only*, 1966.

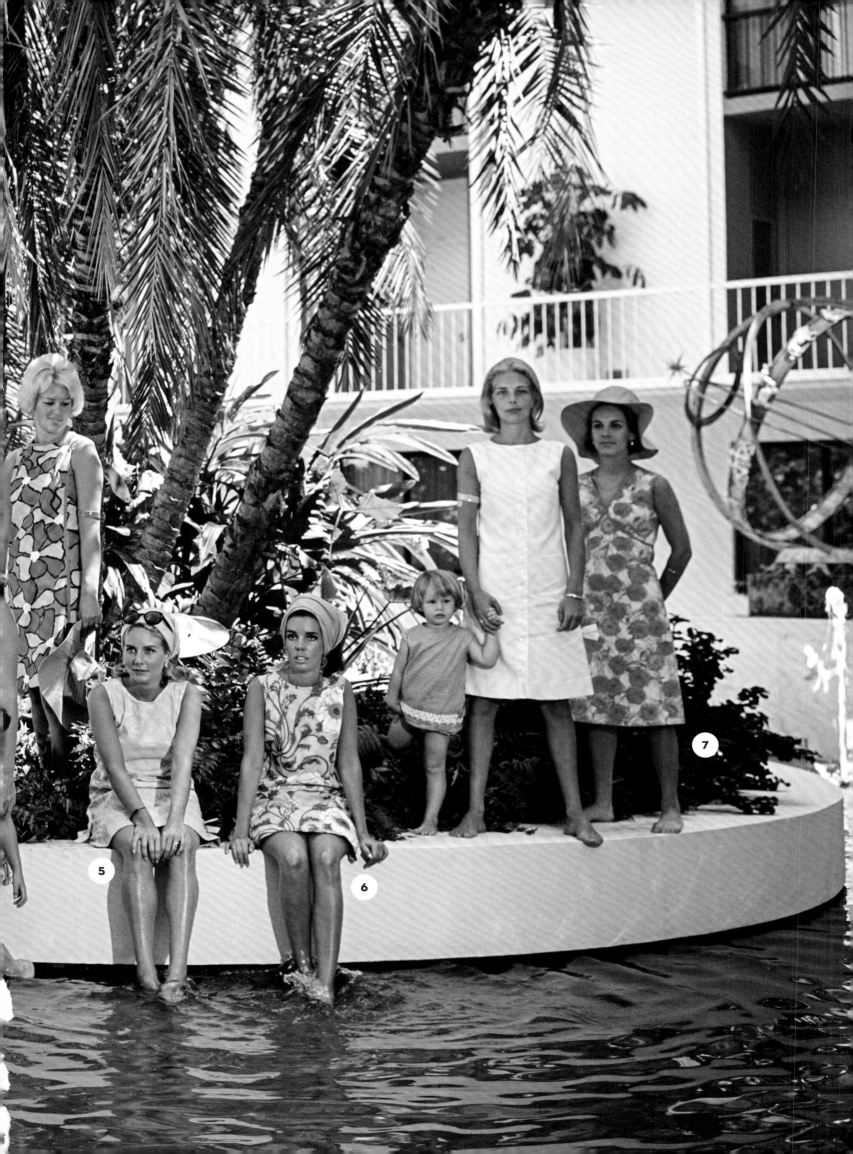

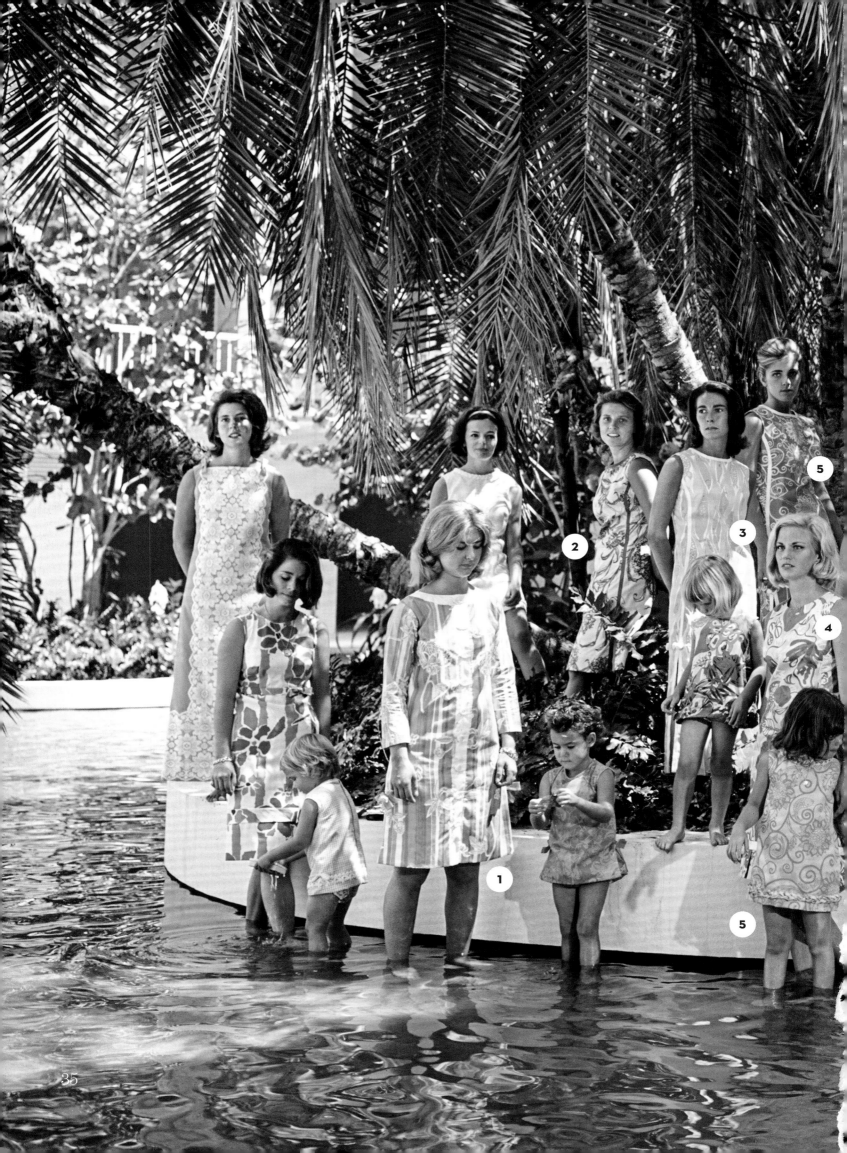

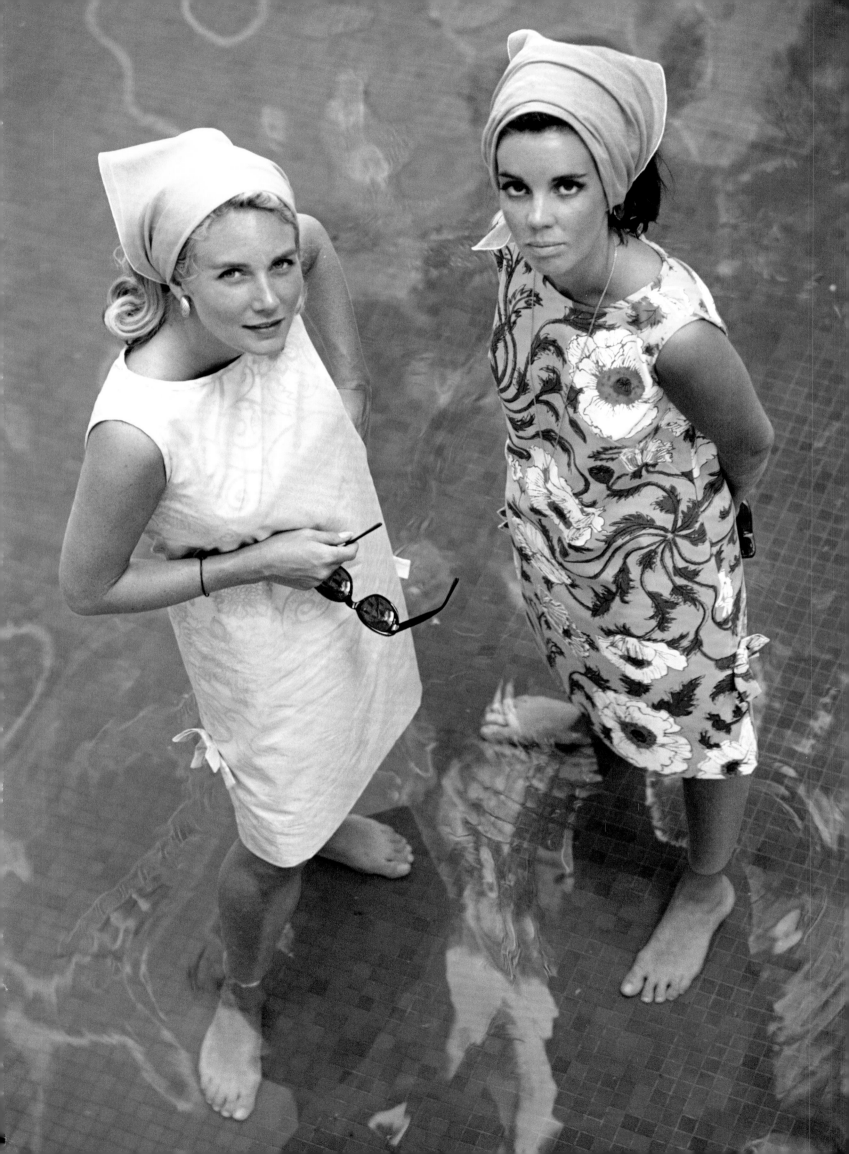

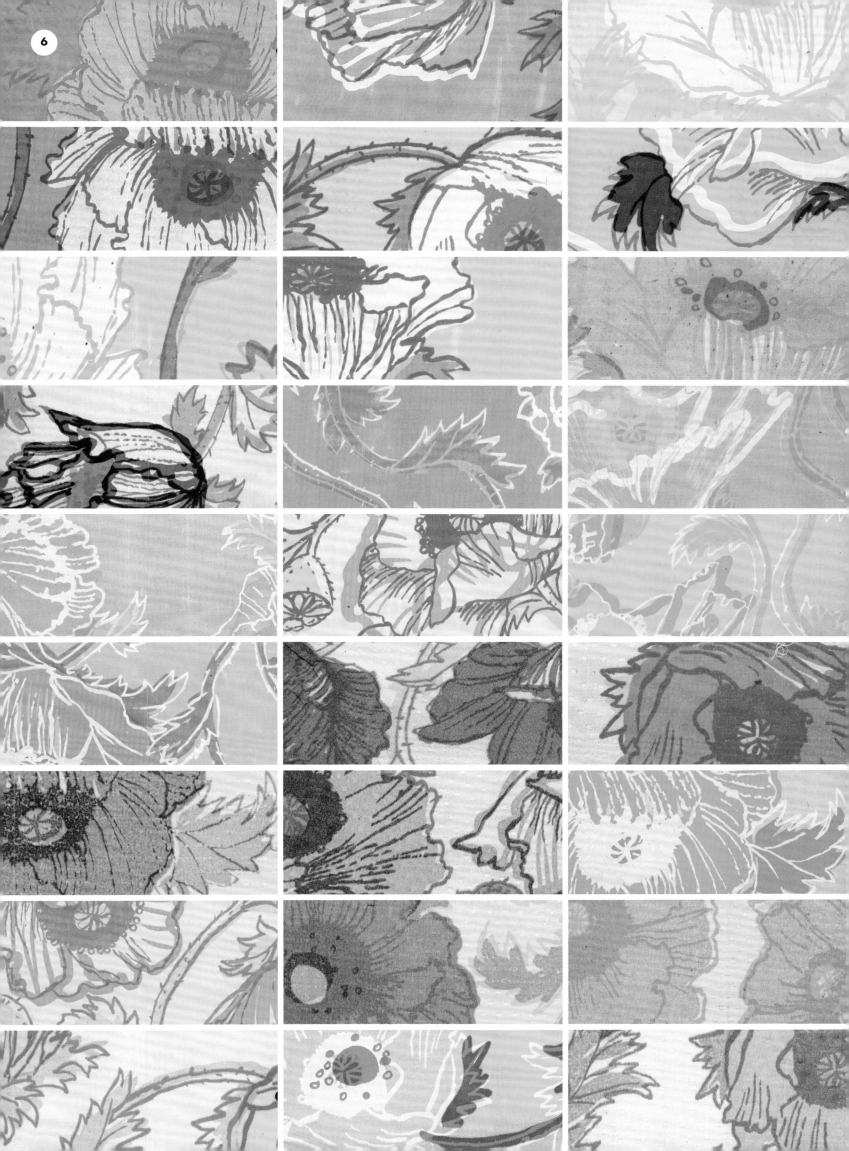

Suzie Zuzek, *Poppies* textile swatch, 1963.

PALM BEACH, FLORIDA · 1964

NOTED SOCIETY LENSMAN Slim Aarons captured several young women and girls of Palm Beach in their Lilly Pulitzer shifts, many in designs by Suzie Zuzek as noted on the key to the right of the photograph.

Suzie Zuzek, *Rock Rose* textile swatch, 1963.

Suzie Zuzek, *Peony Stripe* textile swatch, circa 1964.

Suzie Zuzek, *Carnation* textile swatches, 1963.

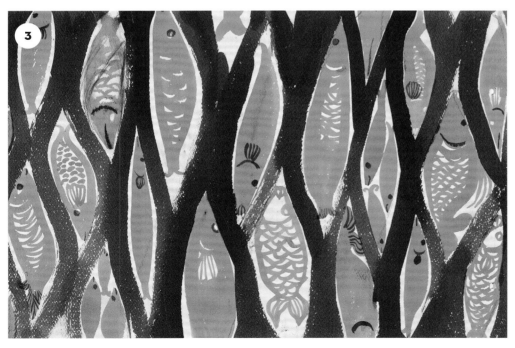

Suzie Zuzek, *KWHPF, INC.* 301, circa 1964.

Suzie Zuzek, *Key Harvest* textile swatches, 1964.

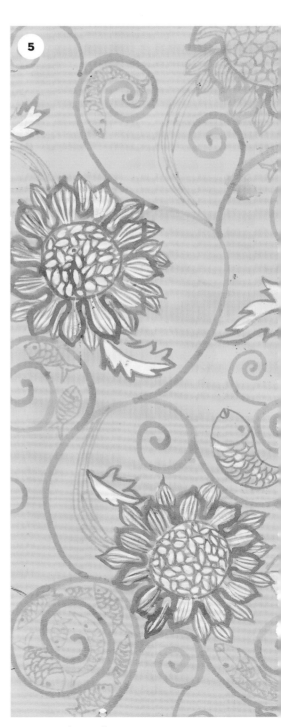

Suzie Zuzek, *Sunflower*, circa 1964.

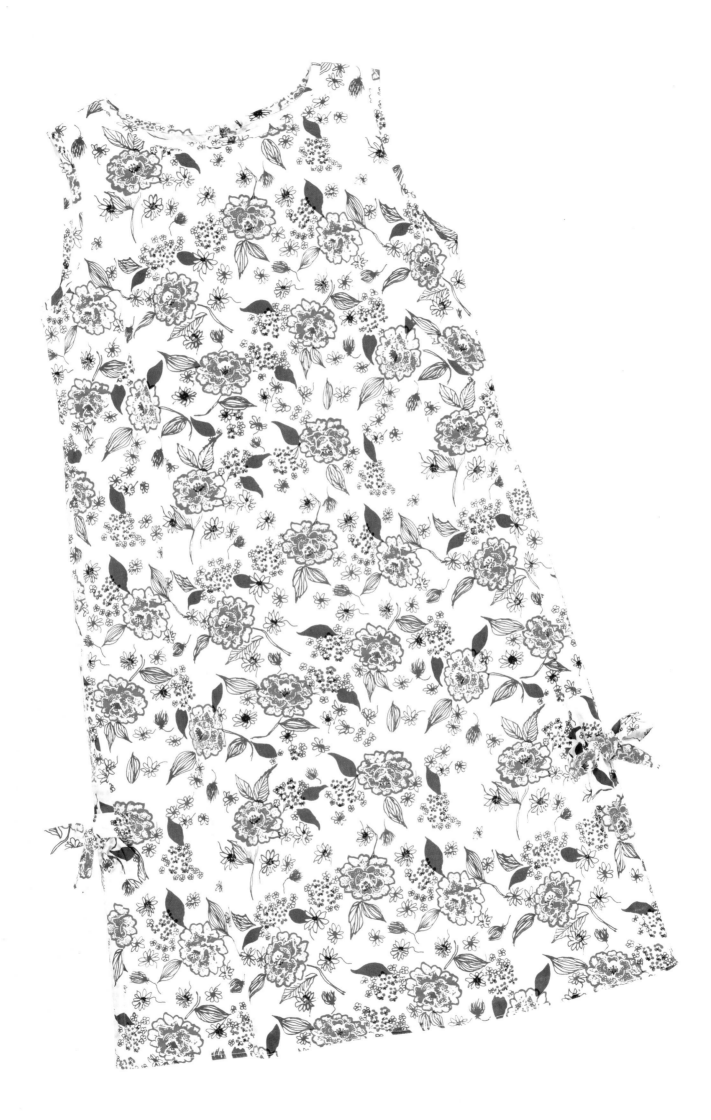

PAINTING THE LILLY

SUZIE ZUZEK ANIMATES LILLY PULITZER FASHIONS

CAROLINE RENNOLDS MILBANK
Independent Fashion Historian and Author

THE SARTORIAL PHENOMENON that was the simple, slit-hem shift dress known as "the Lilly," and particularly as fabricated in a myriad of eye-catching prints by artist Suzie Zuzek for Key West Hand Print Fabrics, has been almost completely ignored by fashion history. The Lilly's deeply entrenched status as a Waspy tribal signifier has tended to obscure the pivotal role that it played at a transitional moment in America as the well-behaved and oh-so-conventional 1950s gave way to the taboo-busting 1960s. The brilliant combination of the narrow but unconstricting silhouette and the wild and colorful Zuzek prints initiated a groundswell that would begin in resort wear and reverberate throughout American fashion on every level.

Whereas the Paris haute couture–dictated sack dress failed to revolutionize the silhouette, the Lilly shift succeeded. Its knee-baring hem introduced the notion of a shorter skirt to America, paving the way for the miniskirt. As adopted by Jacqueline Kennedy, the most *comme il faut* First Lady of all time, the Lilly was worn with bare legs and flat sandals. It was the opening salvo in the break with the Establishment dictum that one was not properly dressed in public without a hat, white gloves, stockings, and close-toed shoes. Although the first Lilly dress would be augmented with other styles, it was the textiles with Zuzek designs that inspired devotees not only to wear Lillys but also to become avid collectors, seeking out every print.

Lilly pants with Zuzek prints revolutionized men's fashion. Not only did the Lilly Pulitzer PJs (short for Pulitzer jeans) precede Gloria Vanderbilt designer jeans by a decade, they also were unisex. Lilly Pulitzer had men and women coveting the same pair of flora- or fauna-printed pants—an experiment in gender fluidity that, unlike those proffered by avant-gardists

OPPOSITE Shift in Zuzek's *KWHPF, INC.* 95. This was one of the first Zuzek prints used by Lilly Pulitzer, an early example where the name *Lilly* does not appear in the design.

RIGHT Suzie Zuzek, *KWHPF, INC.* 95 textile, early 1960s.

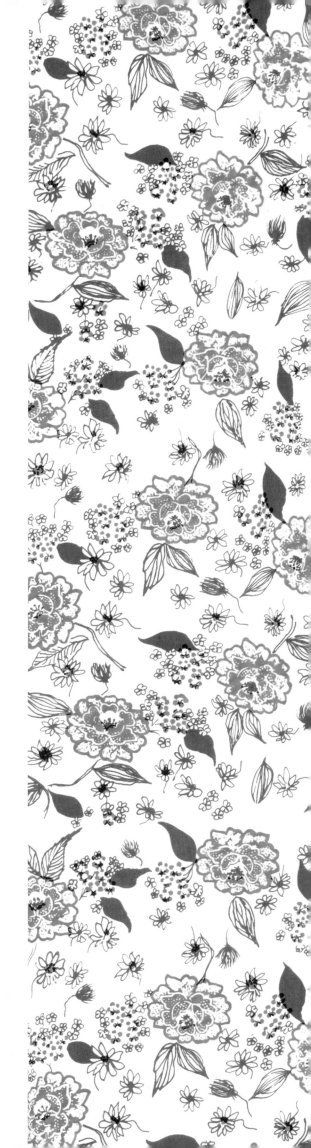

Rudi Gernreich and Pierre Cardin, actually took off. And those men wearing the snazzy florals and animal prints? They were the very epitome of the East Coast Establishment against whom the counterculture was raging. The clothes were sold at first in cleverly casual boutiques where friends gathered to hang out and drink orange juice—an idea in sync with an international trend of small shops that were "in-crowd," "groovy," or "hip," prompting even the most traditional department stores to offer in-store boutiques.

The distinctive Zuzek prints used as decor in the proliferating Lilly Pulitzer and Key West Hand Print Fabrics shops were also popular with customers when sold by the yard to use at home. Lilly Pulitzer did not

invent the idea of a fashion designer expanding into the home environment—that was Paul Poiret in Paris in the 1920s. But picture a house decorated with Zuzek textile designs for Lilly and every member, every generation, of the family Lilly-clad. Simply no other American brand in the 1960s had such an enveloping reach.

Ever since the end of the Second World War, the female fashion silhouette, led by new Paris couture star Christian Dior, had featured the small, fitted bodice and full, sweeping skirts reminiscent of mid-nineteenth-century styles. As adapted everywhere, the silhouette presented women as delicate flowers, which was the very opposite of the broad-shouldered, capable Second World War WAVE or WAC or factory worker. For the next decade, Dior would introduce a new silhouette twice a year. Although none of them became a dominant look, they cemented the notion that couturiers in Paris set the pace when introducing new styles. Cristóbal Balenciaga, the couturier whom Dior called "the master of us all," experimented with silhouette in a more thoughtful, less manipulative way. Throughout the 1950s, he played with the sculptural possibilities of dress, working with lightweight fabric to create airy volumes. When he and his acolyte Hubert de Givenchy simultaneously introduced, in 1957, a relatively simple chemise dress, christened "the sack," it was met with consternation—even outrage.

Fashion editors, who are always loyal to the next new thing, fussed over how to present the sack in a convincing way. In March 1958, Bettina Ballard pronounced that "the moment of truth has come when the *Town & Country* reader has to face up to the chemise look. It is no longer just an exaggerated high fashion from Paris, it is *the* fashion." She spoke too soon. The sack had caused tremendous anxiety. Its untethered silhouette seemed to threaten all notions of "the little woman," an ultra-feminine 1950s homemaker wearing a shirtdress with full skirts, high heels, and an apron. Famously, an episode of the widely watched television comedy *I Love Lucy* mocked the shapeless look. The sack was so controversial that in April 1958, the Eisenhower White House released a statement refuting the rumor that First Lady Mamie Eisenhower had ordered one.

Meanwhile in Palm Beach, a young newlywed was starting to wear a dress that did not have the waist as its focal point. Lilly Pulitzer had been selling the dress for a year or so when, in 1961, she learned of an exciting development: a recently established fabric-printing enterprise in not-too-far-away Key West. The quality of the hand-screening and the exciting print designs entranced her. She famously placed the largest order Key West Hand Print Fabrics had ever received, and

then she doubled it. Her simple shift, now realized in the distinctive screened prints of Key West designer Suzie Zuzek, took off. By 1963, *Life* magazine would report, "Essentially the Lilly is a chemise that has been shortened, shaped, slit in the side seams to give a sense of proportion the sack itself never had. It is made in wildly colorful cotton prints that are hand-screened for Lilly in Key West, and it is lined so it can be worn with a minimum of underwear."

There are parallels as to how Gabrielle "Coco" Chanel and Lilly Pulitzer got their starts in fashion. Both were living in resorts—Chanel in Deauville, Pulitzer in Palm Beach—and both "invented" a garment that was hardly high fashion but that uncannily suited life in that particular place and time. Chanel's first clothing item (after the hats she designed as a novice milliner) was a cozy, almost bulky tunic sweater to be worn over the then-typical look of floor-length lingerie dress when temperatures dipped. The antithesis of everything else available, these tunics had been not so much designed as devised by a woman who herself had abandoned corsets because she could not laugh while wearing them. Chanel did not just

design well for women because she was a woman; she invented how modern women should dress because she herself epitomized the independent, rule-breaking new woman. From this early success, based entirely on practicality and the sense to design for others what she herself wanted to wear, an empire was born. It did not hurt that between the first tunic sweater and Chanel's next designs, easy little suits in jersey with tunic tops and wide skirts, came the First World War, effectuating dramatic change to all aspects of life.

Lilly Pulitzer similarly "invented" a garment that was not so much designed or created as engineered to suit anyone like her—a busy young woman who was juggling marriage, child-rearing, work, and an active social life. Importantly, her narrow shift dress was lined, which crucially eliminated the need for the standard underpinnings of the time: besides a bra and underpants a woman in a dress would have been expected to wear stockings (which in pre-pantyhose days meant a garter belt or girdle) and a full or half-slip, usually of nylon. Although air conditioning existed, it was not yet ubiquitous, so it was both refreshing and liberating to abandon the extra layers. Lilly has said

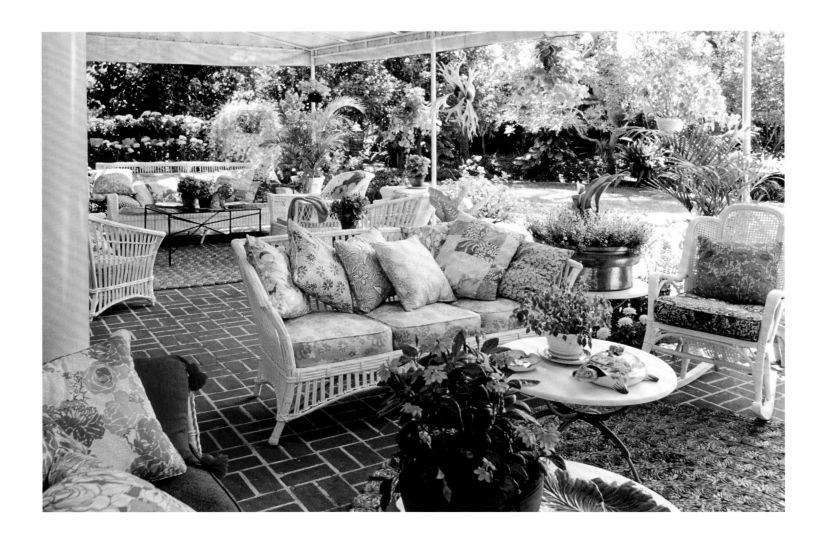

SUZIE ZUZEK FOR LILLY PULITZER

that the alternative at the time to a dress was pants or shorts, which in Palm Beach in the late 1950s/early 1960s meant narrow pants from chic labels Jax or Pucci or high-waisted Bermuda shorts from a label such as McMullen, all notoriously unforgiving. As women's pages and fashion magazines constantly admonished, women should not consider these styles unless they were long and lean. Although tall (and usually described as beautiful), Lilly Pulitzer did not, as *Women's Wear Daily* once put it, look like Twiggy; her shift was designed to be flattering to herself. Because it was cut narrowly, the side slits were a key feature. They made it possible to sit cross-legged on the floor with a child, play golf, or, if living the life Pulitzer, jump off a plane and hit the ground running. Just as had been the case with Chanel's tunic, this garment became popular almost instantaneously.

ABOVE Pillows in a colorful array of Suzie Zuzek prints on Lilly Pulitzer's Palm Beach terrace: *Florrie*, 1973; *Flower Field*, 1973; *Alina*, 1972; *Just Rosey*, 1971; and *Floretta*, 1974. Photographed by Horst P. Horst for the January 1975 issue of *Vogue*.

OPPOSITE Suzie Zuzek, *Floretta*, 1974, seen on lower-left pillow, above.

What gave the original Lilly a head start over all other fashion launches was the social pedigree and milieu of its creator. As the 1960s dawned, there was still a deeply entrenched interest in the doings of "society," even as it was (or perhaps especially because it was) shape-shifting into an increasingly eclectic mix not just of royalty, heiresses, and scions but also of fashion people, art collectors, and artists. Society columns were syndicated nationally in daily newspapers and a columnist such as Igor Cassini, writing as Cholly Knickerbocker for the Hearst newspapers, was said at his height to have twenty million readers (in essence, the number of papers distributed that carried his column). Many gossip columns fell readily into the category of escapist entertainment. American readers clamored for the witty and sometimes trenchant observations of Aileen Mehle, who wrote a deliciously insider column titled "Suzy Says"; Eugenia Sheppard, who called the fashion scene as she saw it; and, until he began relying more on his camera than his pen, the occasionally biting and always hyper-observant Bill Cunningham.

For the first several years, all mentions of the new style called the Lilly were found in social coverage. It was a fun story: a young woman with a recognizable

name selling casual dresses with what seemed like crazy success, in Palm Beach, of all places!—that bastion of haute couture and lavish jewels sported by members of the best-dressed list. No column failed to mention that Lilly was Mrs. Herbert (Peter) Pulitzer, a name familiar to all thanks to the annual namesake prizes. (The time would come, however, when the couple would be referred to as "the Peter (Lilly) Pulitzers.") The young Pulitzers were from families with butlers, portraits of grandparents painted by John Singer Sargent, and strings of racehorses. Their glamour was palpable: Peter turned heads when he walked into the Bath & Tennis Club, and his sister, Patsy, was not only a lauded sportswoman but also a model with the John Robert Powers Agency. Lilly was described as tall, beautiful, dark-haired, "luscious-looking," and, in the soon-to-become-clichéd expression of her free spirit, usually barefoot. The young Pulitzers were seen as curiously entrepreneurial, which they came by genetically, being only two generations removed from people who built oil and newspaper empires. Peter's grandfather was one of the great American immigrant success stories: Joseph Pulitzer emigrated from Hungary to the United States in 1864, having been recruited to fight as a stand-in for

a draftee for the Union side in the Civil War (he served in the Lincoln Cavalry for a year). Landing eventually in St. Louis, he was offered a job on a German newspaper (one of the many languages in which he was fluent) and, from this start in newspapers, his career soared. Lilly's mother's maiden name was Lillian Bostwick, and she was a granddaughter of a Standard Oil founder. Her first marriage was to Robert V. McKim, who was well known in racing circles. Her second marriage was to Ogden Phipps, a name even better known in the same milieu. The Phipps name had such cachet that Lilly was often described in the press as a daughter of Ogden Phipps. It was newsworthy that on January 19, 1963 (just as Lillys

ABOVE, LEFT Lilly Pulitzer—at her desk, Palm Beach, Florida, 1968—wears a shift in Zuzek's *Hi-Lilly-Biscus*. Photographed by John S. Haynsworth.

ABOVE, RIGHT Suzie Zuzek, *Hi-Lilly-Biscus*, 1967.

OPPOSITE Marjorie Merriweather Post (right) with her daughter Dina Merrill (upper left) and granddaughter Nina Rumbough, at Post's Mar-A-Lago in Palm Beach. Merrill is wearing a Lilly Pulitzer shift in Zuzek's *Carnation* (1963). Photographed by Harold Krieger for the July 1966 issue of *McCall's*.

were taking off), her stepfather's three-year-old colt Royal Ascot broke free in the long stretch at Hialeah to win the $32,200 Hibiscus Stakes.

Lilly Pulitzer's mother, often photographed at posh races—where a Phipps horse could be expected to win—epitomized the old guard look still reigning in Palm Beach. Her typical costume consisted of white dress, white hat, double strand of pearls, upper-left-shoulder brooch, white gloves, stockings, and pumps. Her daughter was her sartorial opposite with her simple shift, no stockings, hardly any shoes, and her untouched-by-a-salon hair in a head scarf. Lillys had first taken off with other members of Palm Beach's young guard, who were also rebelling against mothers dressed as Mrs. Phipps did. By 1961, this demographic now included the world's most famous woman, First Lady Jacqueline Kennedy, who was a visitor at holidays to her in-laws, the Joseph P. Kennedys.

That Jacqueline Bouvier Kennedy continues to command intense fascination today makes it difficult to fully comprehend the enormity of her impact in her own time. Everything that she wore or uttered was not just news but inspiration. Women older than she copied her, women younger than she copied her, and women wealthier than she wanted to look like her. The simplicity of most of what she wore meant that women with tight budgets could also afford facsimiles of what she wore. Stores commissioned mannequins that looked like her (and her husband). She raised the bar for a kind of rigorous elegance that gave America a gloss of cultured credibility at the same time that she and her windblown husband and their young children modeled a new informality not seen before in heads of state. Jackie Kennedy being seen, photographed, and described wearing the earliest versions of the Lilly was like rocket fuel for the new style.

The Kennedy family—all of them—would be associated with Lilly Pulitzer for at least a decade. In April 1961, *Time* magazine reported that Mrs. Kennedy attended Good Friday services at St. Edward Roman Catholic Church in Palm Beach wearing a head scarf, a short dress, and sandals. The incident was worthy of a mention in a memoir by White House correspondent Helen Thomas, who recalled, "When Mrs. Kennedy went to mass . . . she appeared in a bandana, a short, sleeveless dress, sandals and no stockings, and, to make the story even better, Peter Lawford called for her in Bermuda shorts and bare feet. The photographers went wild. Pictures of the stockingless First Lady and her barefoot chauffeur were printed in newspapers across the country." Although the sleeveless sheath dress that she wore on that occasion was actually by Morton

Myles for Herbert Sondheim, the First Lady's off-duty warm weather uniform would often be a Lilly shift. Photographs demonstrate that she wore at least three Lillys in 1962. Film footage in the Kennedy Library archive that was shot on Squaw Island off Cape Cod in July 1962 shows the First Lady wearing a pink and yellow Zuzek floral as she greets the President arriving by helicopter. No one else is wearing anything like her happy print or her pre–Mary Quant knee-baring hem. Visiting Ravello, Italy with her sister in August, she wore a Lilly in a Zuzek polka-dot daisy print, and that same summer in Hyannis Port, she posed with her husband and two children sitting on a porch railing in a red-and-white gingham check Lilly. The last appears to be from the first wave of shifts made by Lilly Pulitzer's Swiss dressmaker in various yard goods from the five-and-dime, but all the dresses clearly bear the Lilly signature of boxy shape with high, close armholes, side slits edged with a flat band of contrasting fabric topped with a flat bow, and knee-baring hemline. Easter 1963 found the First Lady again wearing her red-and-white gingham Lilly, decorating Easter eggs with her children and a teenage visitor, Kathy Fay, daughter of one of her husband's navy buddies. Exemplifying that it would not be a holiday in

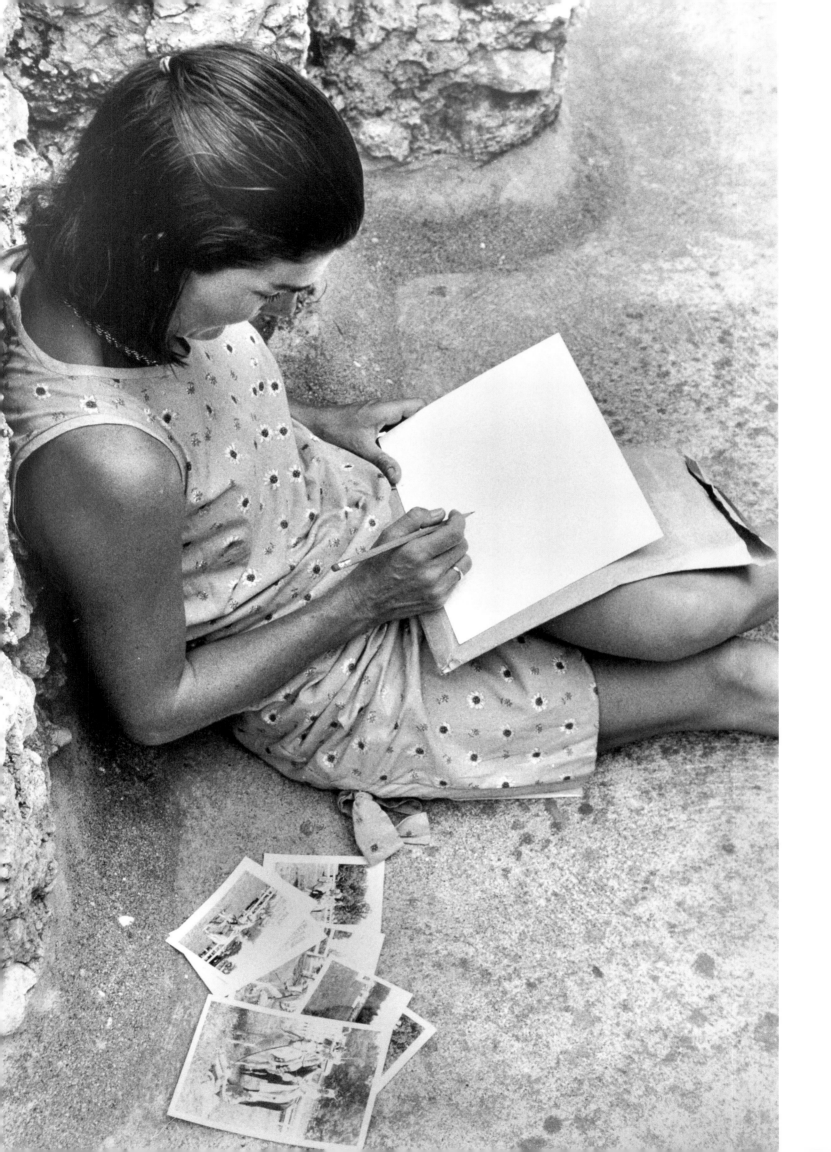

Palm Beach without a visit to the Lilly Pulitzer boutique, the First Lady took the fifteen-year-old Kathy Fay shopping that day and bought her first Lilly for her. First daughter Caroline was photographed in a Minnie (the miniature Lilly shift named after Lilly's daughter), jumping on a trampoline at a birthday party in Palm Beach and at Hyannis Port, carrying a bouquet as she accompanied her father to visit her mother in the hospital where she had given birth to son Patrick. Matriarch Rose Kennedy posed next to granddaughter Kathleen in matching Lilly shifts. When patriarch Joseph P. Kennedy was photographed for the first time in a wheelchair following his major stroke in 1963, *Women's Wear Daily* reported, "Who can recall, for instance, a time hitherto, when a news photograph of Joseph Kennedy—the first taken since his illness—is also captioned in a tag line 'Mr. Kennedy's niece, shown with him, is wearing a Lilly, made by Lilly Pulitzer of Palm Beach.' This is news? The first time out for the President's father . . . But apparently, that's the way the editors evaluate news these days."

After the assassination of John F. Kennedy in November 1963, Ethel, wife of the president's brother Bobby Kennedy, also began to be closely watched by the fashion press, with *Women's Wear Daily* reporting, perhaps for the first time, news of shopping expeditions in Osterville, Cape Cod. On September 1, 1967, it was revealed only that Ethel had ventured out of the Kennedy compound in Hyannis, but by September 5, *Women's Wear Daily* was able to run a sketch of four Lilly dresses of Ethel's, noting that although she had a closet full of Lillys, she had just bought three new ones at the Lilly Pulitzer shop near Hyannis Port. Such nuggets of information were parsed for political insight as to whether there was another Kennedy presidential run brewing; Robert Kennedy's assassination in 1968 and Ted Kennedy's involvement at Chappaquiddick put an end to such reporting.

The first article to mention Lilly in a fashion as opposed to a social context ran in *Women's Wear Daily* on October 9, 1962. Paul Hanenberg described the phenomenon: "natural, unfitted shape . . . shifty, straight . . . got its start like a bolt from the blue when Lilly Pulitzer wore her design in her husband's orange-juice bar last winter. The resort colony's Young Elegants flipped. 'The place became a mad-house,'

OPPOSITE Jacqueline Kennedy wears a Lilly Pulitzer shift in Zuzek's *Polka Daisies* in turquoise and yellow, Ravello, Italy, August 1962. Kennedy's embrace of the Lilly in 1962 catapulted Lilly Pulitzer and Zuzek's prints into stardom.

RIGHT Jacqueline Kennedy, wearing a Lilly shift in an early Zuzek floral, greets husband President John F. Kennedy on Squaw Island at Hyannis Port, Massachusetts, July 20, 1962.

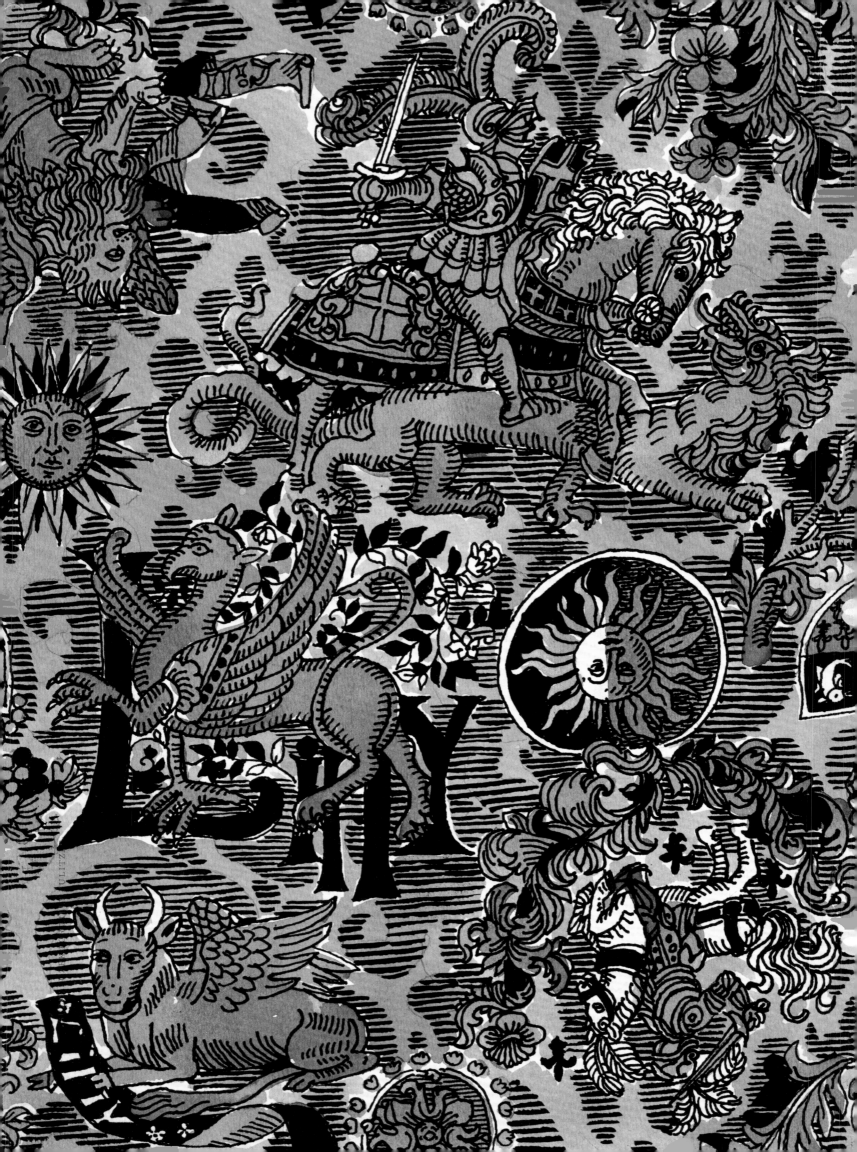

she says, 'and I went into production.' The Lilly is known by its exclusive exotic hand-screened cotton prints . . . splashy colors, right for sand, patio, at-home . . . comes in long and short with bow-topped side slits. Lilly sees it as a replacement for the over-worked shorts and pants . . . but has a jumpsuit for the die-hards. Gary of Miami produces her designs."

In a case of true synergy, Lilly Pulitzer's original shift dress—so simple that its design could be mistaken for a Simplicity Pattern, a dress that could be sewn by a beginner—was not just perfectly complemented but also energized by Suzie Zuzek's artful designs that were complex imaginary worlds, rewarding close scrutiny with ever-emerging details. Combined, the two

OPPOSITE Suzie Zuzek, *Heraldry*, 1970, a design used in the Men's Stuff line.

ABOVE Zuzek prints on PJs at the Men's Stuff showroom, Gotham Hotel, New York, 1968. Photographed by John S. Haynsworth.

elements embody the concept of the simple silhouette of the 1960s, providing a blank canvas on which all manner of zeitgeist phenomena could be projected. As fashion broke away from a dependence on haute elegance, it would respond to such stimuli as the counterculture and psychedelia, Space Age exploration, and all that was happening in the visual and performing arts. Not since the 1920s fashions of artist Sonia Delaunay had art and fashion been so closely aligned. Pop Art made its way into the haute couture in 1966 via Yves Saint Laurent's use of Tom Wesselmann nudes. Op Art inspired such American designers as James Galanos, Pauline Trigère, Rudi Gernreich, and Geoffrey Beene. Larry Aldrich asked Julian Tomchin to interpret one of Bridget Riley's optical paintings for a fabric to be used in dresses. Before long, Andy Warhol was experimenting with a paper dress standing in for the picture plane of one of his canvases or prints. In 1965, *Vogue*'s travel editor Despina Messinesi described the Lilly shifts in Zuzek prints

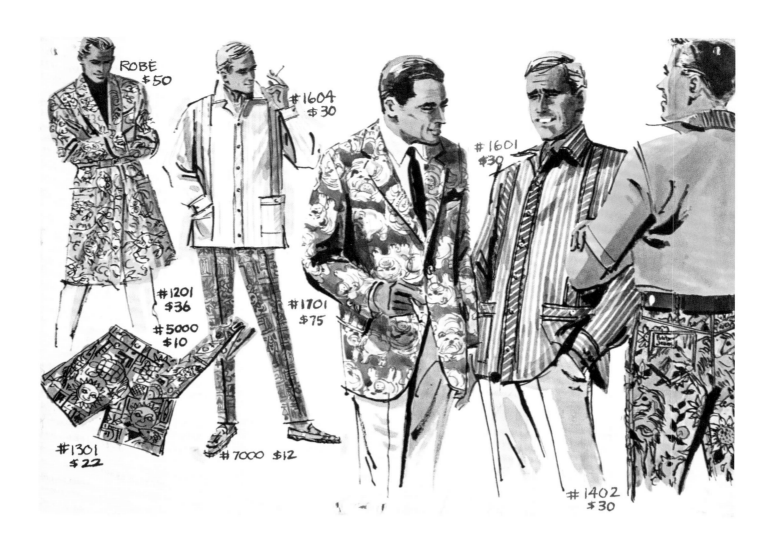

Labels on illustration:
ROBE $50
#1604 $30
#1601 $30
#1201 $36
#5000 $10
#1701 $75
#1301 $22
#7000 $12
#1402 $30

hanging closely together in the Palm Beach boutique: "The tightwad of Lillys have the impact of Pop Art."

That the earliest Zuzek patterns used in Lilly clothing were predominately floral has significance because flowers would emerge as potent and prolific symbols as the 1960s progressed. In 1964, Andy Warhol—who was just beginning to redefine what could be considered art and whose use of multiples and commercial techniques such as silkscreen blurred boundaries— lifted a photograph of several (perhaps even Floridian) hibiscus blossoms from a magazine, cropped it, and used it as a launching point for what would be his enduring photography-based, silkscreen *Flowers* series. In 1965, Beat poet Allen Ginsberg published an essay promoting nonviolent protest against the Vietnam War, suggesting

ABOVE Men's Stuff postcard, 1968. Robe in *Sand Fiddlers*, 1968; shorts and pants in *Harlillyquin*, 1968; jacket in *Bulldogs*, 1968; and pants in *Lilly's Llamas*, 1967. All prints by Suzie Zuzek.

OPPOSITE Lilly Pulitzer bathrobes, shorts, and swim trunks— many in prints by Suzie Zuzek—from the personal wardrobe of best-dressed actor Douglas Fairbanks Jr. Photographed for Doyle New York's auction of Fairbanks's estate.

the use of "masses of flowers—a visual spectacle," optics that could provide the polar opposite of violence and weaponry. In 1967, a viral moment happened when a hippie was photographed placing a carnation in a soldier/ policeman's rifle. By the end of the decade, the peaceful protest flower had morphed into a flat vinyl decal for cars or a detail of body painting for bikini-clad comediennes on *Rowan & Martin's Laugh-In*. Against this ubiquity, Zuzek's florals had a painterly, expressionist vitality.

When Lilly branched out into men's styles, she at first veered toward the more animal-centric designs in Zuzek's oeuvre. The initial impetus may have been the thought that an animal print would be received as more "manly" than a floral, but this became moot when Lilly's male customers cottoned to both genres of Zuzek prints. Animals—the wilder, the better—were indisputably "in" during the 1960s. Such patterns could connote danger or daring and cut a wide swath across American culture. At the high end were the creations of haute jeweler David Webb (copied for the mass market by costume jeweler Kenneth Jay Lane), including trophy-head bangles and brooches enameled with the stripes and spots of leopards, tigers, and giraffes. In ready-to-wear,

designer Rudi Gernreich offered head-to-toe giraffe or tiger ensembles for women in 1966. To underscore the sexual predator character of Mrs. Robinson, played by Anne Bancroft in 1967's *The Graduate*, director Mike Nichols dictated that she wear touches of leopard and giraffe in practically every scene. Tigers served as mascots for cornflakes, gasoline (one of the most successful ad campaigns of the automobile-crazed 1960s was that of Esso whose tag line "Put a tiger in your tank" equated a wild beast with speed and power), and perfume. In 1975, singer and dancer Lola Falana became the first black model spokeswoman for Fabergé's Tigress perfume. Falana appeared in print and video ads wearing a tiger-striped bodysuit. Zuzek's animals tend to be of the gamboling, not stalking, variety, representing whimsy rather than danger. They appear as shapes anchoring a pattern: a cat or a whale or a hippo or a lion's head literally animates the field. Of particular interest to the Lilly Pulitzer constituency, a Zuzek tiger or bulldog could instantly broadcast the wearer's alma mater.

Pulitzer jeans, which were known simply as PJs, were so popular with both men and women that when Jackie Kennedy "wanted a pair from Lilly's in Palm Beach recently, her size was all sold out," reported the "Suzy Says" syndicated column on April 19, 1968. At the time, unisex style went in only one direction: a woman would "borrow" a brother's oversize shirt, and jeans were worn by men, women, and, especially, teenagers (but only in a casual context). Men adopting a look that could be viewed as feminine was a concept not seen since before the Industrial Revolution had clothed men in the uniform of a sack suit. A gentleman in printed pants was the polar (bear!) opposite of the Man in the Gray Flannel Suit who had personified the 1950s. Within a year, the pants, which *Vogue* called the "hipsters," had invaded the sacred territory of formal dress. The fashion magazine reported that "the newest rage at debutante and college parties is Lilly Pulitzer's bright silk-screened velveteen Pulitzer Jeans—worn with a black tie and dinner jacket. They're for men— until women bought them." Notables reported having purchased or been seen wearing Pulitzer Men's Stuff included the Duke of Windsor, Gianni Uzielli, Douglas Fairbanks Jr., and, remarkably, New York City's patrician Mayor John Lindsay, who wore a Lilly jacket in Zuzek's *Crazy Quilt* print while in office. For men to wear Zuzek prints was a socially palatable form of rebelliousness, like wearing longer hair or sideburns. Lilly Pulitzer Men's Stuff catalogues soon came to feature entire wardrobes of an assortment of looks, not just PJs but also knit shirts, swim trunks, bathrobes, walking shorts, half-placket long-sleeved shirts, ties, and knit slacks. Amusingly, all could be ordered in Zuzek prints, wild or mild.

The 1960s saw numerous print-driven fashions flourish. Maija Isola for Marimekko of Finland found an international audience with the proliferation of contemporary Design Research stores. From Paris originated the Chinoiserie-tinged florals of Léonard and the thematic realism of Hermès, where prints were based on all manner of equestrian and other sportif elements. The patterns that have come to define the 1960s tended toward the bright and graphic with strong use of negative space. The Lilly shift with its tell-tale bows was copied by other designers, but Zuzek's prints were inimitable. Regularly described as "Florida bright," they are distinctive for their densely vegetal, jungle-layered grounds, and, particularly as chosen by Lilly, for their use of opaque white. Zuzek prints came to be beloved for their zest, exuberance, and even for the distinctive quality of the hand printing.

As the 1960s progressed into the 1970s, the Lilly silhouette became narrower and elongated. Skirts flared in A-shapes, and pants belled. Novelty chez Lilly generally took the form of slight variations: the introduction of a ruffle or a petaled collar, an elbow-length sleeve or a halter neck. As always, the simplicity of the styles served to highlight the vivacity of the prints. Rarely did a garment feature gathering or draping; the great majority of clothes were flat, further ensuring that the Zuzek print would dominate. A constant was the bands of three-dimensional white machine lace, used as contrast against the lush prints much as Chanel's braid gave definition to her tweed jackets. In 1971, *Women's Wear Daily* reported that "the rumor that the Lilly shift

is dead is greatly exaggerated. This year Lilly put hot-pants under floor-length skirts and they are both moving strongly." This would be the last time a Lilly Pulitzer article of clothing would be seen as "fashion-forward" as the original shift and printed jeans had been. As the 1970s progressed, the Lilly Pulitzer client was interested not in new silhouettes but in new print versions of favorite styles. The continued success of the company was firmly rooted in this appetite. Aficionados rushed to the stores when the call came that a new order had come in.

A fashion history truism has it that the styles of the present day are derived from the sports clothing of the past. Originally a subset of sportswear, resort fashion has introduced, beginning in the nineteenth century, numerous styles into a contemporary fashion vocabulary. As advances in transportation increased mobility, travel destinations came to include places to relax away from the cities. Clothing styles that come to us from this change in behavior include the yachting looks popularized by British couture house Redfern in the late nineteenth century and the little white silk day dress that Jean Patou created for tennis star Helen Wills that became a dominant day look of the second half of the 1920s. The primarily fluid beach pajama of the late 1920s and early 1930s paved the way for women wearing pants in public. Resort wear since the 1930s provided the first rompers, Capri pants, sundresses, and bare-midriff styles. Resort clothes were offered by couturiers and designers who understood their clients' wardrobe requirements, hence evening dresses to wear at a casino, bathing suits and decorative cover-ups for the seaside, ski suits and clothes for après ski.

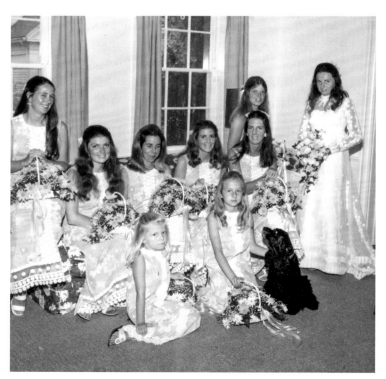

Although fashion magazines had begun in the 1920s publishing annual issues devoted to clothes for resorts, no designer specialized in this area. Closest were sportswear designers such as Claire McCardell and B. H. Wragge, who were by 1940 designing systems of dressing based on separates aimed at making a wardrobe of limited pieces work for a multitude of

OPPOSITE, LEFT Bridesmaids and flower girls in Lilly Pulitzer dresses in Zuzek's *Agnes* (1973), Martha's Vineyard, 1973.

OPPOSITE, RIGHT Flower girl (center) in *Agnes* with young wedding guests also in Lilly Pulitzer: Zuzek's *Trinket* (1971) on left and *Saturday Morning* (1971) on right.

ABOVE, LEFT In a 1972 department-store photograph, a model wears a mandarin-neck, side-slit Lilly shift in Zuzek's *Fafner's Butters*.

ABOVE, RIGHT Suzie Zuzek, *Fafner's Butters*, 1971.

functions, including day, evening, sport, and weekend. While the haute couture houses still presented their collections twice a year (fall/winter and spring/summer), sportswear designers understood that clothing needed to adapt to the quickening pace of life in the jet age. As the first American resort-wear designer, Lilly Pulitzer had one foot planted in the area of sportswear. Her catalogues offered interchangeable separates and looks that could go from day into evening, and through her network of stores, offered resort wear at all times of the year. She was the first U.S. designer to recognize that beach-appropriate clothes were being worn somewhere year-round.

As the 1970s progressed into the 1980s, the Lilly Pulitzer look became more firmly rooted in the resort category than ever—outside and seemingly impervious to what was in fashion. Although the Lilly shift had served as workwear for its creator, it hardly suited the needs of the increasing number of women in law firms and

investment banks. The cotton/polyester blend in cheery hues was at odds with a widespread trend of natural fibers and earth tones. Perhaps in an attempt to change her stripes, Lilly Pulitzer offered in 1984 a catalogue that contained solids and just one of what had been her most beloved signature, a Zuzek print. The change backfired and added to the mounting events that led to the company declaring bankruptcy.

No one would ever have confused the painterly Zuzek designs with the kaleidoscopic yet precisely drawn prints of Emilio Pucci, although both brands were easily recognizable, often acknowledged as status symbols (when the term was rarely used), and equally adored. Before the styles of each could be purchased at department stores, such as Saks Fifth Avenue and Lord & Taylor, wearing a Pucci or a Lilly conveyed the status of having traveled to Capri or Palm Beach, locales of ineffable glamour. Both brands were invented by aristocrats—Pucci with his ancient family titles and Lilly with her Gilded Age *Social Register* associations. (Both were even "signed" with handwritten first names. Pucci originally used his first name, Emilio, so as not to embarrass his family.) The biggest difference was in price. At the time of its widespread introduction, the Lilly shift cost about a third of its 1963 Pucci counterpart, a printed silk jersey dress that weighed just four ounces. Most important, the Pucci silk dress was mercilessly unforgiving. The wearer had to be well girdled or well toned. Lilly's styles, on the other hand, were described as having been cut with "sympathy." Both were often described as collector's pieces, unusual at a time when a closet was a closet, and not a display room for "It bags" and other sartorial acquisitions. The notion of seeking out every version of a look was unusual.

Early Lilly responders belonged to a kind of club. They were easily recognizable—seen across the room—in identifiable, beloved Zuzek prints. They wore Lilly as benefit committee members or to sing madrigals at Vassar. College boys packed Lilly pants to take on their spring break beach pilgrimages. When the Lilly catalogue arrived, it seemed like a message from a friend. There was an intimate tone to the handwritten note signed "XX" or "Ta-Ta, Lilly." Salespeople at the boutiques were friends of friends; *Women's Wear Daily* described them as debutantes—some of them called themselves "Lilly girls." Same thing for the men's stores: Edsel Ford, scion of the Ford motor family, worked at the Lilly men's store in Southampton in 1968. Love even blossomed at a Lilly store. In a brief memoir for *Harper's Bazaar* titled "Growing Up Lilly," novelist Kimberly Cutter, sister of author and style entrepreneur Amanda Cutter Brooks, recounted the story of their mother, Elizabeth Whittemore, having worked for the summer

ABOVE The only model in a print, at right, wears a Lilly Pulitzer bikini and robe in Zuzek's *Dorothy* (1974). Photographed by Deborah Turbeville for the May 1975 issue of *Vogue*.

at the Lilly shop on Worth Avenue in Palm Beach. In walked a young man named Stephen Cutter, and it was "love at first sight." At their 1966 wedding, Lilly designed the bridesmaids' dresses in a Zuzek green-and-white orchid print.

That a brand could develop from a single article of clothing had never before happened—although such a model would work again for Ralph Lauren when he launched his Polo label with a wide necktie in 1967 and for Tory Burch when her business took off with a tunic and a pair of sandals in 2004. From a shift dress grew an entire resort-wear company—America's first—its success cemented by the distinctive Zuzek prints, which became a much-loved aesthetic. The Lilly style could swing both daring and conventional simultaneously, which is highly unusual. With its whiffs of bohemian Key West by way of haute Palm Beach, it became the gold standard for affordable luxury. The Lilly shift dress played a pivotal role in the transition from 1950s

formality to relaxed 1960s sensibility, but the influence of Zuzek in her designs for Lilly pants has perhaps even more resonance today as seen in such high-fashion looks as the Gucci floral pantsuit worn interchangeably by men or women. In 2020, when the centuries-old notion of a gender binary is being challenged, the precedent set by the exuberant early Lilly pants certainly has legs.

OPPOSITE Lilly Pulitzer (left), her sister Flossie Doubleday (center), and their children, Palm Beach. The ladies wear Lilly Pulitzer dresses in Zuzek's *Sunflower* (circa 1964), and their daughters are in dresses in one of Zuzek's early designs. Photographed by Betty Kuhner.

ABOVE, LEFT Unisex Pulitzer Jeans in Zuzek prints: he's sporting a pair in *Lilly's Tigers* (1967), while she's wearing *Lilly's Pansy* (1965). Photographed by John S. Haynsworth for the August 1968 issue of *Pictorial Life*.

ABOVE, RIGHT Suzie Zuzek, *Lilly's Pansy*, 1965.

CASE STUDY

SUZIE ZUZEK'S DESIGNS for Key West Hand Print Fabrics
are beloved for their loose, spontaneous quality, but
capturing the feeling of the artist's hand required a team
of specialists. Each color in the pattern requires its own
screen. Color separations are the basis for transferring the
design to the screen, and the technician who traces the
pattern onto the acetate film can have a big impact on the
character of the finished product. Textile dye chemists
mix the custom colors used in the prints. The printers
ensure that the colors register correctly one over the next,
and that the impression is crisp.

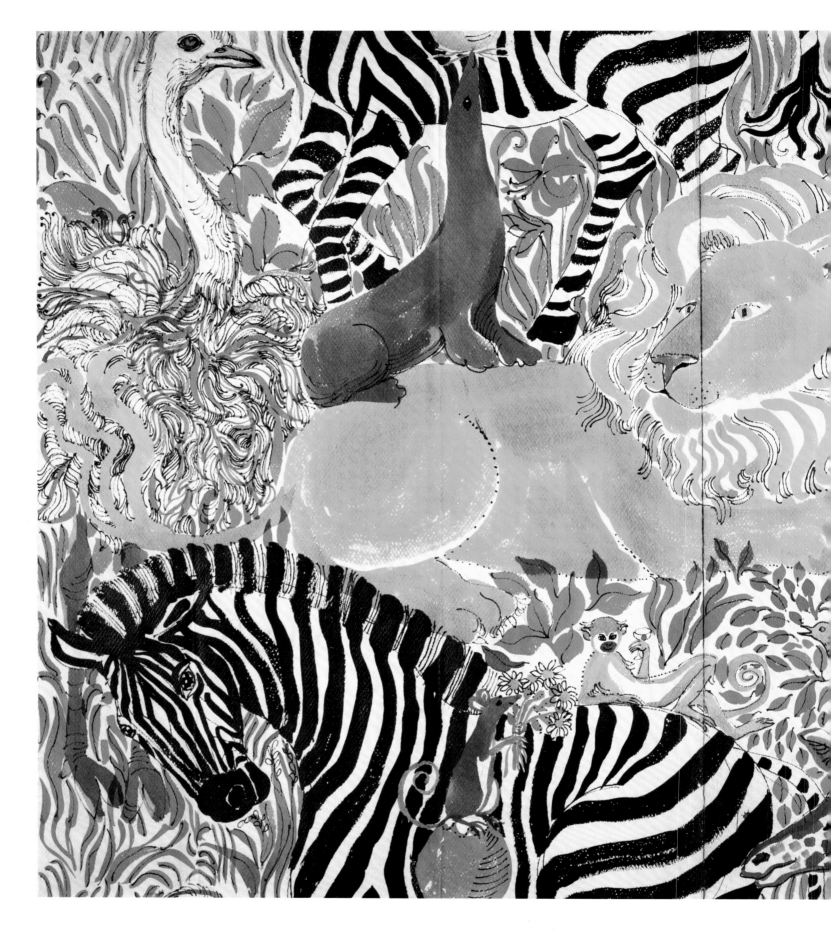

ZUZEK'S PLAYFUL DRAWINGS are also skillful technical documents. The design repeats both horizontally and vertically in a straight repeat: the giraffe head at the center bottom fits neatly on the giraffe neck at the top, and the tail feathers of the ostrich on the left edge are completed on the right edge. The design is carefully balanced so there will be no unexpected effects when it is repeated over and over. This 36 x 54 inch drawing was printed at one-to-one scale.

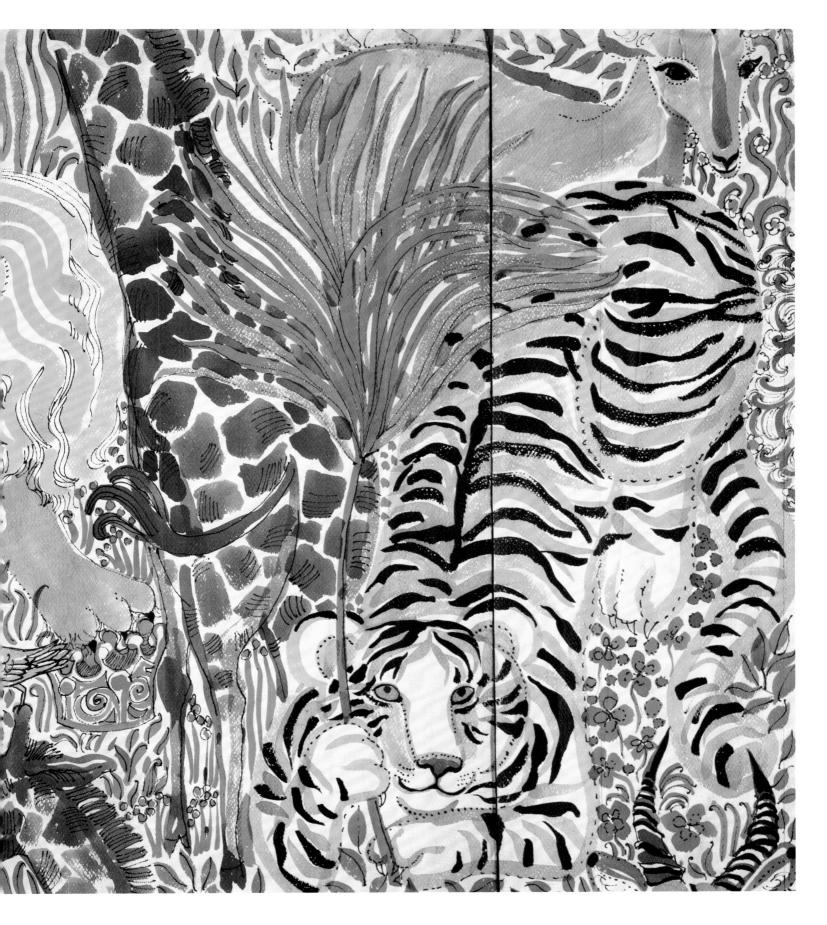

PREVIOUS SPREAD Suzie Zuzek, *Zek's Zoo* textile (detail), 1974.

ABOVE Suzie Zuzek, *Zek's Zoo*, 1974; brush and watercolor, pen and ink, graphite on paper. *Zek* was a nickname given to Suzie by Peter Pell and Lilly Pulitzer.

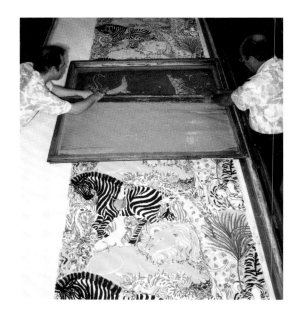

LAYING A SHEET OF ACETATE film over the original artwork, a technician traces over all the parts of the design to be printed in a particular color. Usually these are done in black ink, but they are shown in color here to demonstrate how the four colors work together in the design. The screens, typically fine nylon mesh stretched over a wooden frame, are coated with a photographic emulsion. The acetate serves as negative, placed between the emulsion and a light source. Where the light passes through the acetate, the emulsion is exposed and hardens, forming a stencil of the areas to be printed in that specific color. Each screen is placed over the fabric, using registration pins along the sides of the table to ensure that the four screens are correctly aligned. The printing ink is poured into the screen and spread across its surface, then the ink is forced through the screen by pulling across it with a rubber blade or squeegee. Between each impression, one screen width is skipped to avoid smearing the wet ink. This image shows the second pass, where the blank areas are being filled in. This process is repeated for each color. When the printing is complete, the fabric is heat-set to make the colors wash-fast.

LEFT *Zek's Zoo* color separations.

ABOVE Key West Hand Print Fabrics technicians printing *Zek's Zoo*, circa 1974.

OPPOSITE Caftan in *Zek's Zoo*, courtesy of June Klausing.

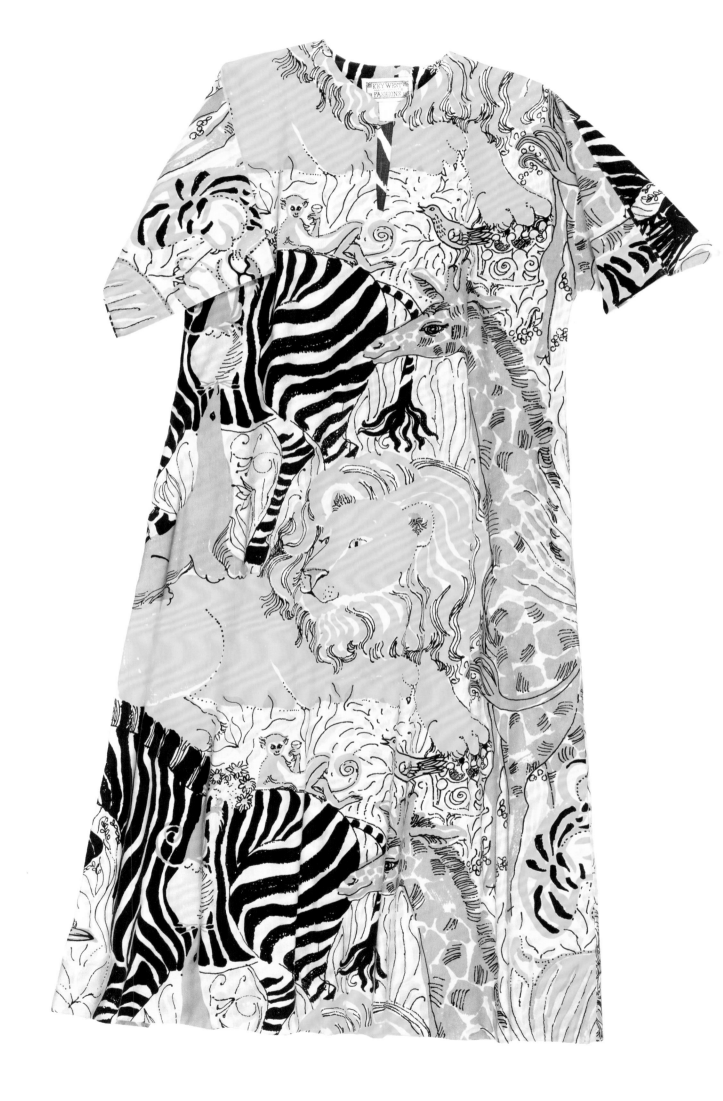

Zeks Zoo Greige #D-13301

Screen #1 Screen #2 Screen #3

15 K ext 15 K ext 15 K ext
50-blue 3G 150-blue 3G 150-green B
 500-yellow RF
Screen #4 500-yellow 3G

15 K ext
500-blue 2G
500-navy

Zeks Zoo Greige #D-13302

Screen #1 Screen #2 Screen #3

15 K ext 15 K ext 15 K ext
500-yellow RF 150-fuchsia 150-green B
500-yellow 3G 500-yellow RF
 500-yellow 3G

Screen #4

Black

OPPOSITE Alternate color combinations, or colorways, can be printed
from the same screens. Color cards give the recipe for each of the custom colors
and serve as a record of the colorways that were produced.

ABOVE The finished fabrics were sold by the yard, or made into a variety of home
furnishings, accessories, and fashions. Here, Lilly Pulitzer is in the window of her Palm Beach
store with a caftan in *Zek's Zoo* on the left, 1982. Photographed by Diana Walker.

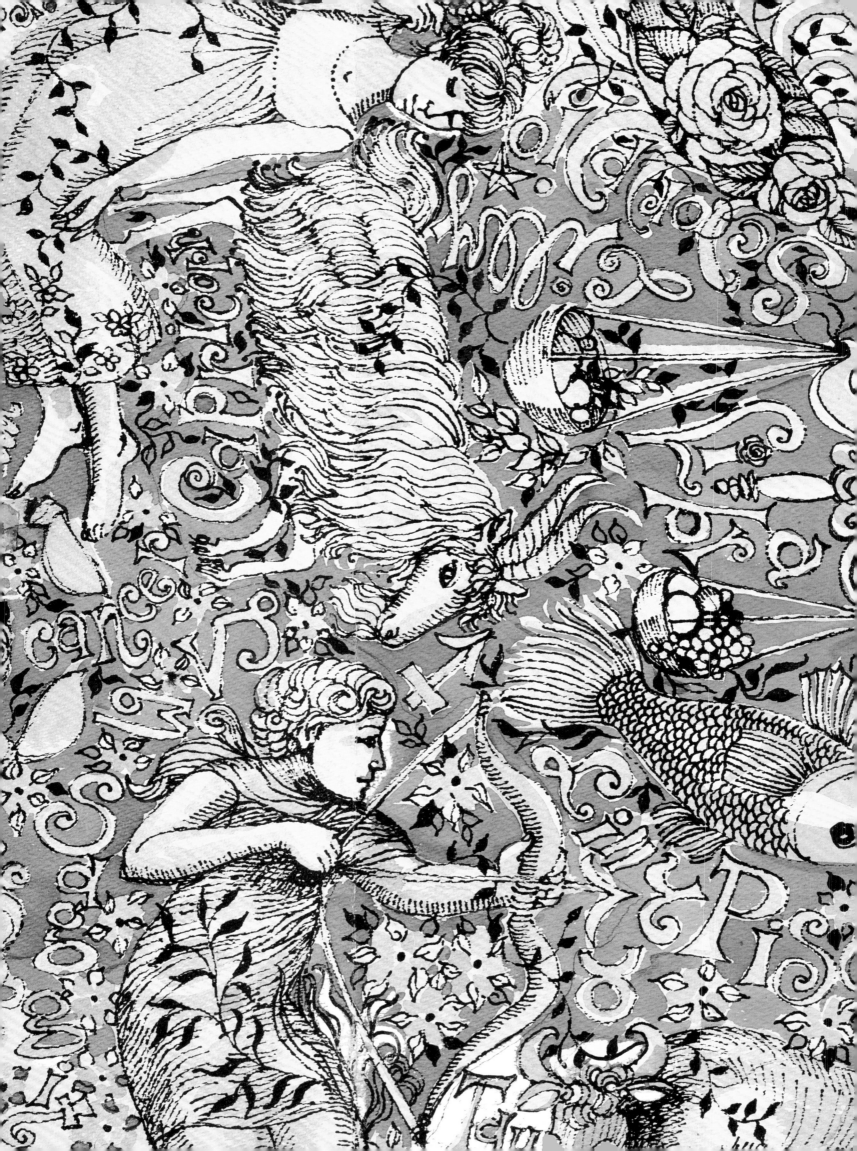

PORTFOLIO

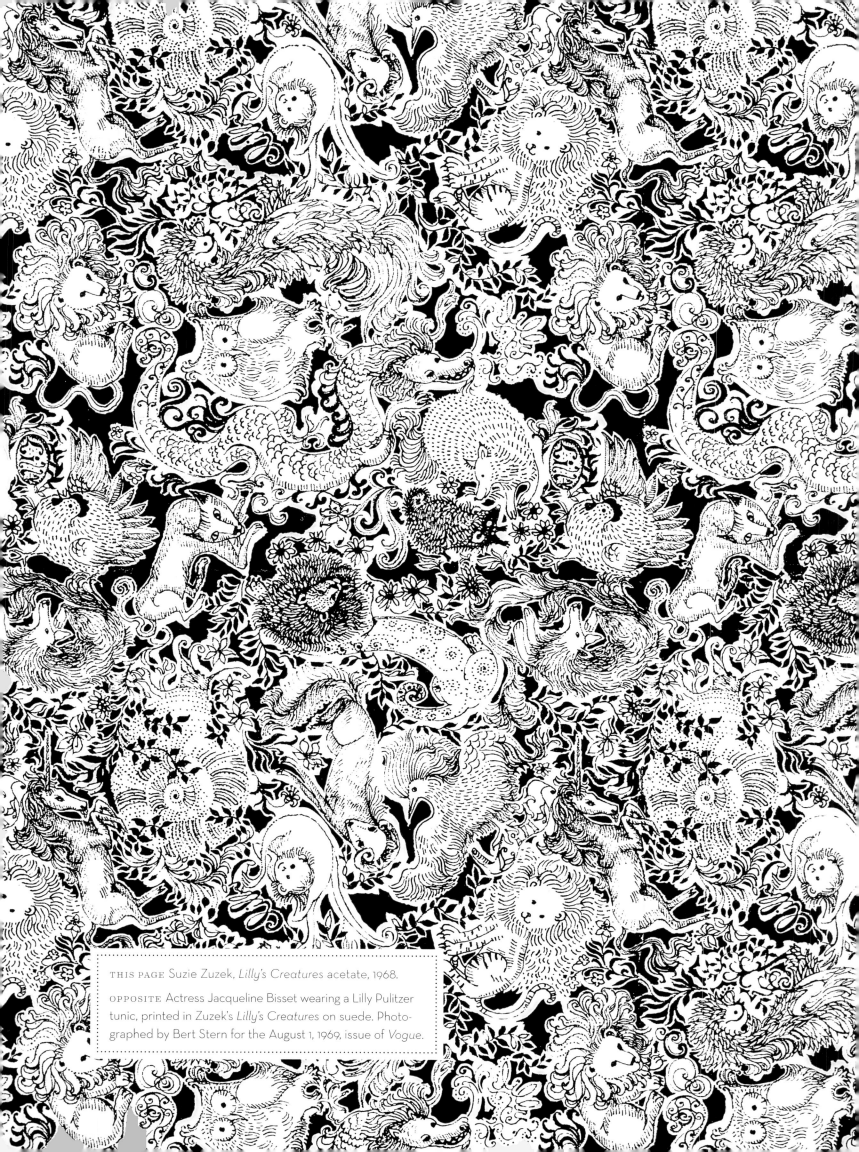

THIS PAGE Suzie Zuzek, *Lilly's Creatures* acetate, 1968.

OPPOSITE Actress Jacqueline Bisset wearing a Lilly Pulitzer tunic, printed in Zuzek's *Lilly's Creatures* on suede. Photographed by Bert Stern for the August 1, 1969, issue of *Vogue*.

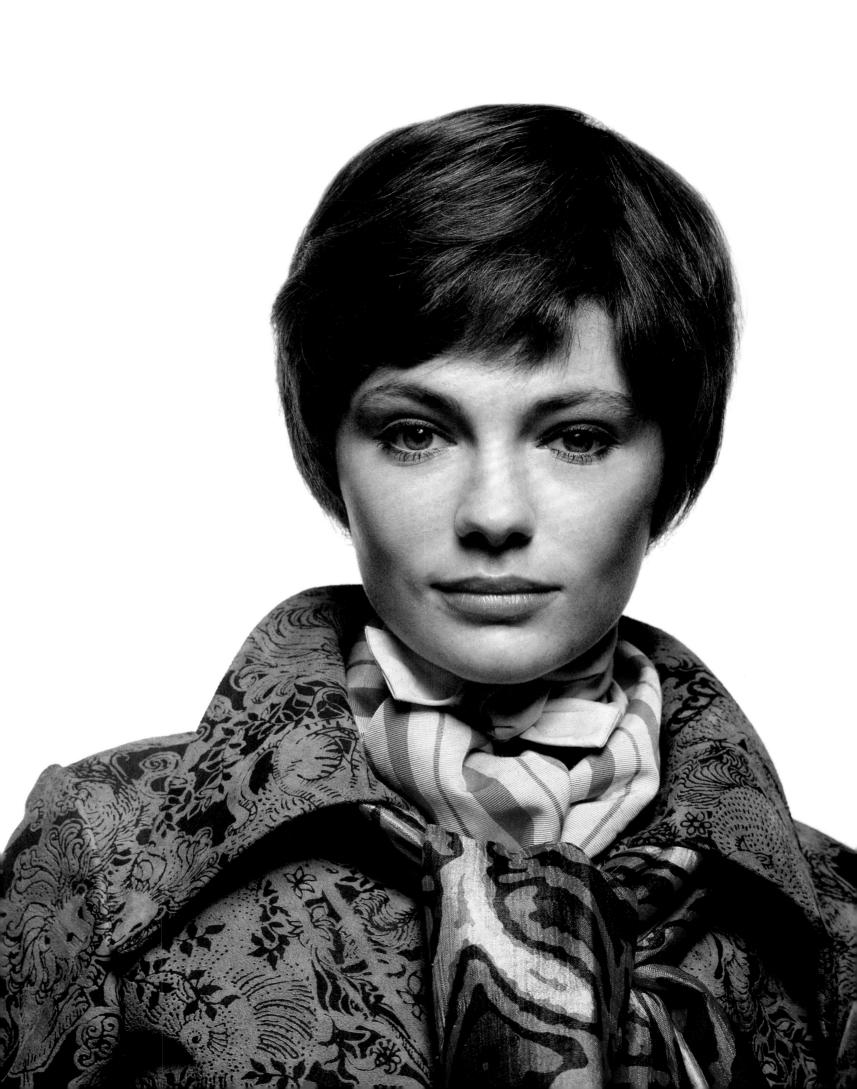

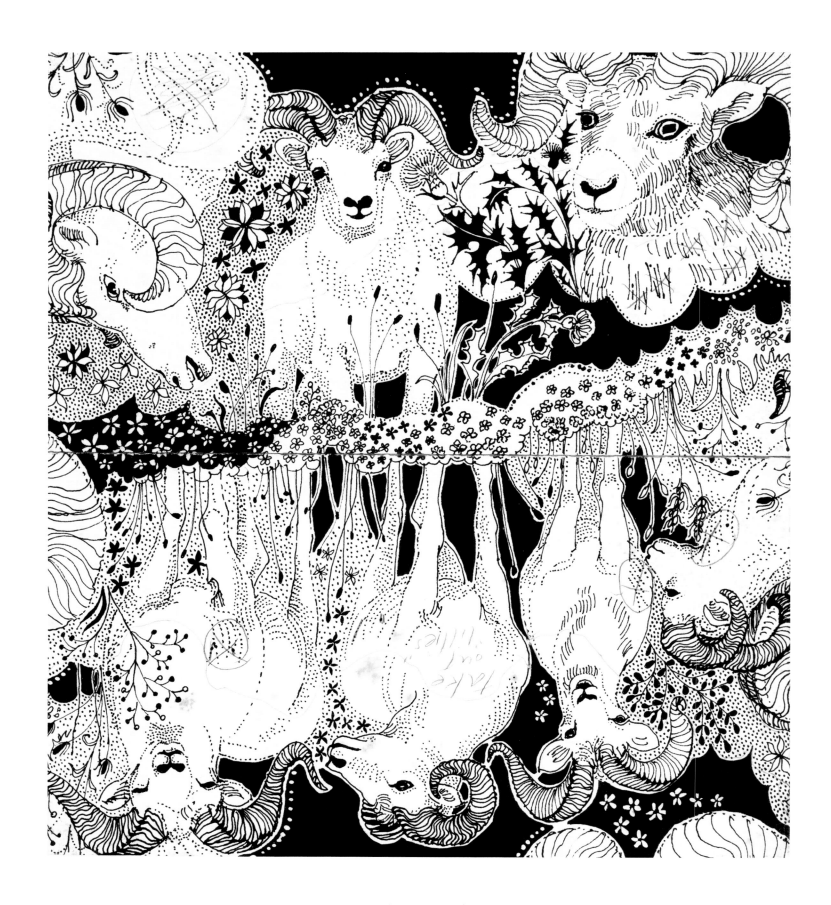

PREVIOUS SPREAD Textile swatches of Zuzek's *Lilly's Creatures*.

ABOVE Suzie Zuzek, *Sam's Rams*, 1979. Lilly's name
would be added or removed from textile designs, to reflect its intended use.

OPPOSITE Suzie Zuzek, *Ostrich*, 1976.

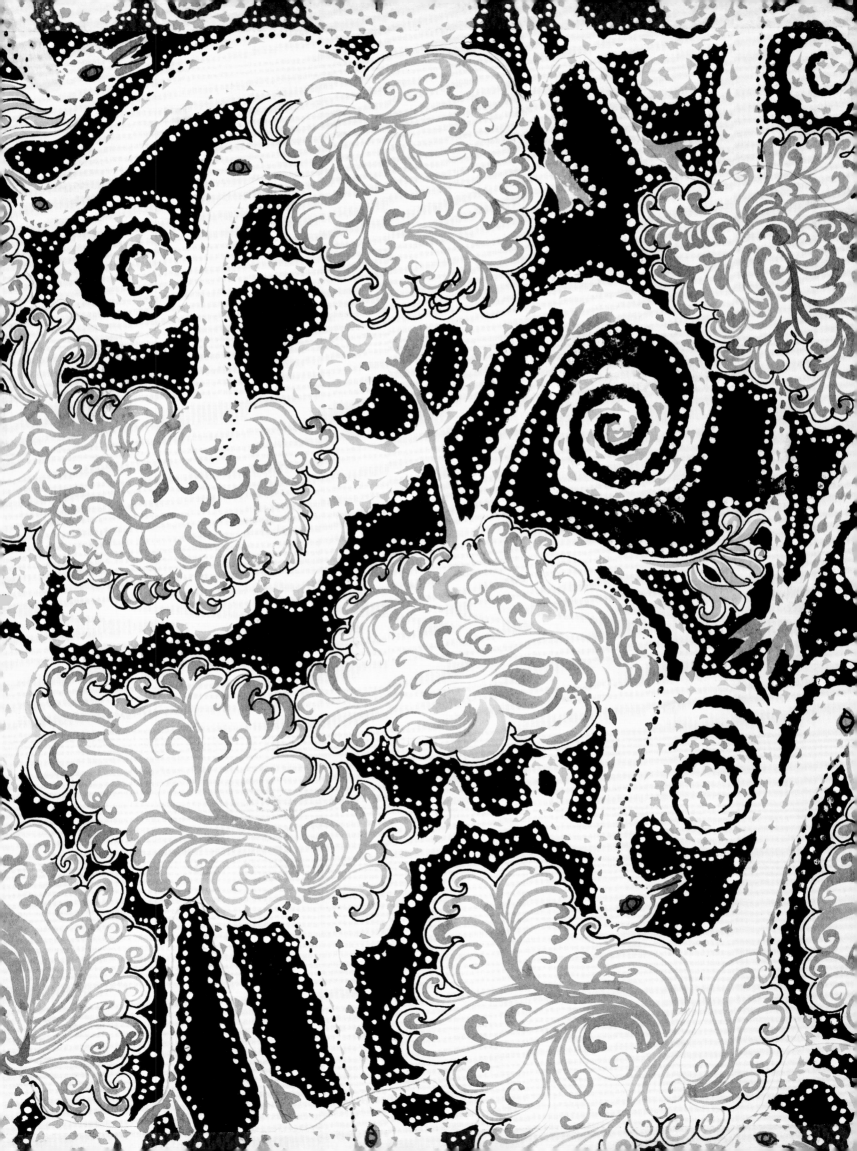

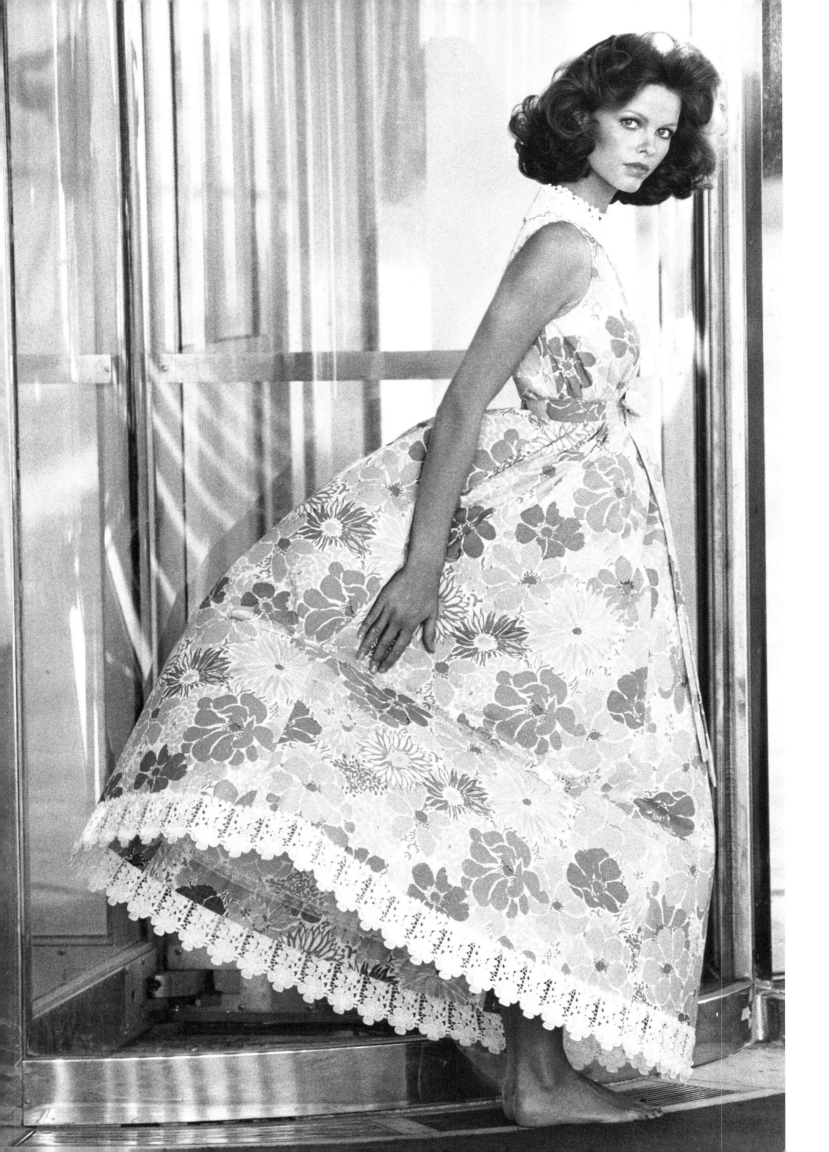

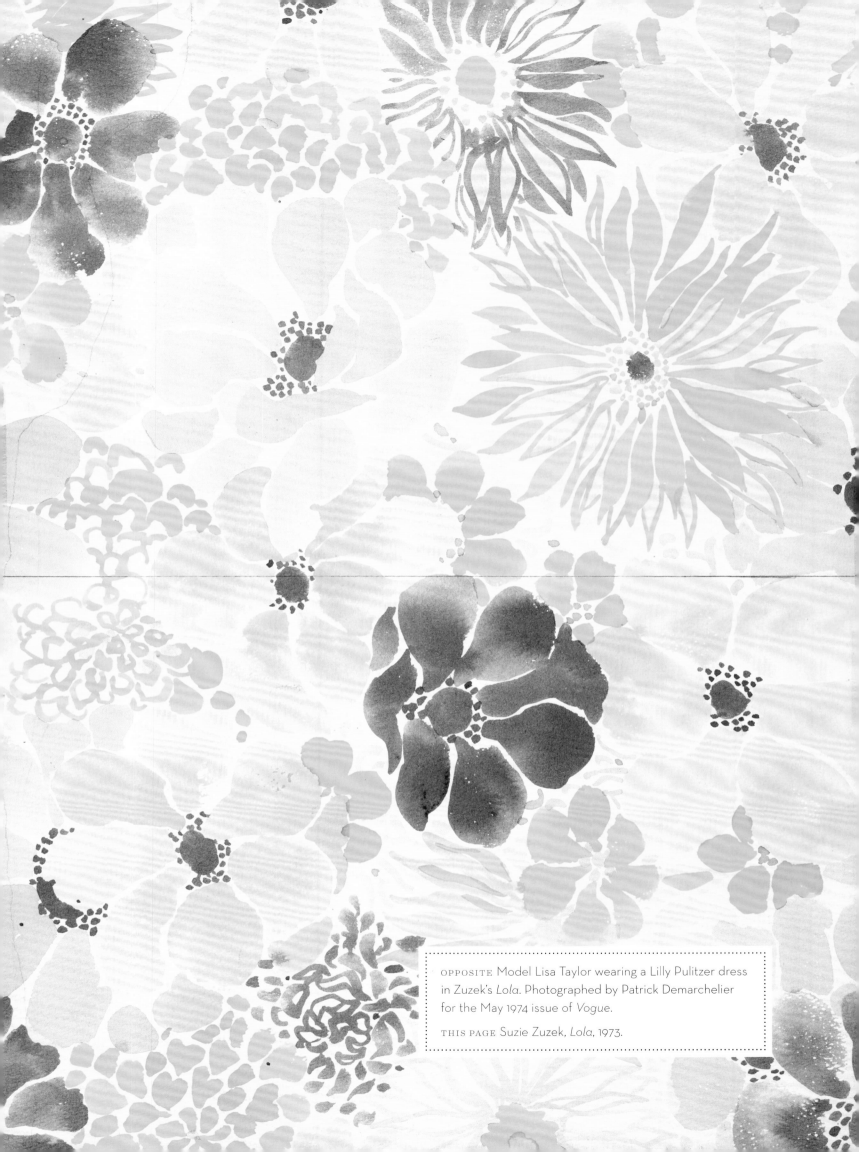

OPPOSITE Model Lisa Taylor wearing a Lilly Pulitzer dress in Zuzek's *Lola*. Photographed by Patrick Demarchelier for the May 1974 issue of *Vogue*.

THIS PAGE Suzie Zuzek, *Lola*, 1973.

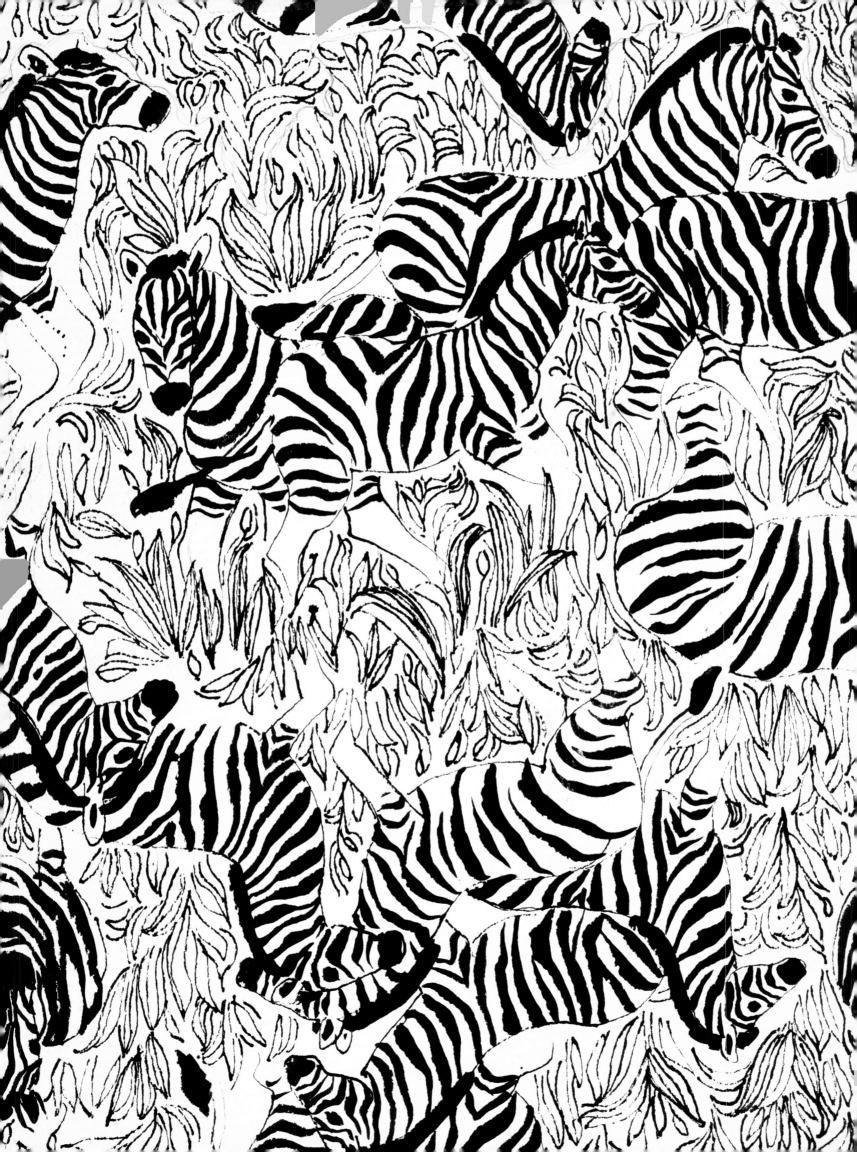

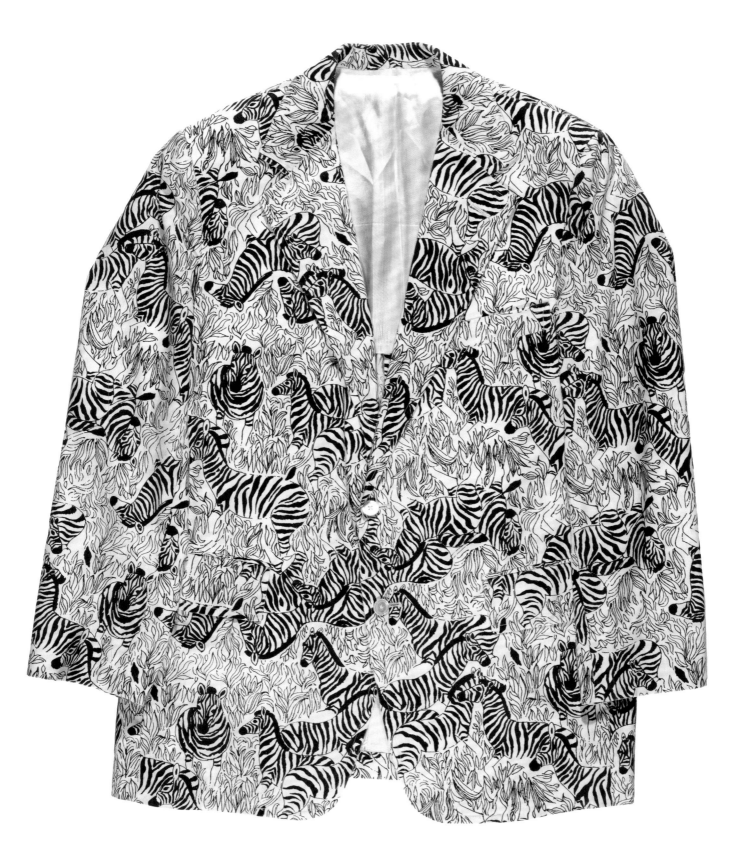

OPPOSITE Suzie Zuzek, *Z*, 1978.

ABOVE Lilly Pulitzer men's jacket in Zuzek's *Z* print.

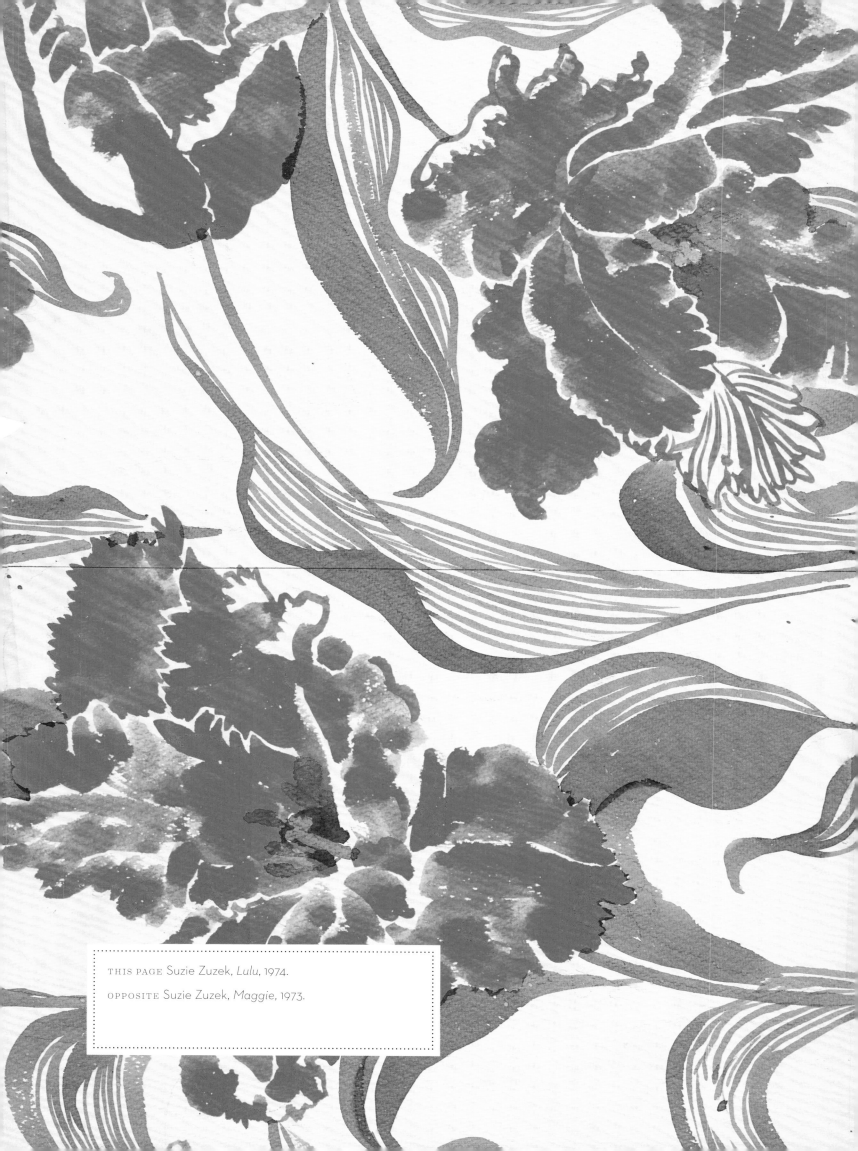

THIS PAGE Suzie Zuzek, *Lulu*, 1974.

OPPOSITE Suzie Zuzek, *Maggie*, 1973.

ABOVE Lilly Pulitzer sleeveless shift in Zuzek's *Sunflower*, 1964.
Photographed by Slim Aarons.

OPPOSITE Suzie Zuzek, *Sunflower* acetate, circa 1964.
An example of the artist's exceptional detail in her line work
is shown here in the flowers' seeds and the animated fish.

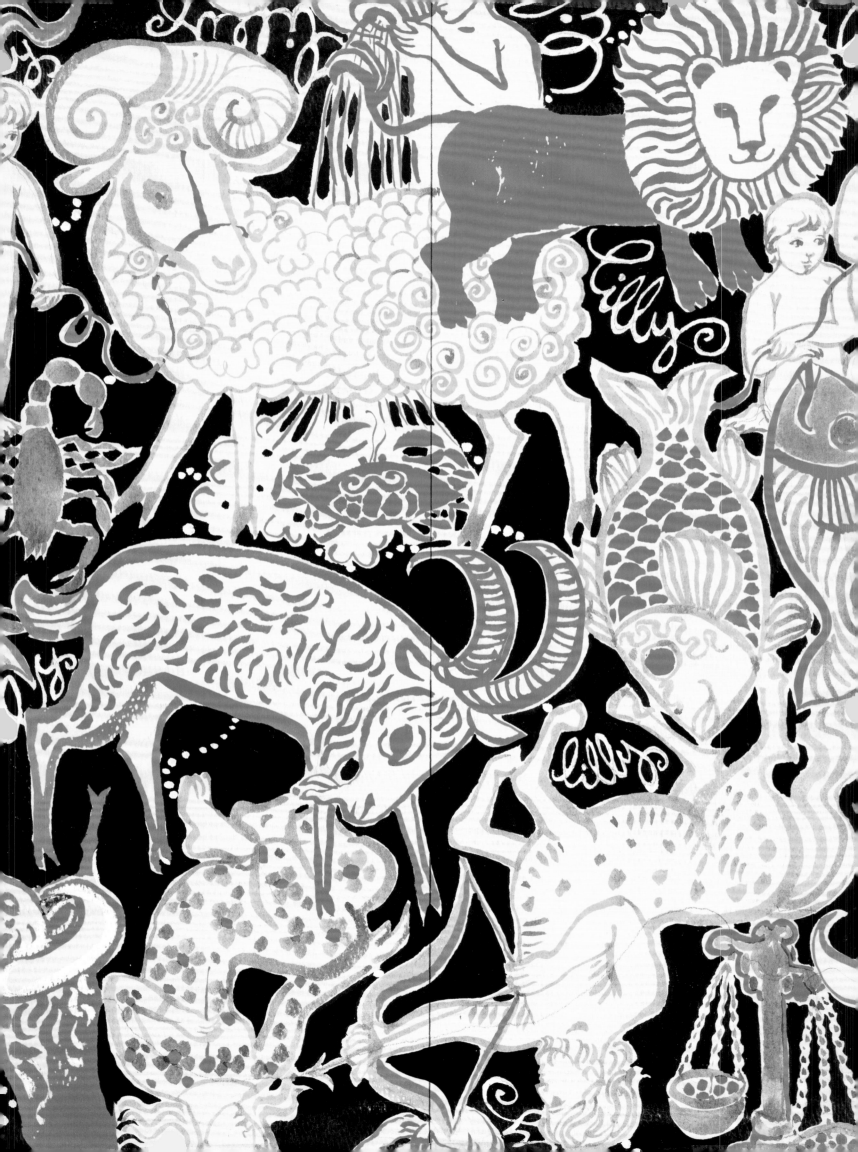

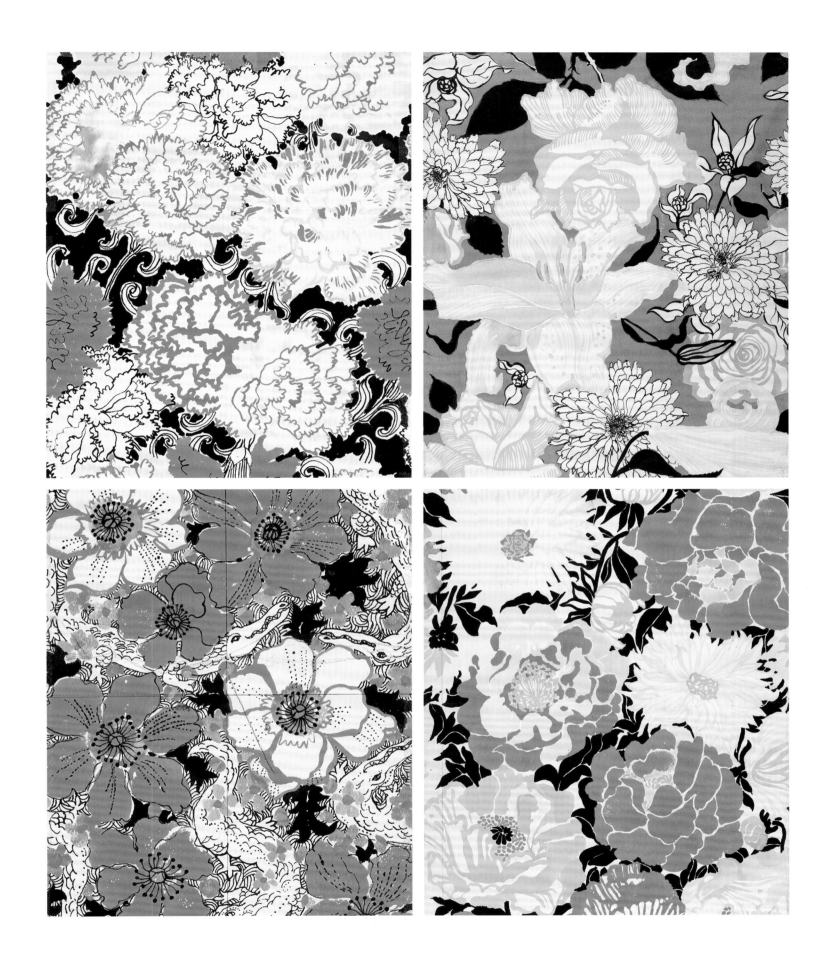

OPPOSITE Suzie Zuzek, *Horoscopes*, 1973.

ABOVE, CLOCKWISE FROM TOP LEFT *Kathy's Karnations II*, 1971; *KWHPF, INC. 404*, late 1960s; *Gloryosa*, 1974; and *Lilly Gators*, 1972. All drawings by Suzie Zuzek.

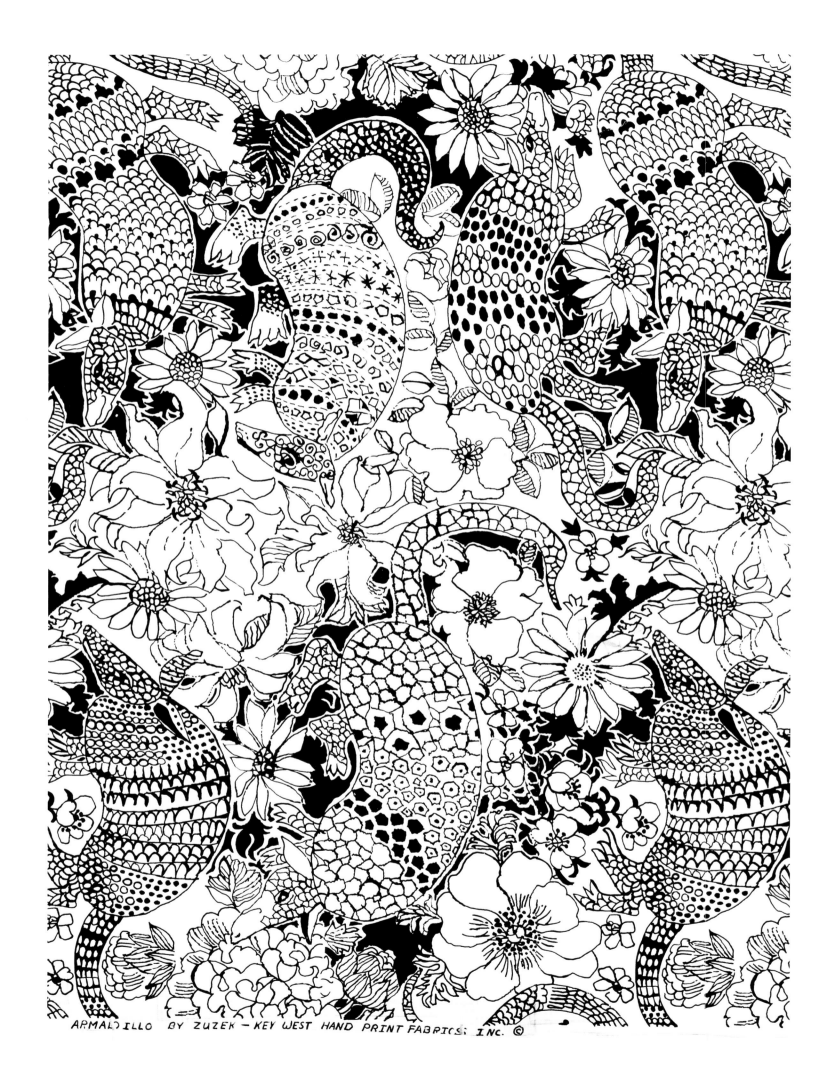

ARMADILLO BY ZUZEK — KEY WEST HAND PRINT FABRICS, INC. ©

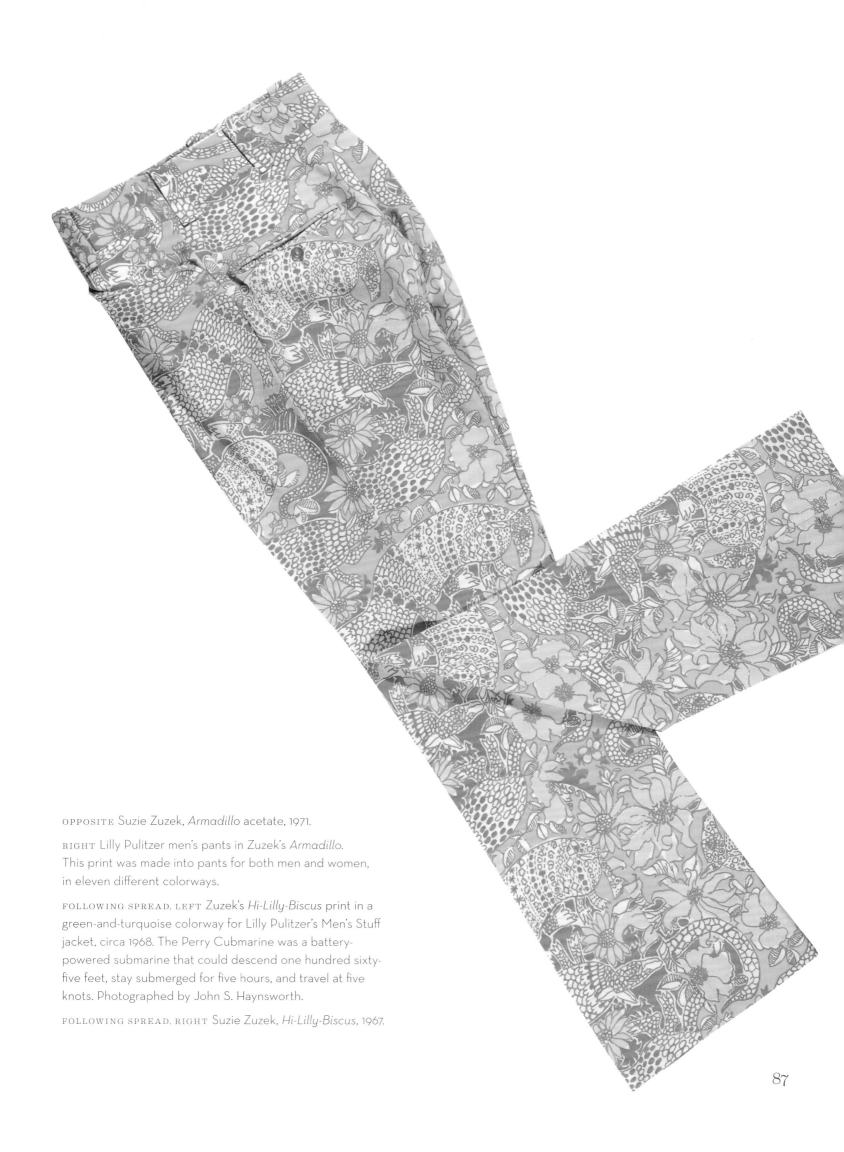

OPPOSITE Suzie Zuzek, *Armadillo* acetate, 1971.

RIGHT Lilly Pulitzer men's pants in Zuzek's *Armadillo*. This print was made into pants for both men and women, in eleven different colorways.

FOLLOWING SPREAD, LEFT Zuzek's *Hi-Lilly-Biscus* print in a green-and-turquoise colorway for Lilly Pulitzer's Men's Stuff jacket, circa 1968. The Perry Cubmarine was a battery-powered submarine that could descend one hundred sixty-five feet, stay submerged for five hours, and travel at five knots. Photographed by John S. Haynsworth.

FOLLOWING SPREAD, RIGHT Suzie Zuzek, *Hi-Lilly-Biscus*, 1967.

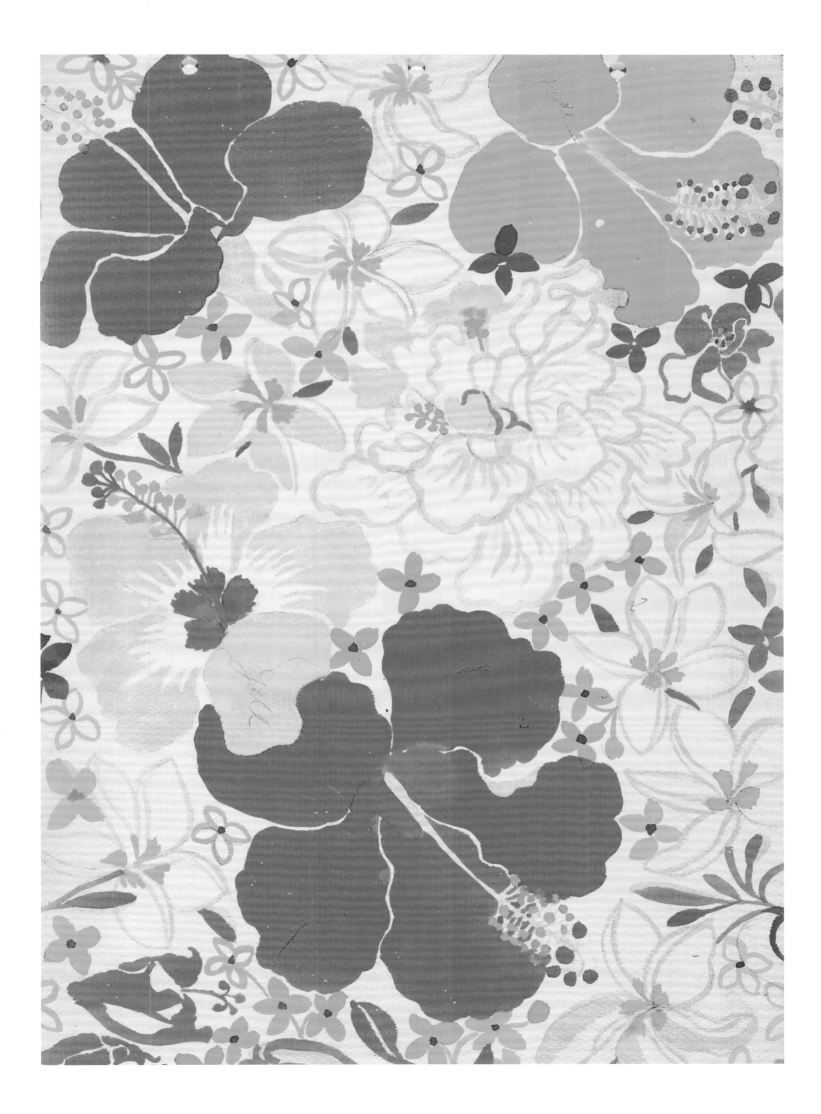

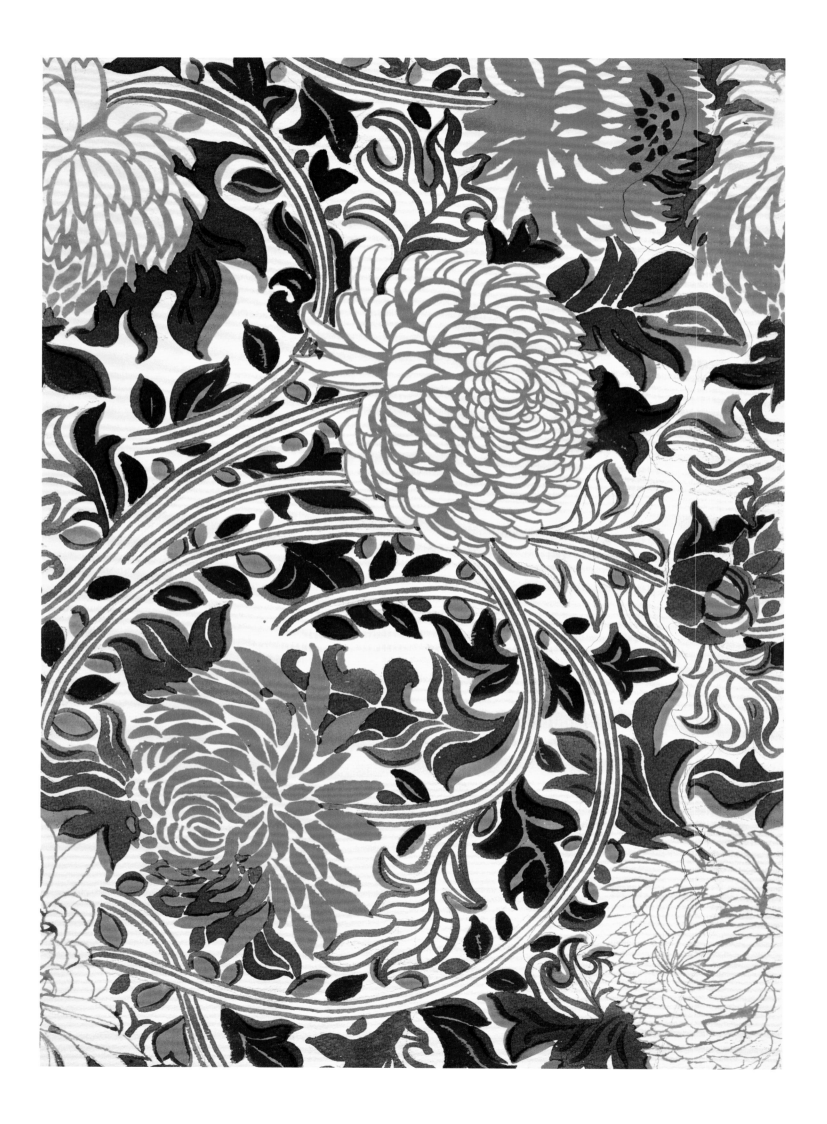

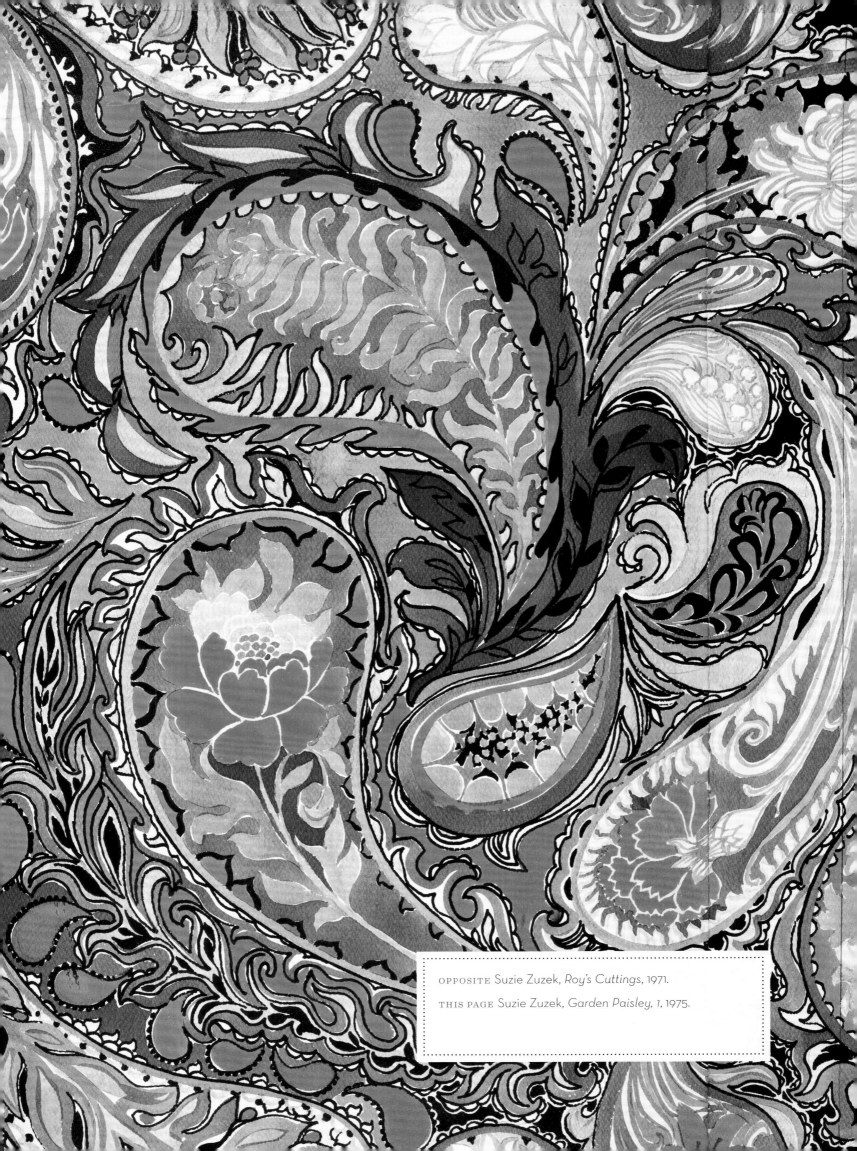

OPPOSITE Suzie Zuzek, *Roy's Cuttings*, 1971.

THIS PAGE Suzie Zuzek, *Garden Paisley, 1*, 1975.

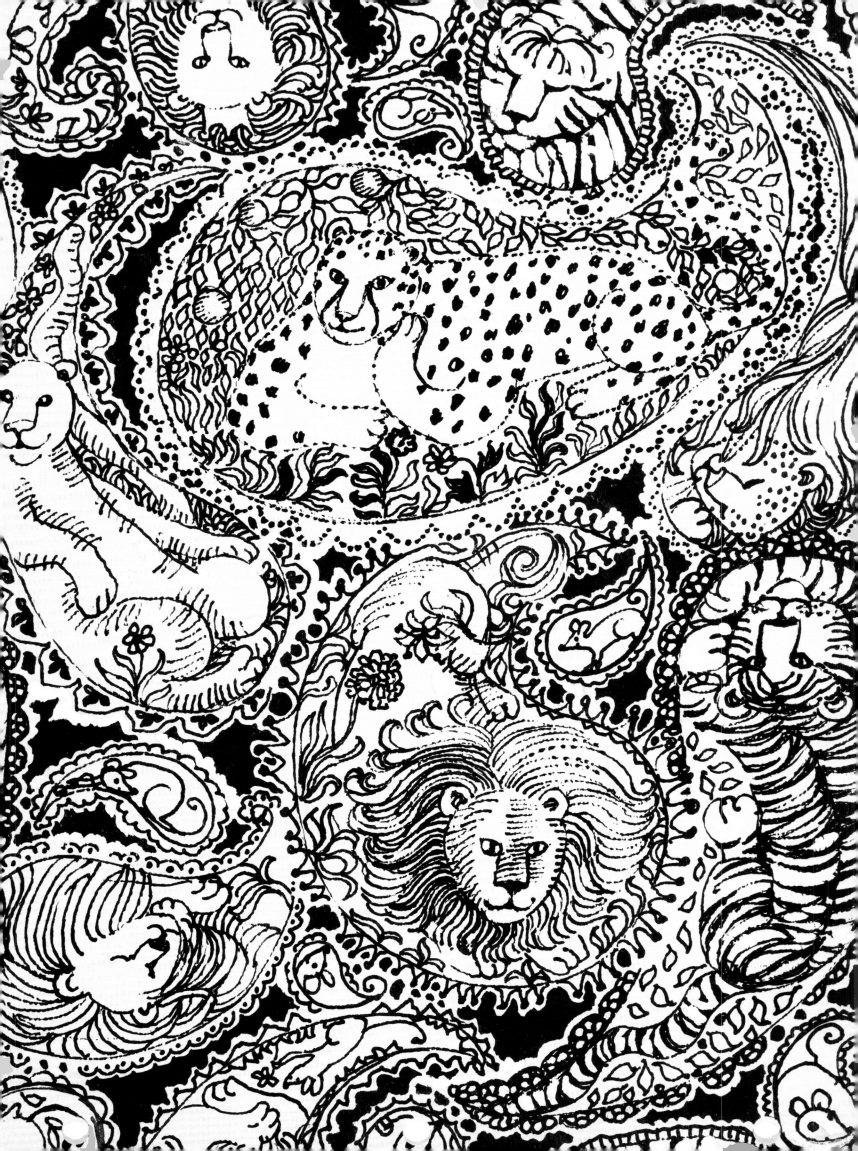

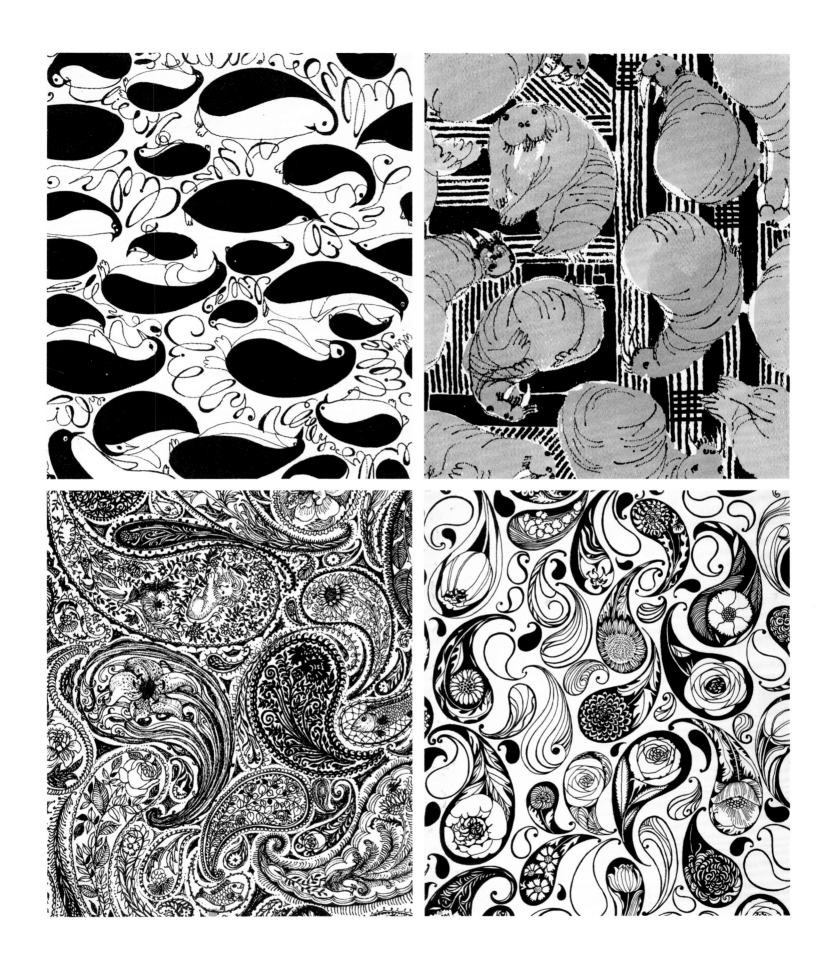

OPPOSITE Suzie Zuzek, *Cat & Mouse*, 1970.

ABOVE, CLOCKWISE FROM TOP LEFT *Lilly's Penguins*, 1967; *Wallowing Walruses*,
1968; *Solaris Paisley*, mid 1960s; and *Lace Paisley*, 1965. All drawings by
Suzie Zuzek. In the artist's hands, the classic paisley pattern took on many guises.

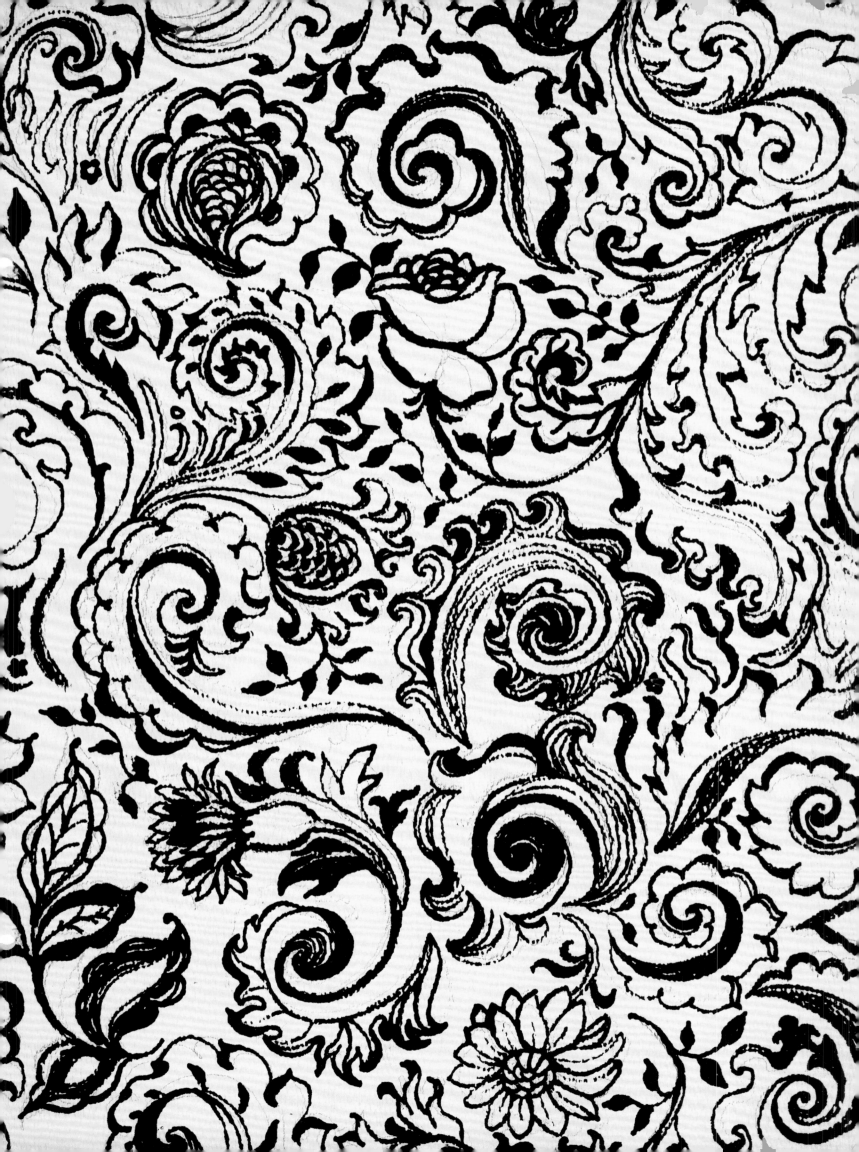

OPPOSITE Suzie Zuzek, *Barbara's Baroque*, 1968.

ABOVE Lilly Pulitzer wool dress in Zuzek's *Barbara's Baroque*. Another one of the artist's most popular designs, this pattern was printed in forty-seven different colorways on wool, on cotton, and on silk.

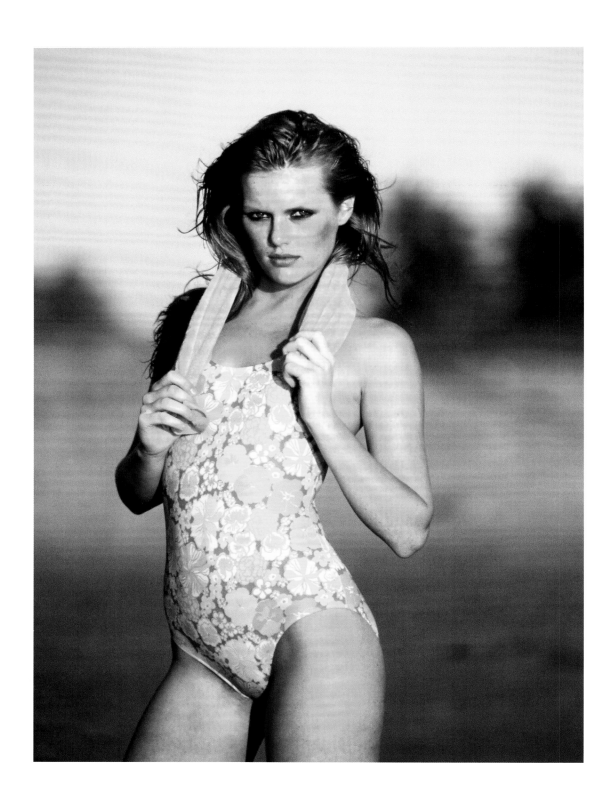

ABOVE Model Patti Hansen in a Lilly Pulitzer maillot in Zuzek's *Spangle*.
Photographed by Mike Reinhardt for the May 1979 issue of *Vogue*.

OPPOSITE Suzie Zuzek, *Spangle*, 1978.

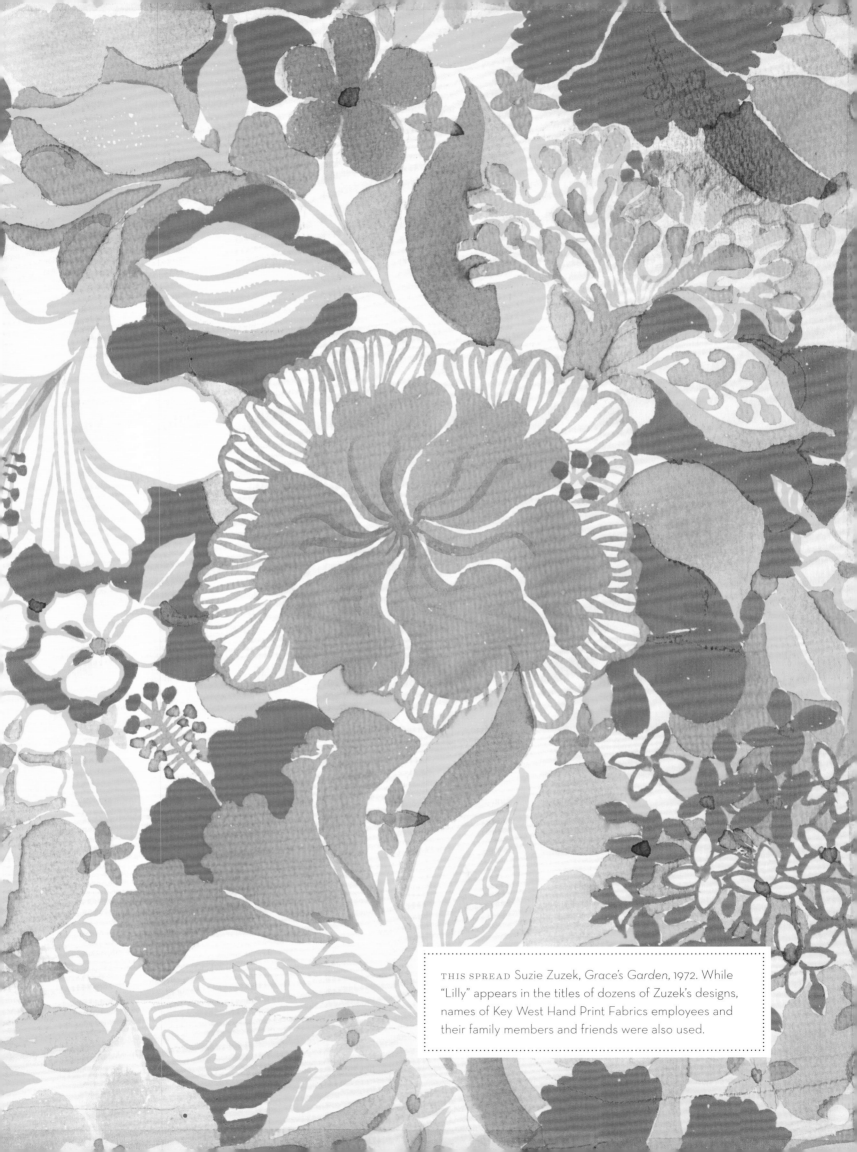

THIS SPREAD Suzie Zuzek, *Grace's Garden*, 1972. While "Lilly" appears in the titles of dozens of Zuzek's designs, names of Key West Hand Print Fabrics employees and their family members and friends were also used.

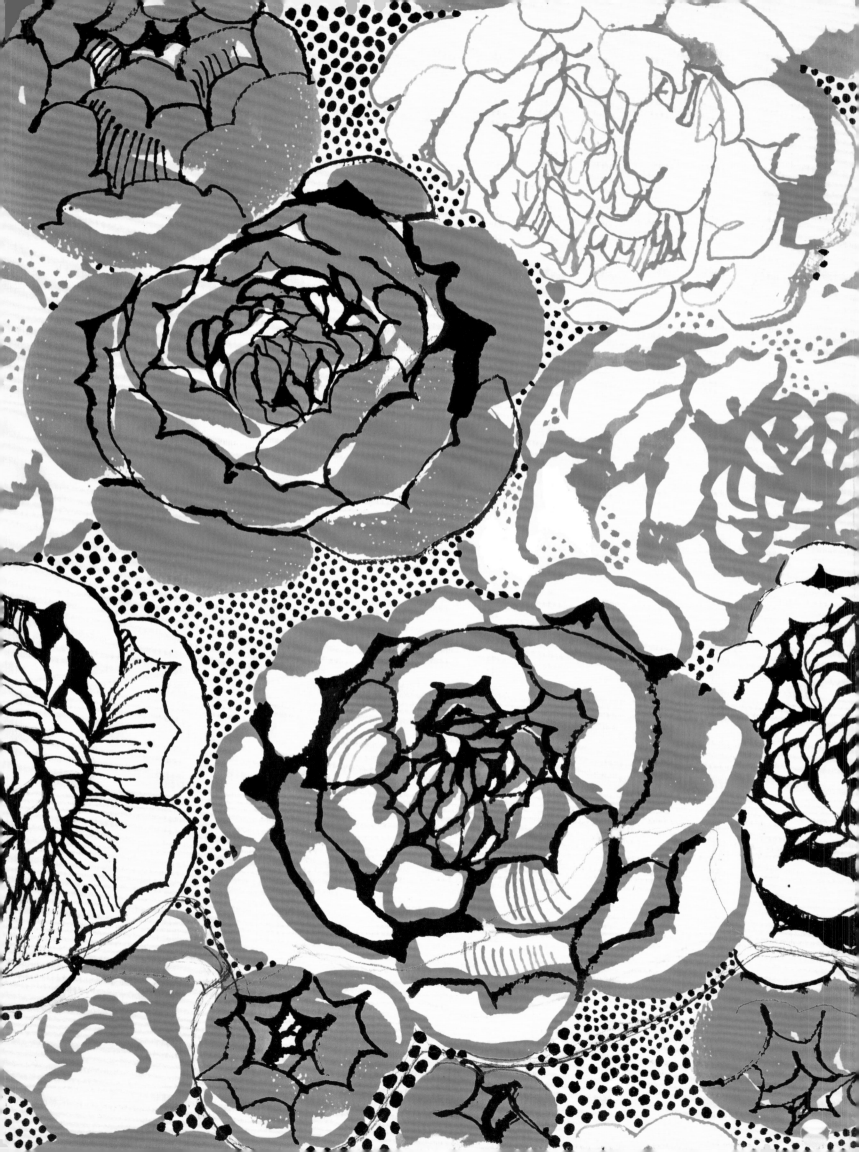

OPPOSITE Suzie Zuzek, *Helen's Anemones*, 1971.

ABOVE Lilly Pulitzer swimsuit in Zuzek's *Helen's Anemones*, early 1970s.
Photographed by John S. Haynsworth.

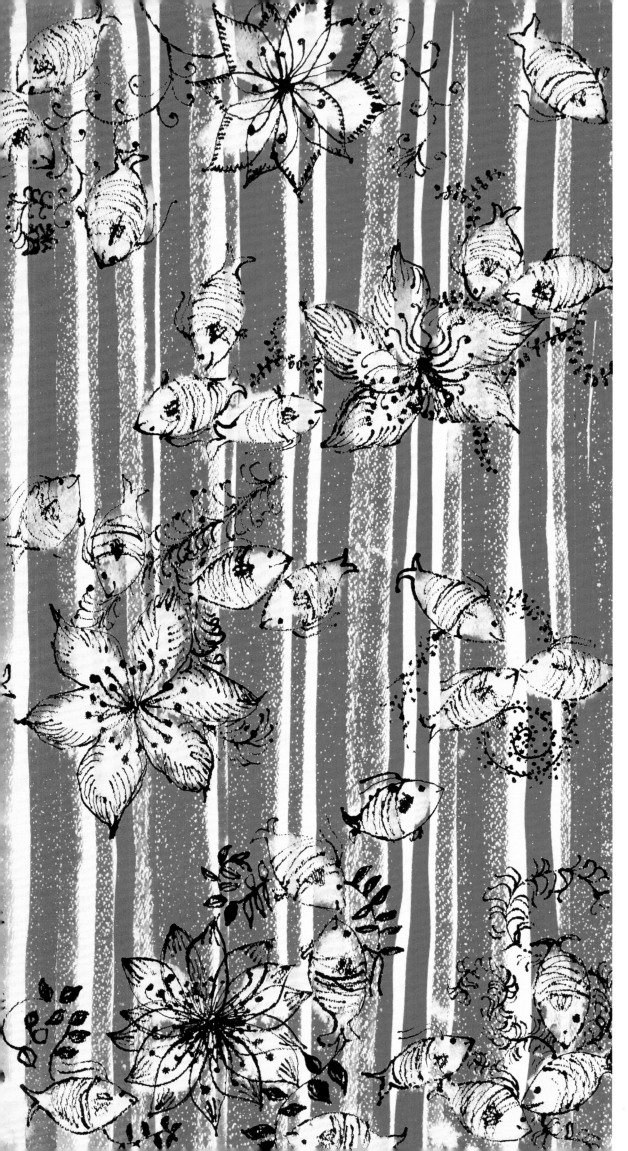

LEFT Suzie Zuzek, *Zebra Fish*, 1964.

OPPOSITE. CLOCKWISE FROM TOP LEFT *Azaleas*, 1972; *Tropical Harvest*, 1973; *Fireworks*, 1975; and *Sprilillying*, 1967. All drawings by Suzie Zuzek.

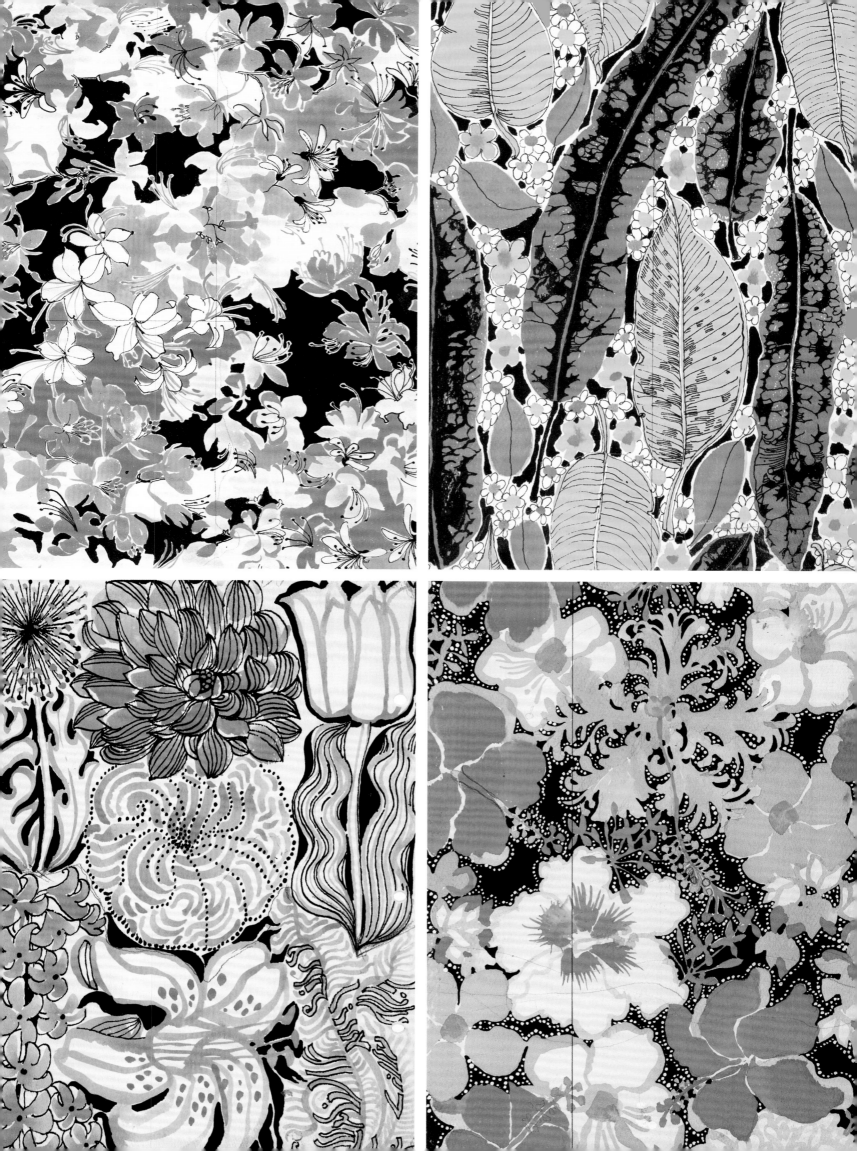

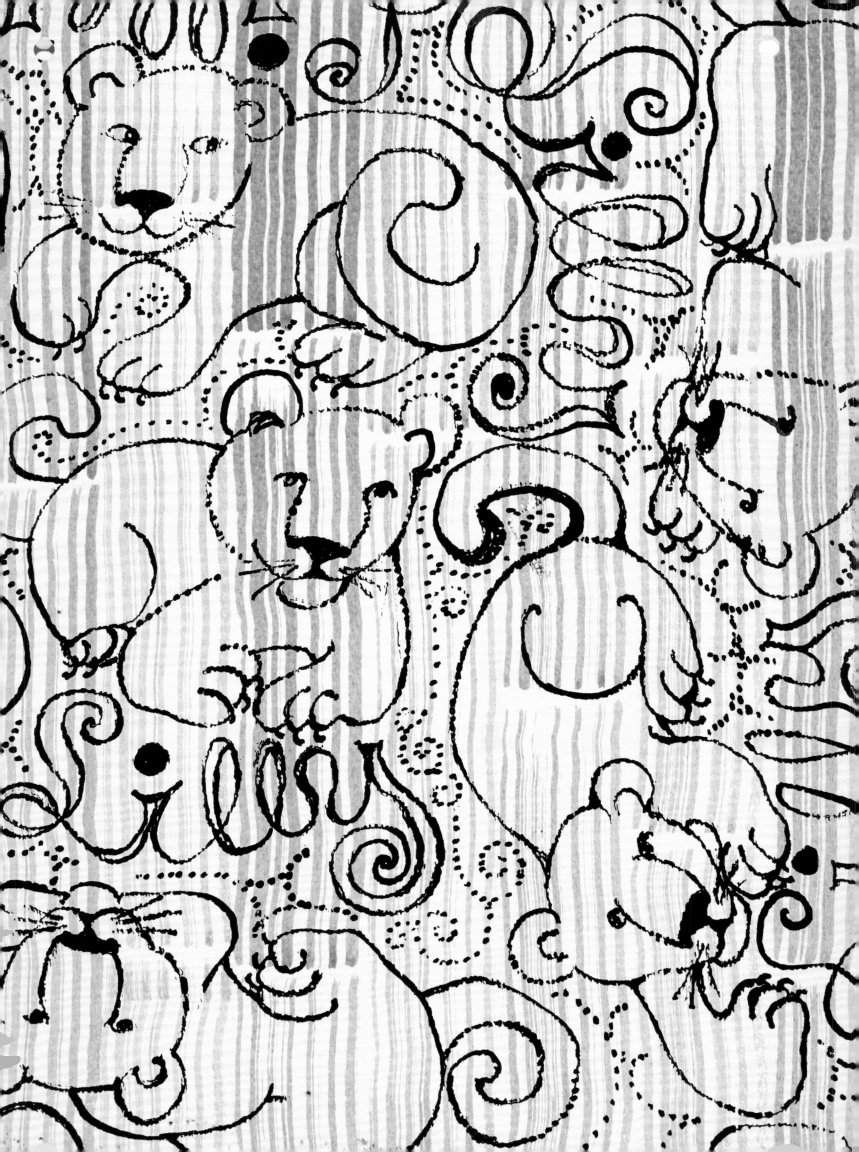

OPPOSITE Suzie Zuzek, *Lion Stripe*, circa 1967.

ABOVE Model wearing Lilly Pulitzer pants in Zuzek's *Lion Stripe*, circa 1968.
This print was another popular Zuzek design made into both men's
and women's PJs. Photographed by John S. Haynsworth.

LEFT Lilly Pulitzer dress in Zuzek's *Felice*.

OPPOSITE Suzie Zuzek, *Felice*, 1971.

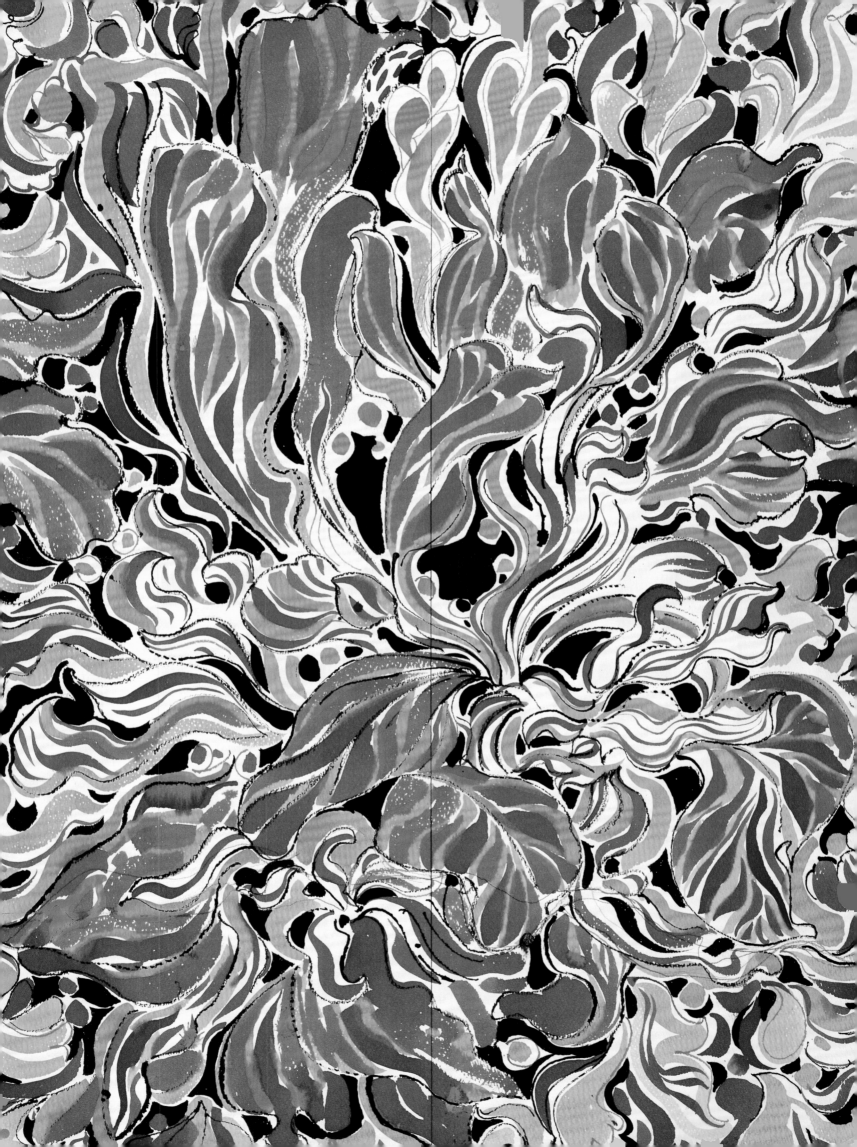

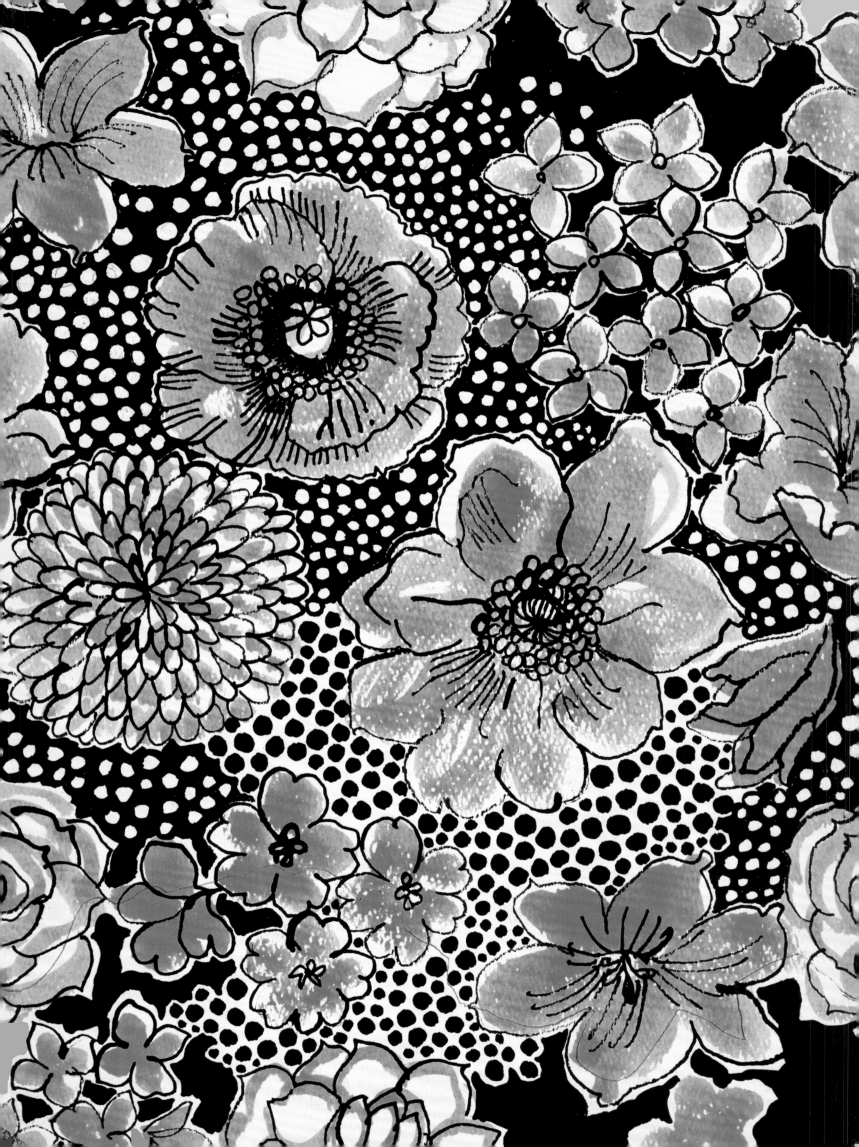

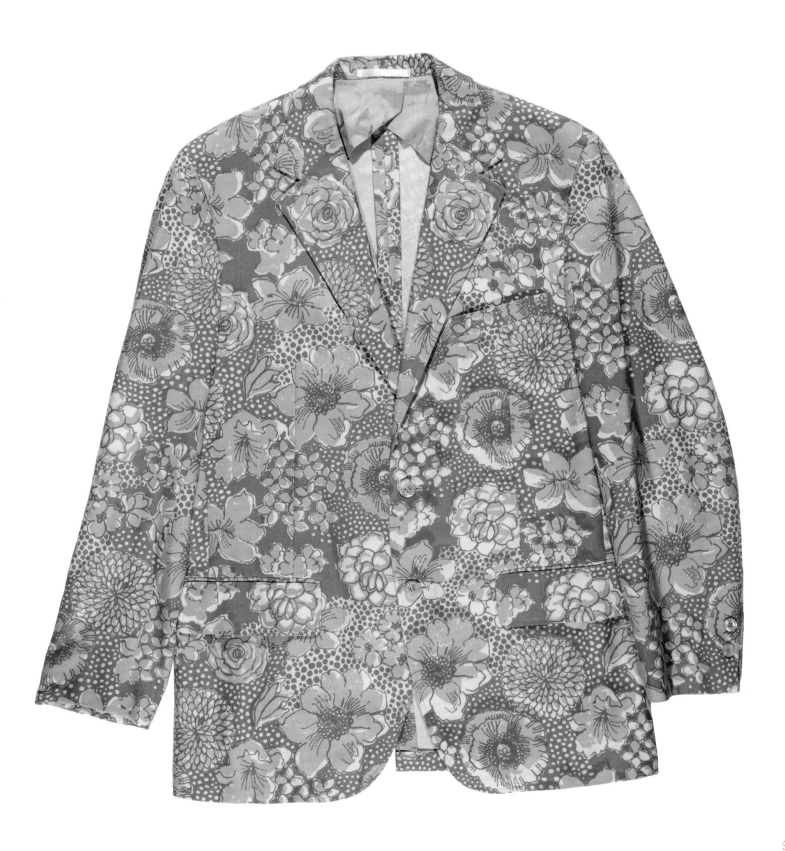

OPPOSITE Suzie Zuzek, *Champagne*, 1969.

ABOVE Lilly Pulitzer men's jacket in Zuzek's *Champagne*. This design was printed in twenty different colorways, initially on an absinthe-colored fabric and later on white velvet.

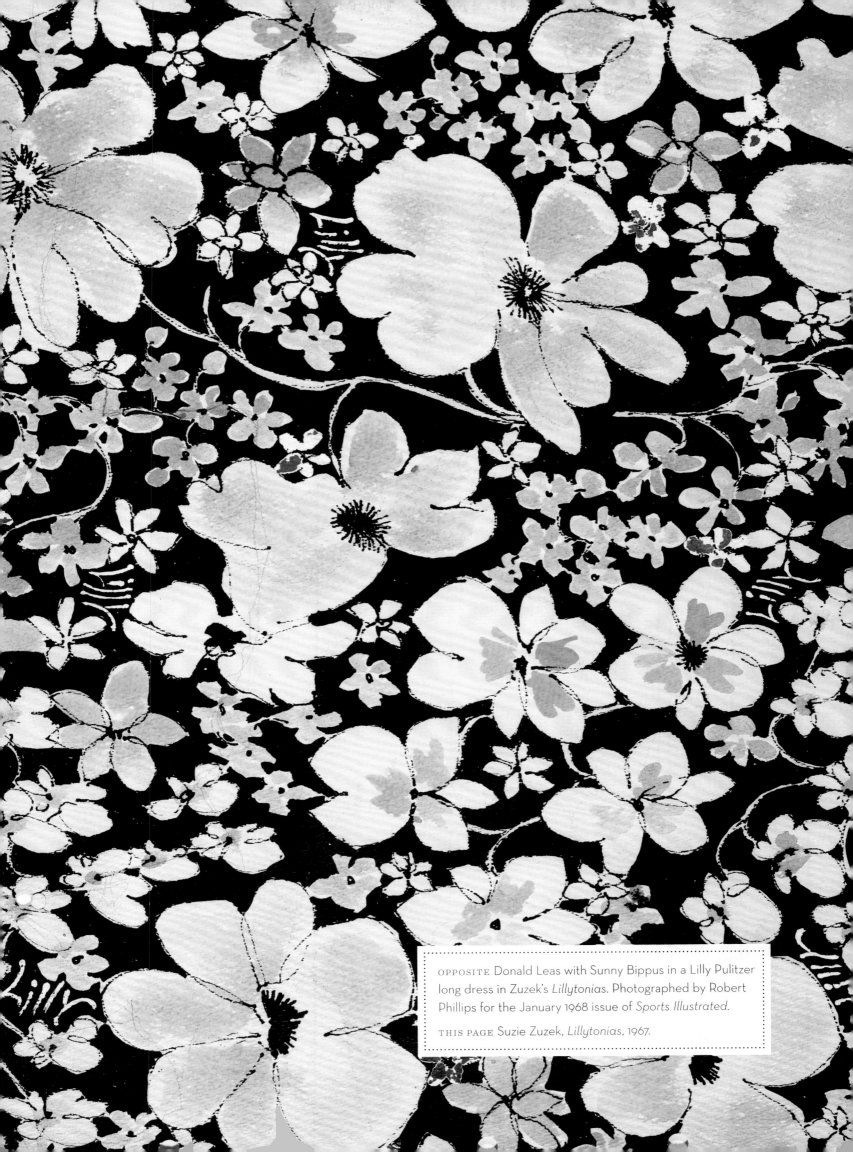

OPPOSITE Donald Leas with Sunny Bippus in a Lilly Pulitzer long dress in Zuzek's *Lillytonias*. Photographed by Robert Phillips for the January 1968 issue of *Sports Illustrated*.

THIS PAGE Suzie Zuzek, *Lillytonias*, 1967.

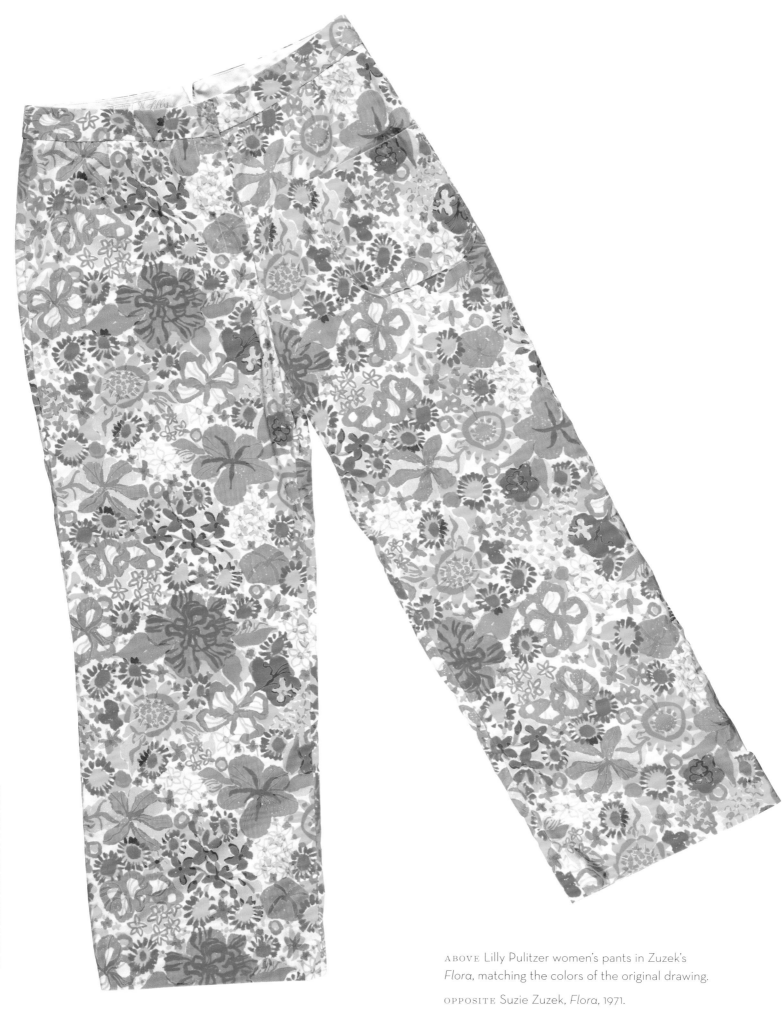

ABOVE Lilly Pulitzer women's pants in Zuzek's *Flora*, matching the colors of the original drawing.

OPPOSITE Suzie Zuzek, *Flora*, 1971.

112

OPPOSITE Suzie Zuzek, *Charlie*, 1978.

ABOVE Lilly Pulitzer shift in Zuzek's *Charlie*.

ABOVE, CLOCKWISE FROM TOP LEFT *Shasta-Lilly*, 1969; *Daffa-Dillard*, 1967; *Coreopsis*, 1969; and *Rosanna*, 1973. All drawings by Suzie Zuzek.

OPPOSITE Suzie Zuzek, *Puffins*, 1981. Colorways for this design were typically in four shades of the same hue.

OPPOSITE Suzie Zuzek, *Claudia*, 1971.

ABOVE Lilly Pulitzer dress in Zuzek's *Claudia*. Photographed by John S. Haynsworth.

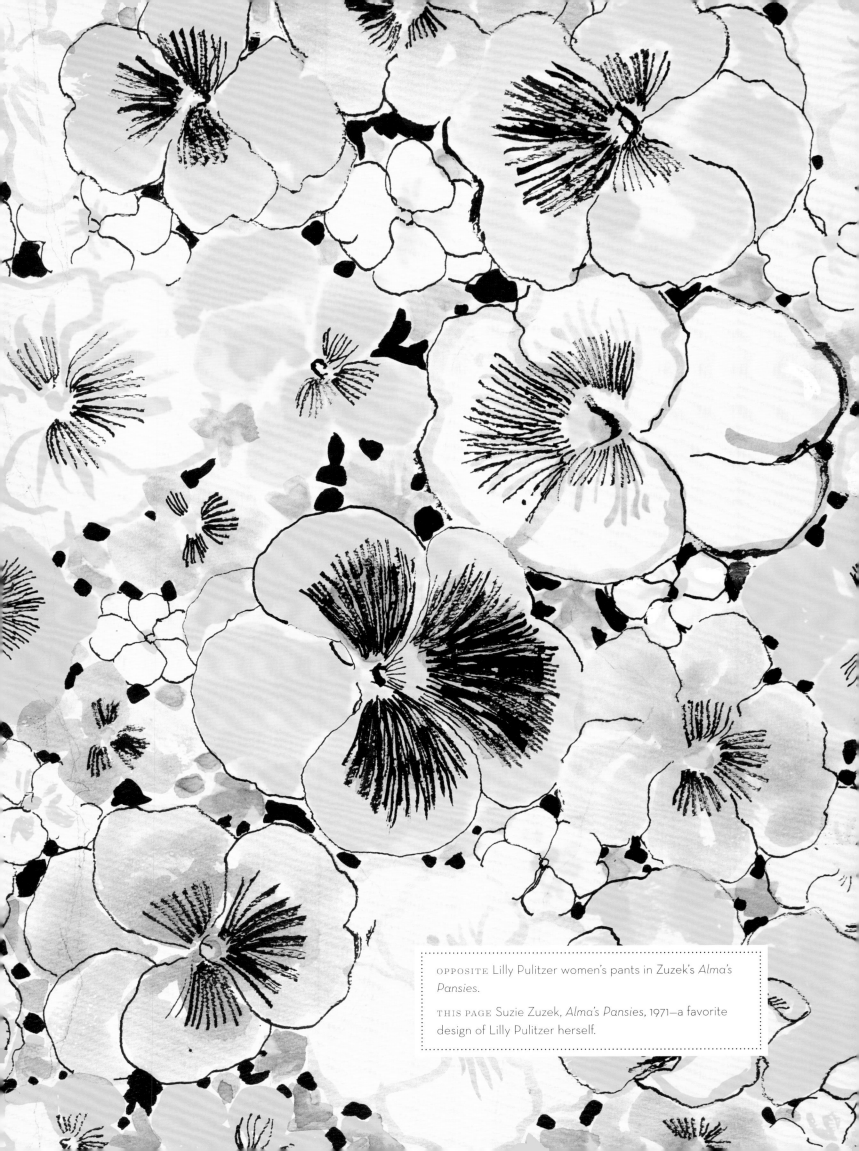

OPPOSITE Lilly Pulitzer women's pants in Zuzek's *Alma's Pansies*.

THIS PAGE Suzie Zuzek, *Alma's Pansies*, 1971—a favorite design of Lilly Pulitzer herself.

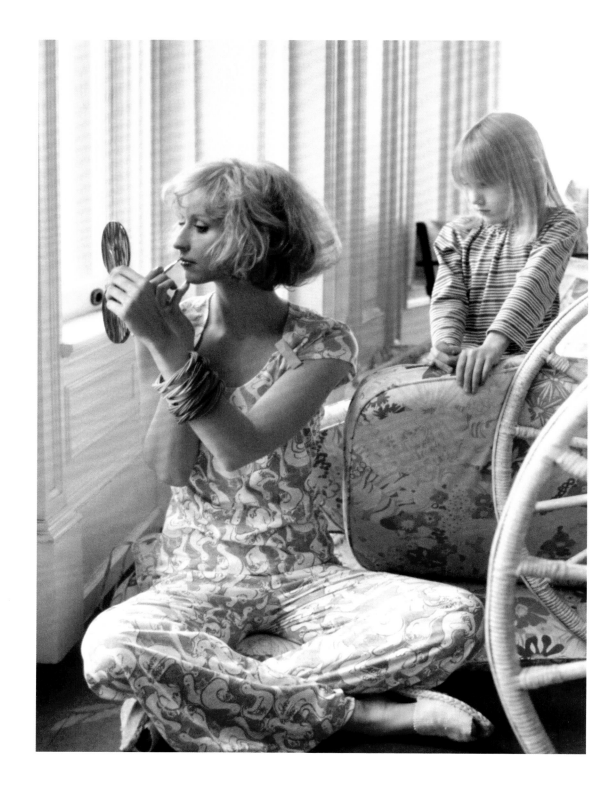

ABOVE Model Chris Royer wearing a Lilly Pulitzer outfit in Zuzek's *Quack*. Photographed by
Deborah Turbeville for the June 1975 issue of *Vogue*.

OPPOSITE Suzie Zuzek, *Quack*, 1975.

FOLLOWING SPREAD, LEFT, CLOCKWISE FROM TOP LEFT Suzie Zuzek, *Ponchita's Petunias*, 1967; Lilly Pulitzer
women's top in Zuzek's *Ponchita's Petunias*; Suzie Zuzek, *Par*, 1972; Lilly Pulitzer golf skirt in Zuzek's *Par*.

FOLLOWING SPREAD, RIGHT, CLOCKWISE FROM TOP LEFT Suzie Zuzek, *Josh*, 1979; Lilly Pulitzer
golf skirt in Zuzek's *Josh*; Suzie Zuzek, *Currie*, 1980; Lilly Pulitzer women's Bermuda shorts in Zuzek's *Currie*.

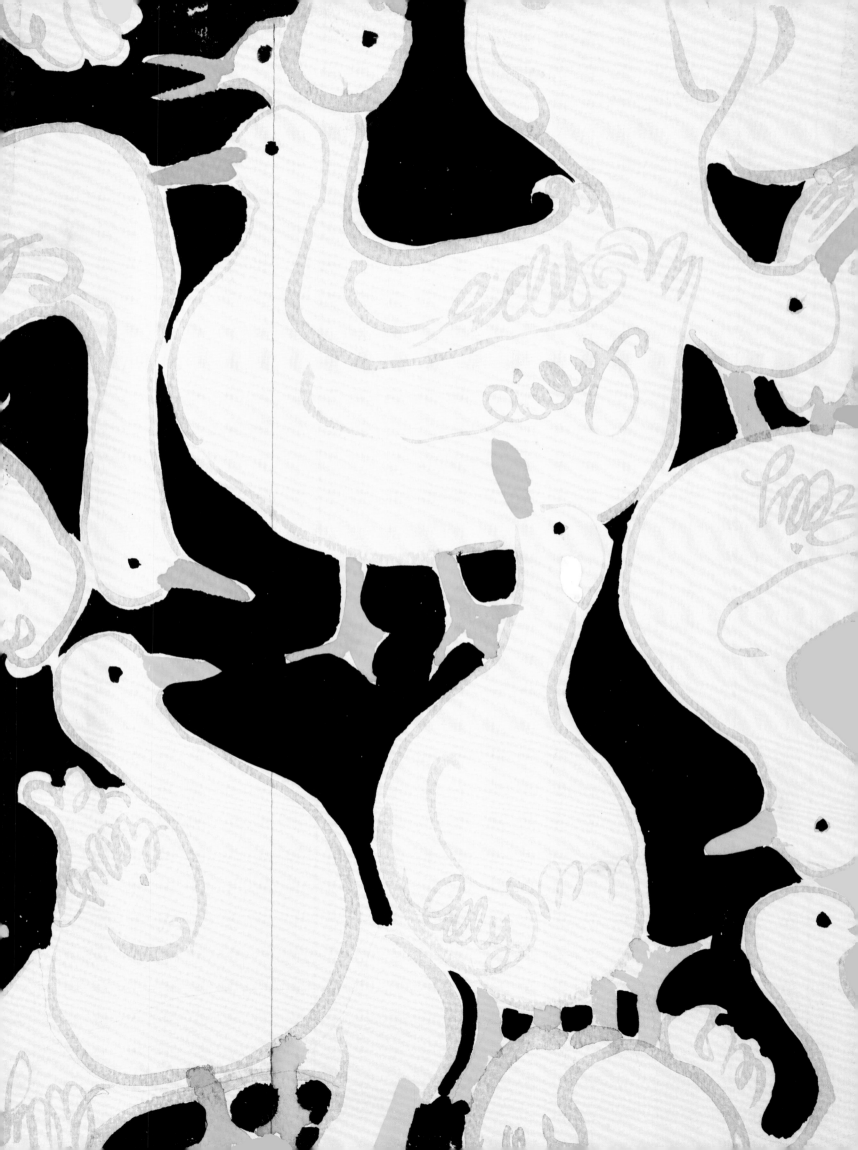

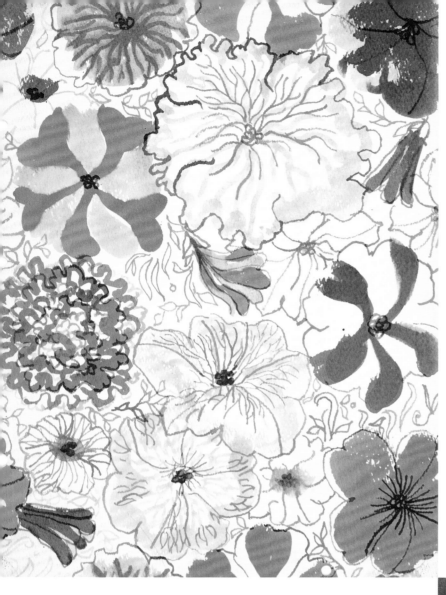

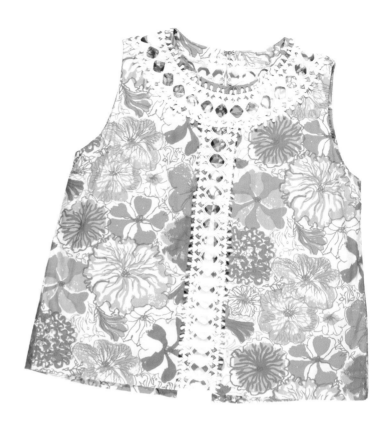

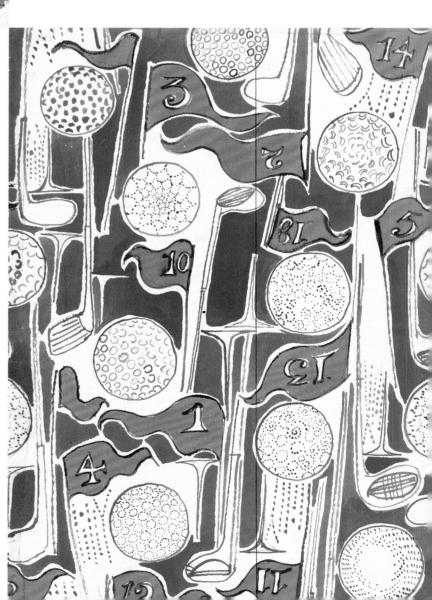

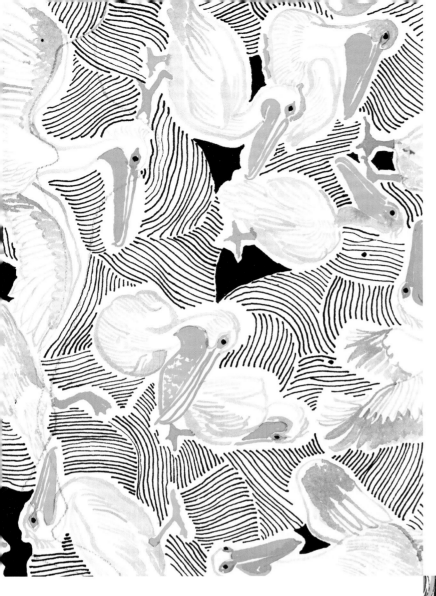

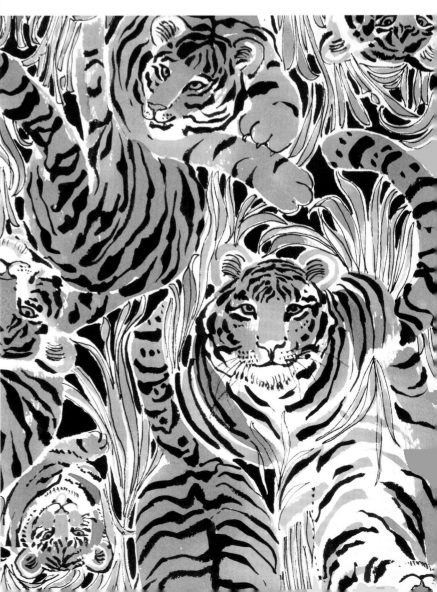

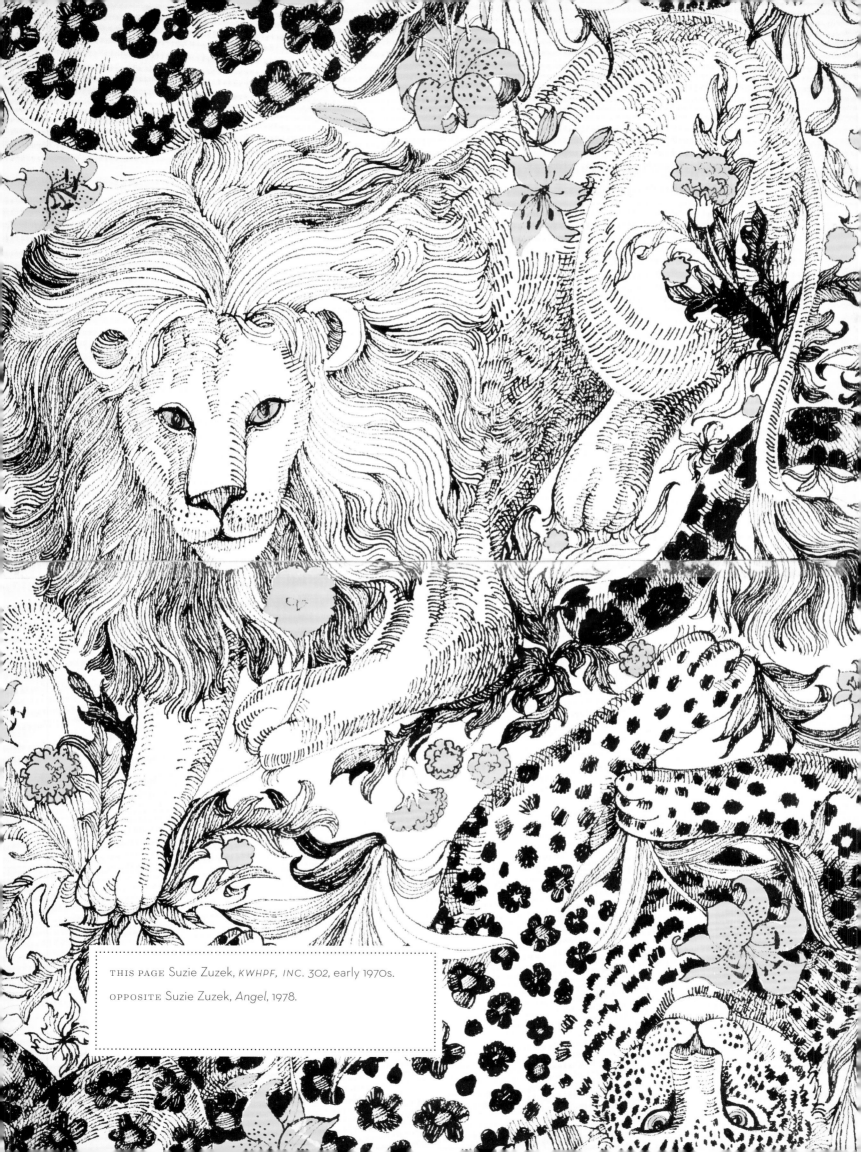

THIS PAGE Suzie Zuzek, *KWHPF, INC.* 302, early 1970s.

OPPOSITE Suzie Zuzek, *Angel*, 1978.

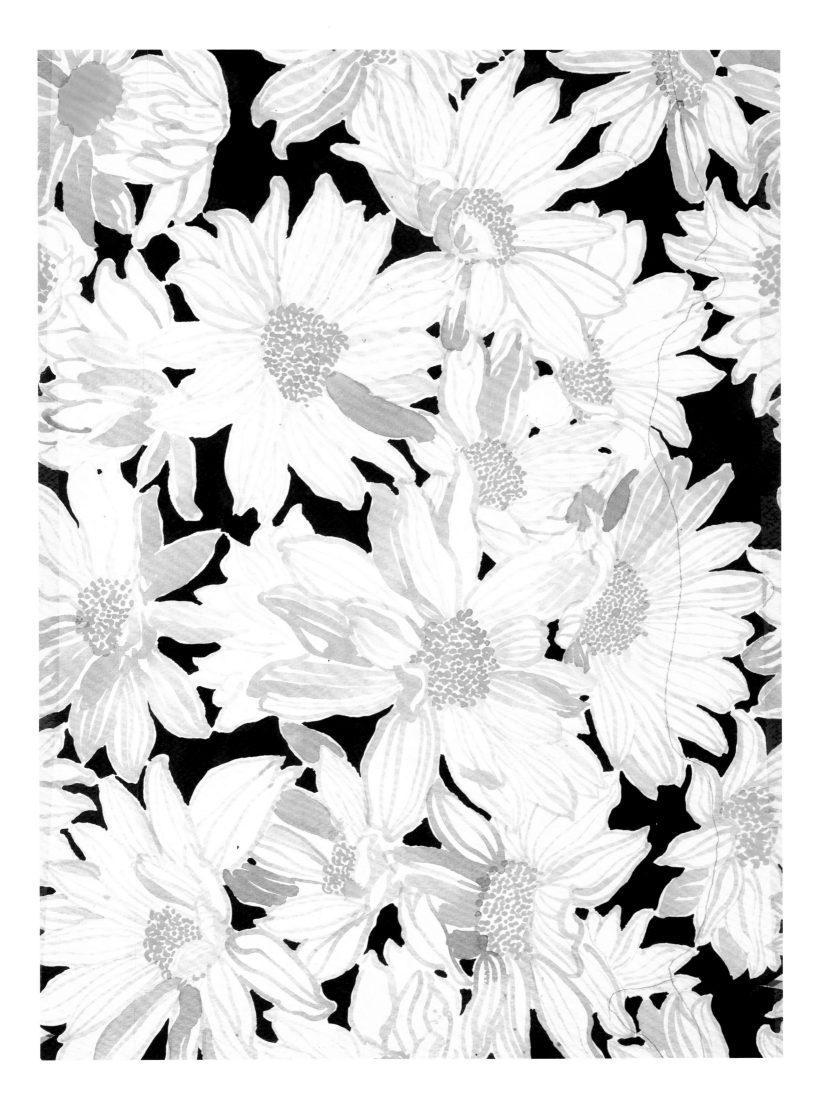

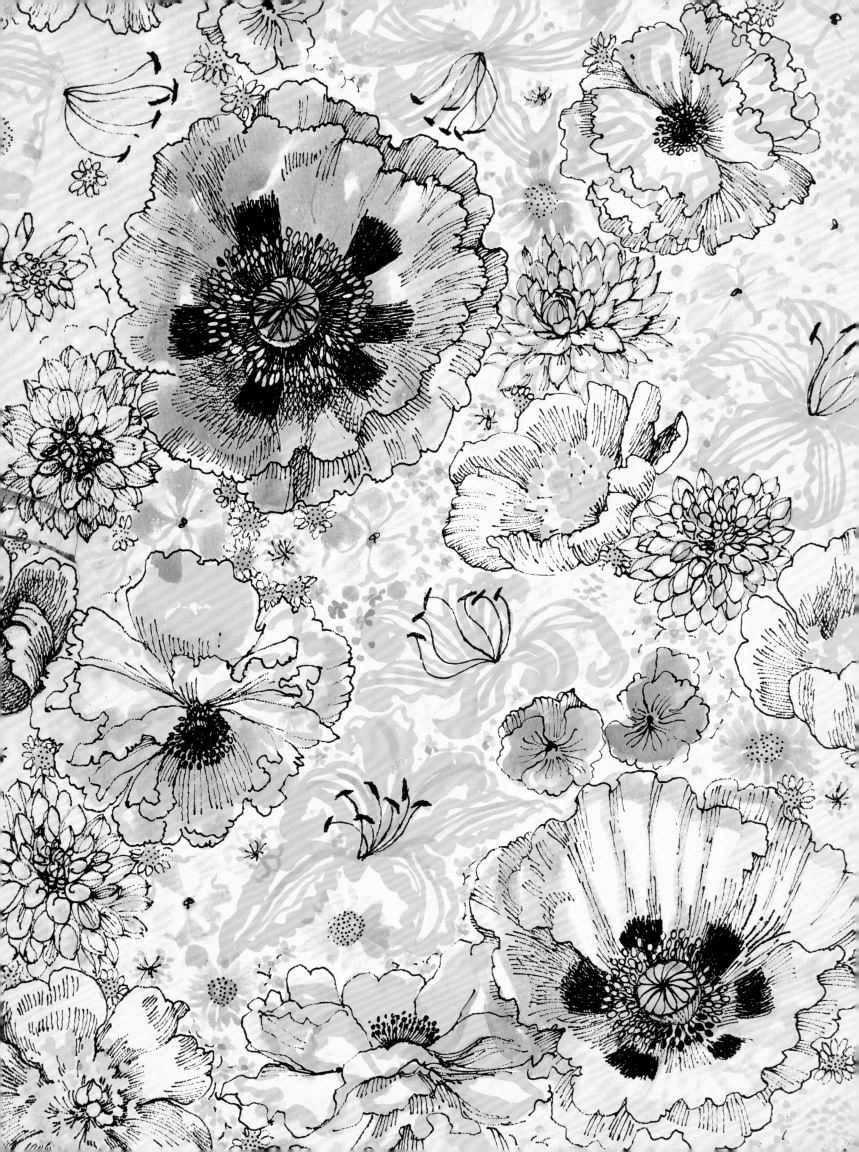

OPPOSITE Suzie Zuzek, *Poplies*, 1967.

ABOVE Model wearing a short Lilly Pulitzer dress in Zuzek's *Poplies*.
Photographed by Richard Noble for the May 1968 issue of *Holiday*.

ABOVE Lilly Pulitzer shift in Zuzek's *Menagerie*. This interpretation of the print is in only one color, as opposed to the original drawing , which has the animals rendered in black.

OPPOSITE Suzie Zuzek, *Menagerie*, 1971.

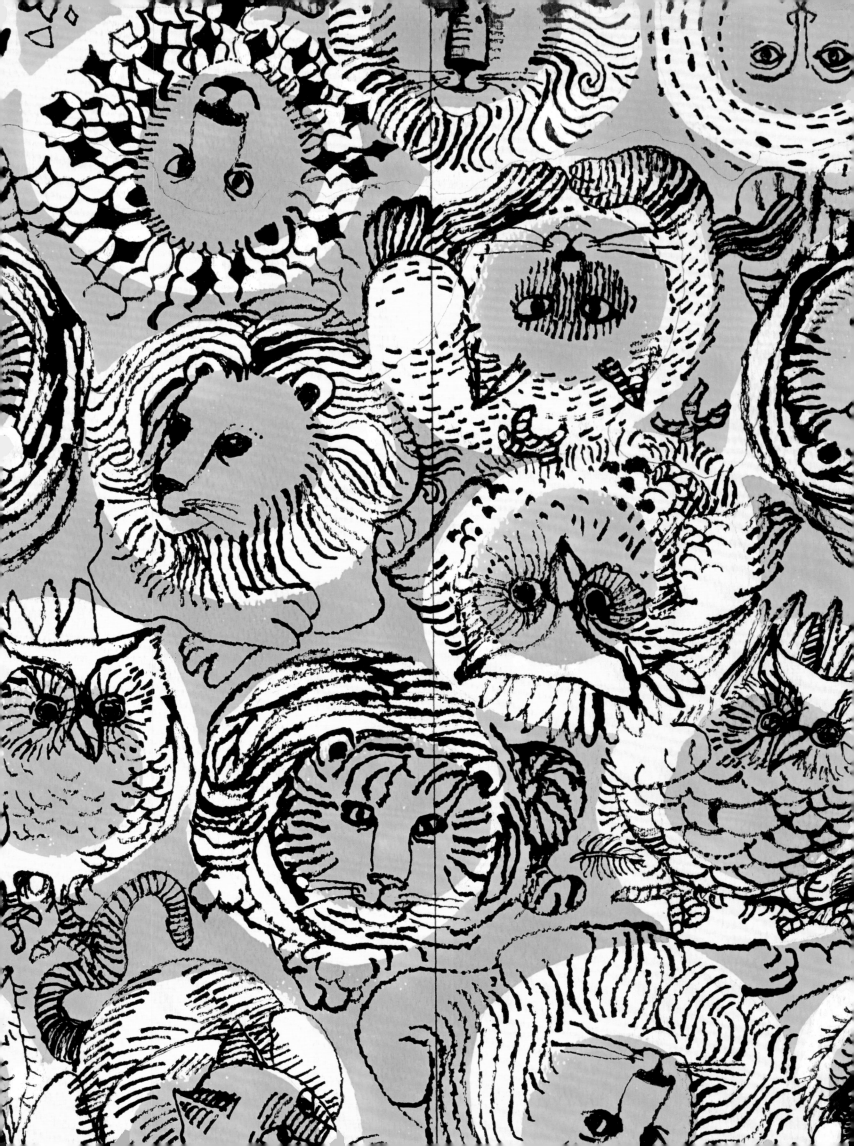

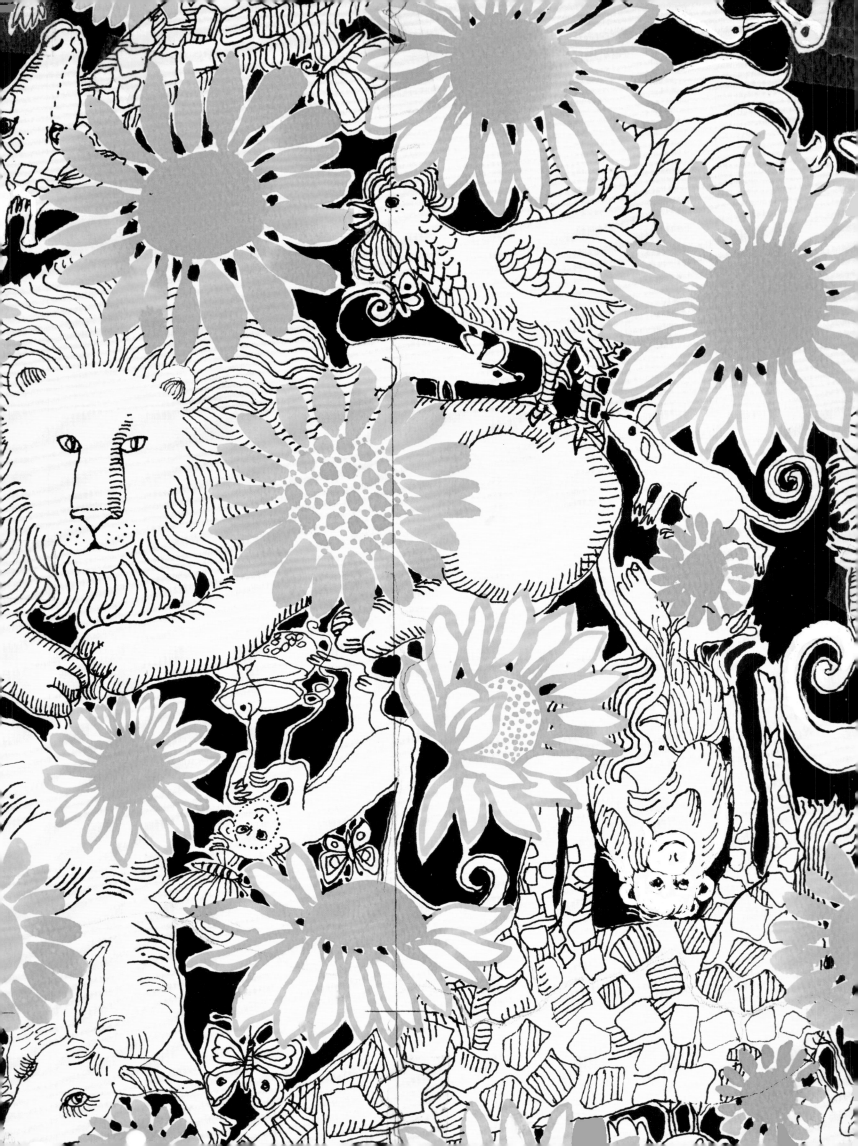

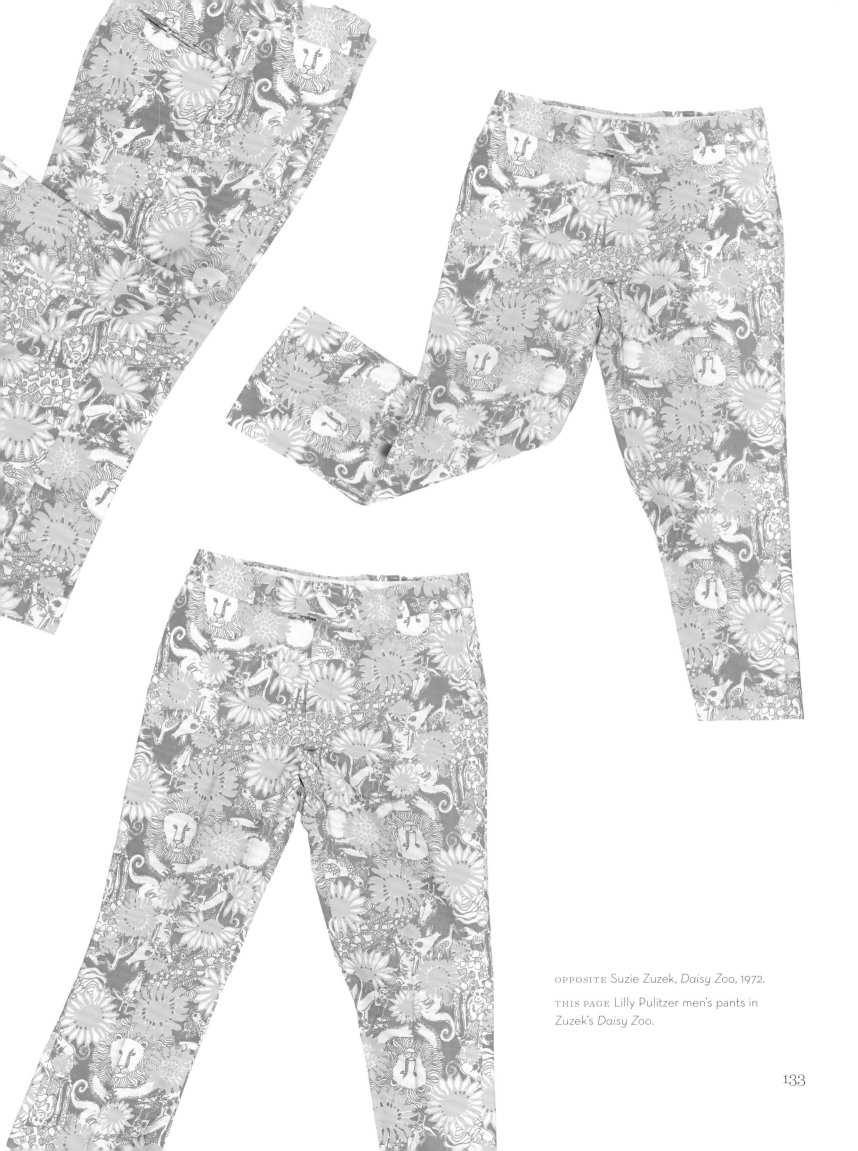

OPPOSITE Suzie Zuzek, *Daisy Zoo*, 1972.

THIS PAGE Lilly Pulitzer men's pants in Zuzek's *Daisy Zoo*.

133

ABOVE Lilly Pulitzer men's pants in Zuzek's *Lilly's Tigers*, circa 1968.
Photographed by John S. Haynsworth.

OPPOSITE Suzie Zuzek, *Lilly's Tigers*, 1967, one of the first designs used for the
Men's Stuff line. In a February 2, 1968, *Miami Herald* article Lilly stated,
"The timing is right for printed jeans right now. Men are now more responsive to color."

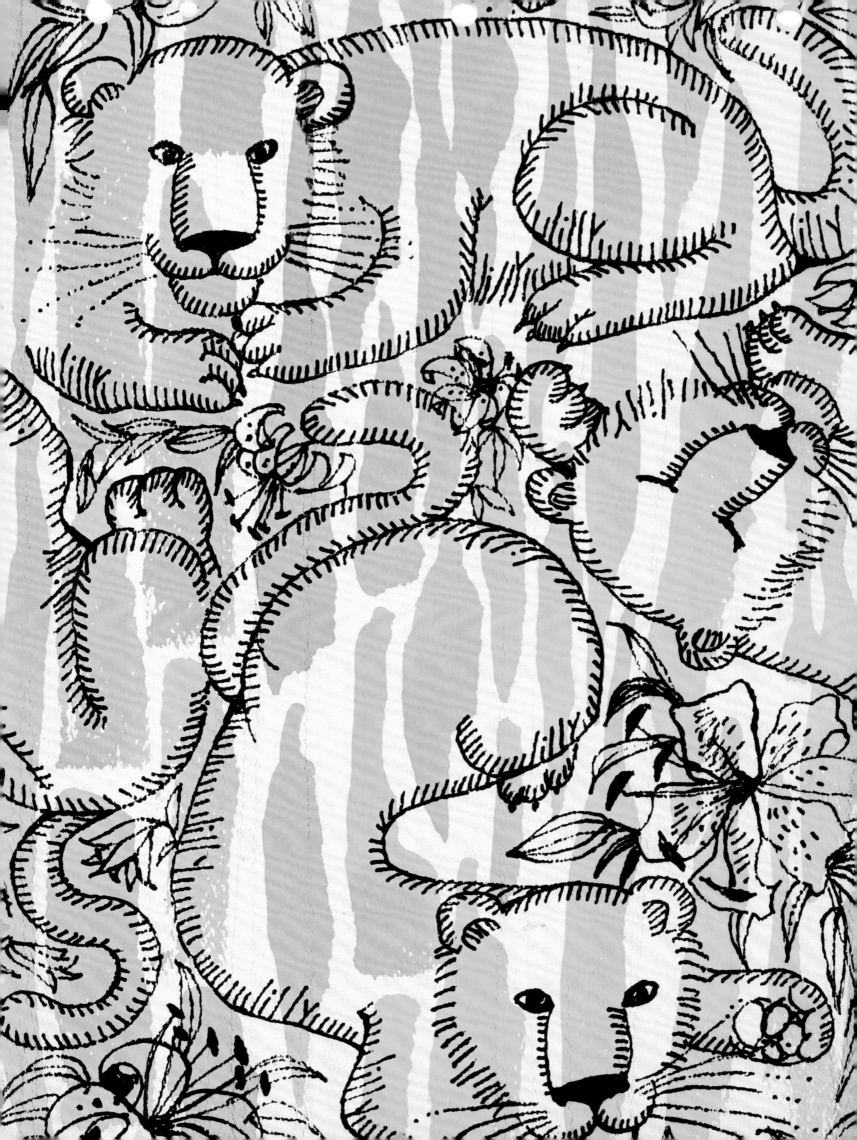

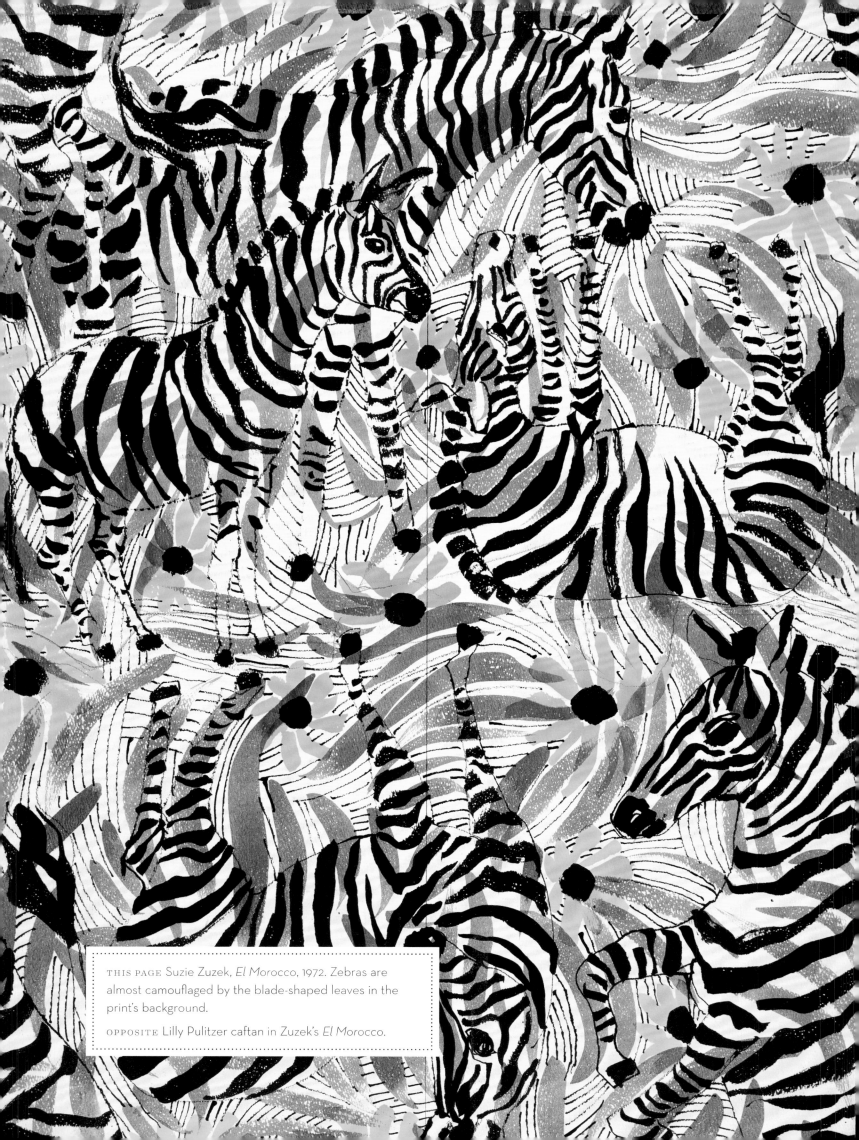

THIS PAGE Suzie Zuzek, *El Morocco*, 1972. Zebras are almost camouflaged by the blade-shaped leaves in the print's background.

OPPOSITE Lilly Pulitzer caftan in Zuzek's *El Morocco*.

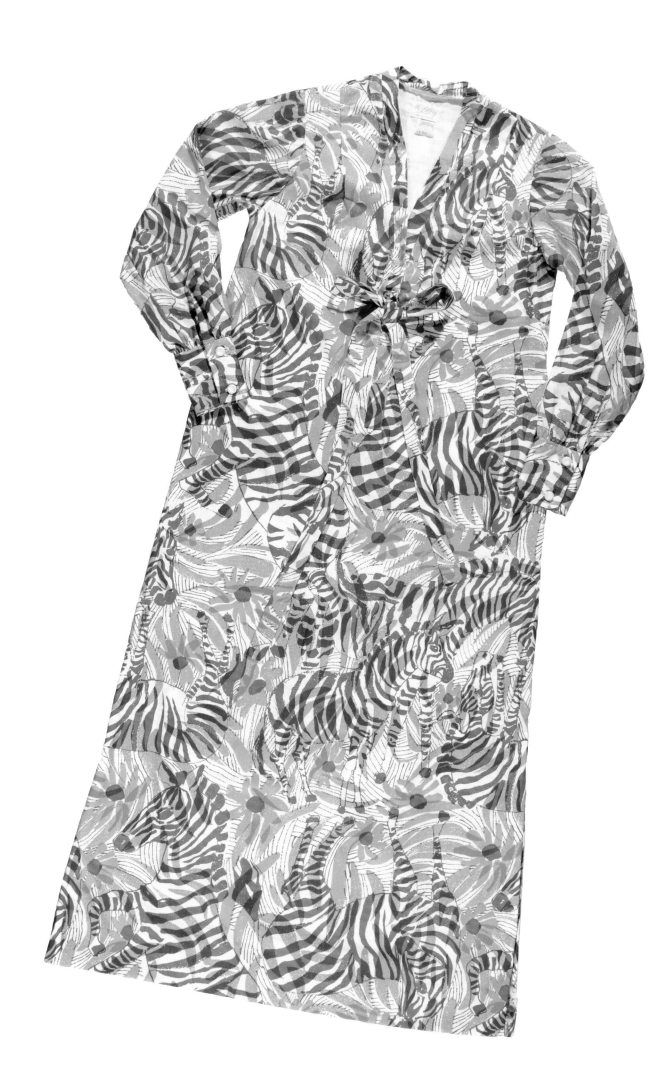

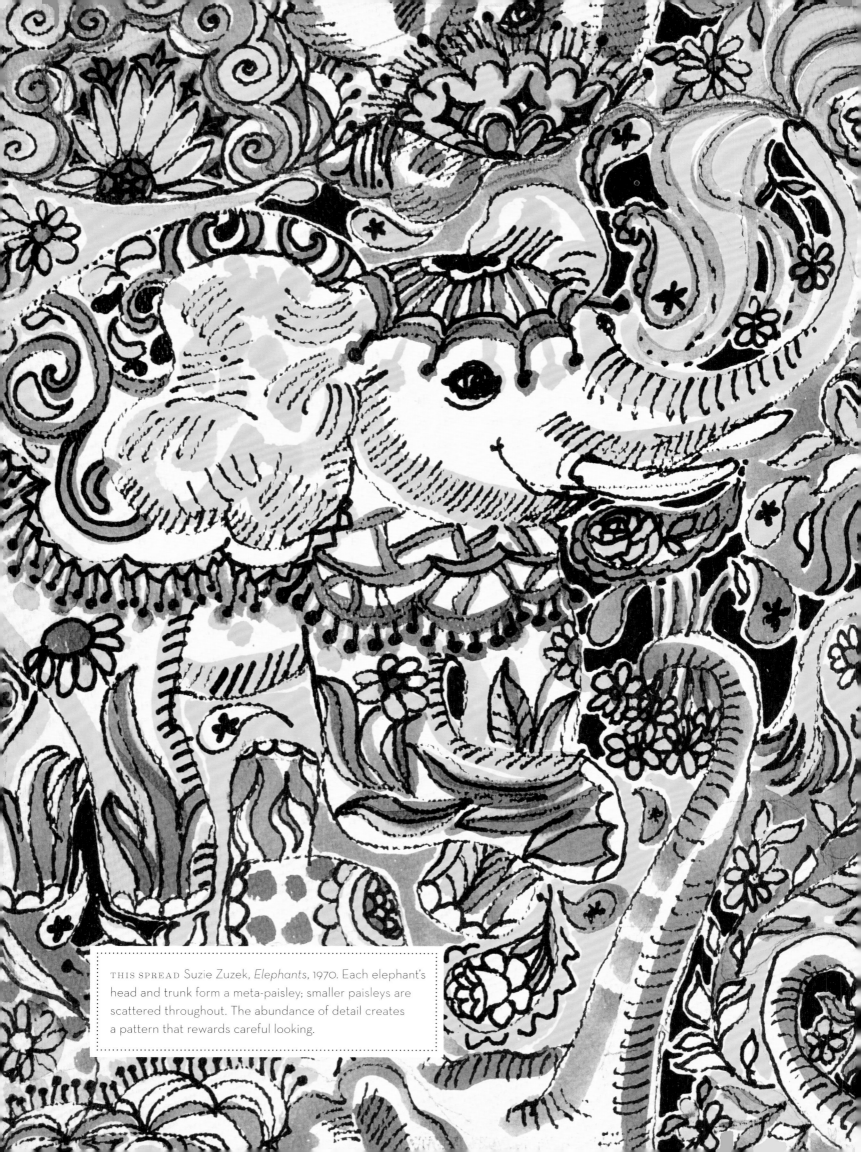

THIS SPREAD Suzie Zuzek, *Elephants*, 1970. Each elephant's head and trunk form a meta-paisley; smaller paisleys are scattered throughout. The abundance of detail creates a pattern that rewards careful looking.

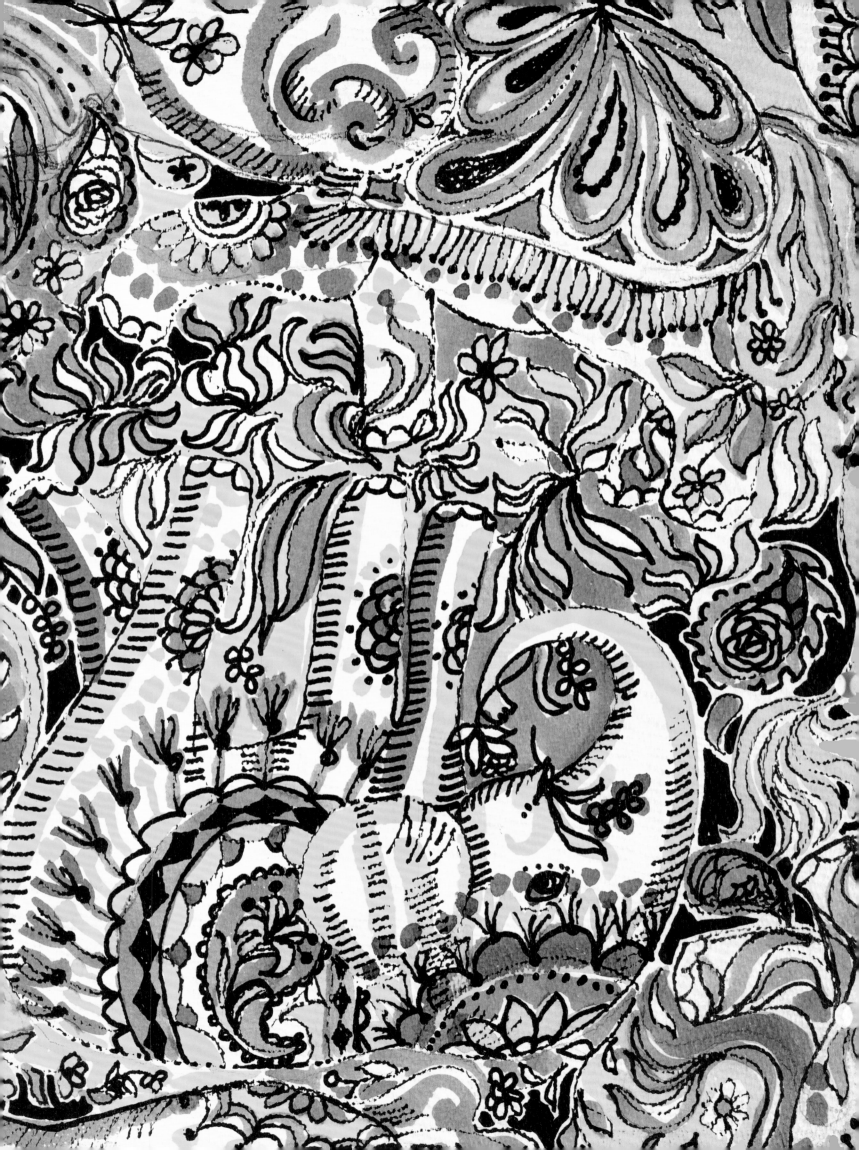

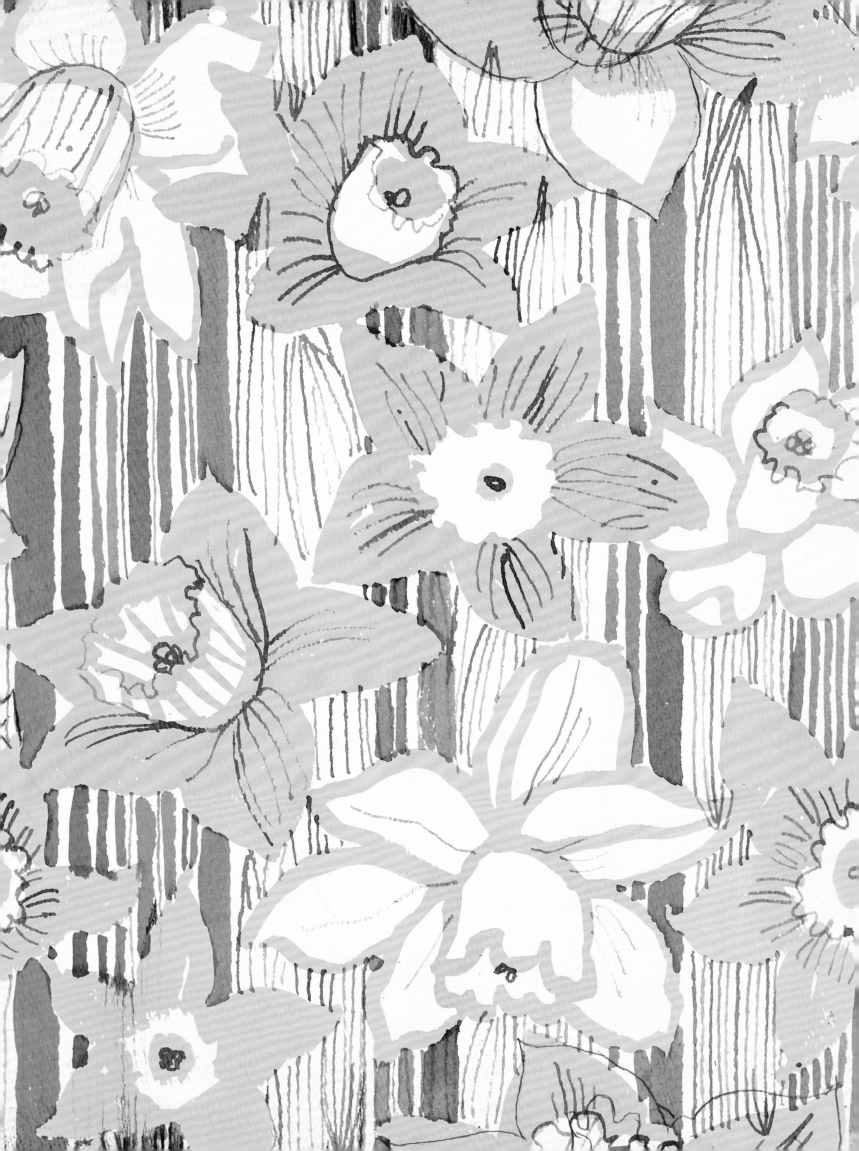

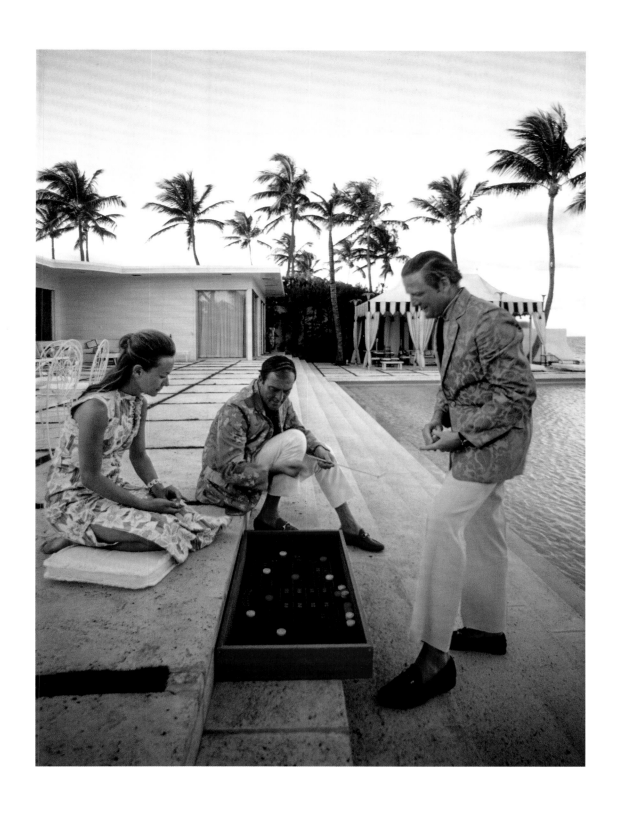

OPPOSITE Suzie Zuzek, *Jackie's Jonquils*, 1967.

ABOVE Lilly Pulitzer sleeveless long shift in Zuzek's *Jackie's Jonquils*; Men's Stuff
jacket (at center) in Zuzek's *Hi-Lilly-Biscus*. Photographed by Robert Phillips
for the January 1968 issue of *Sports Illustrated*. The original caption reported:
"Resorters model Pulitzer cottons at the home of Mrs. Albert Bostwick.
Claire and Garrick Stephenson . . . join Donald Leas at a portable craps table."

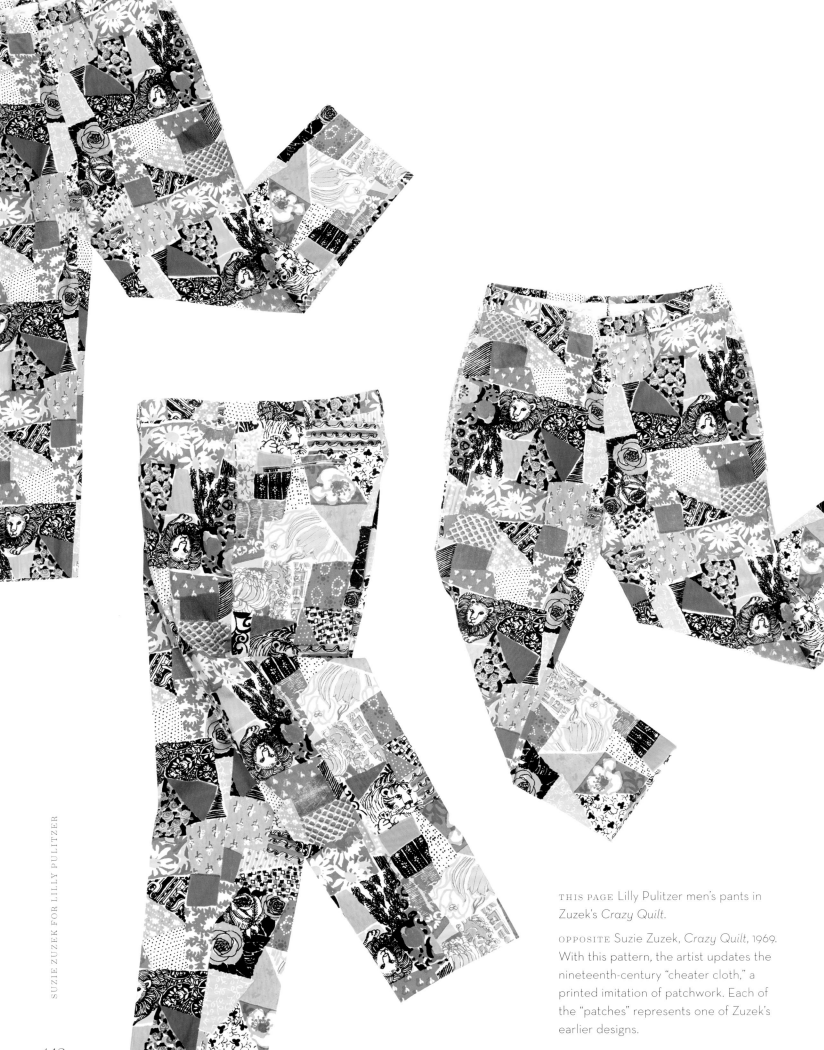

SUZIE ZUZEK FOR LILLY PULITZER

THIS PAGE Lilly Pulitzer men's pants in Zuzek's *Crazy Quilt*.

OPPOSITE Suzie Zuzek, *Crazy Quilt*, 1969. With this pattern, the artist updates the nineteenth-century "cheater cloth," a printed imitation of patchwork. Each of the "patches" represents one of Zuzek's earlier designs.

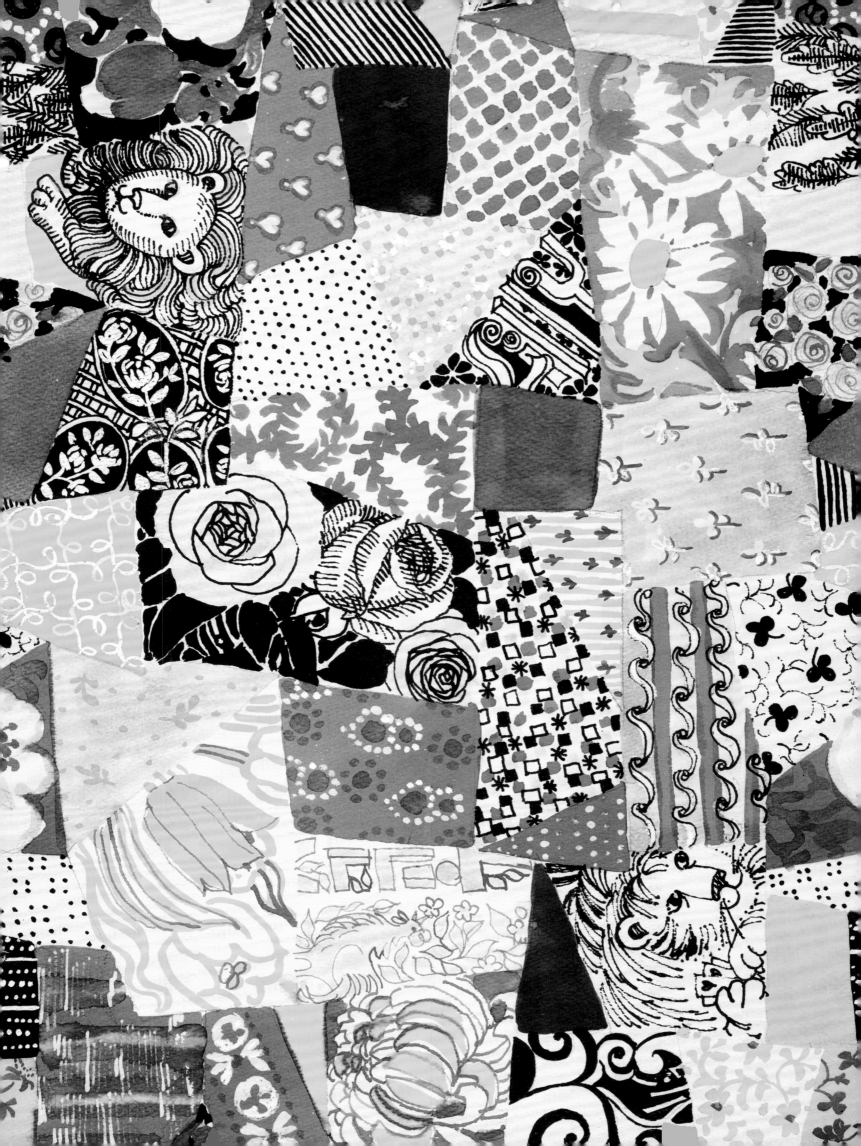

OPPOSITE Lilly Pulitzer dress in Zuzek's *Cayman*.
Photographed by Helmut Newton for the January 1973 issue of *Vogue*.

ABOVE Suzie Zuzek, *Cayman* textile swatches, 1972.

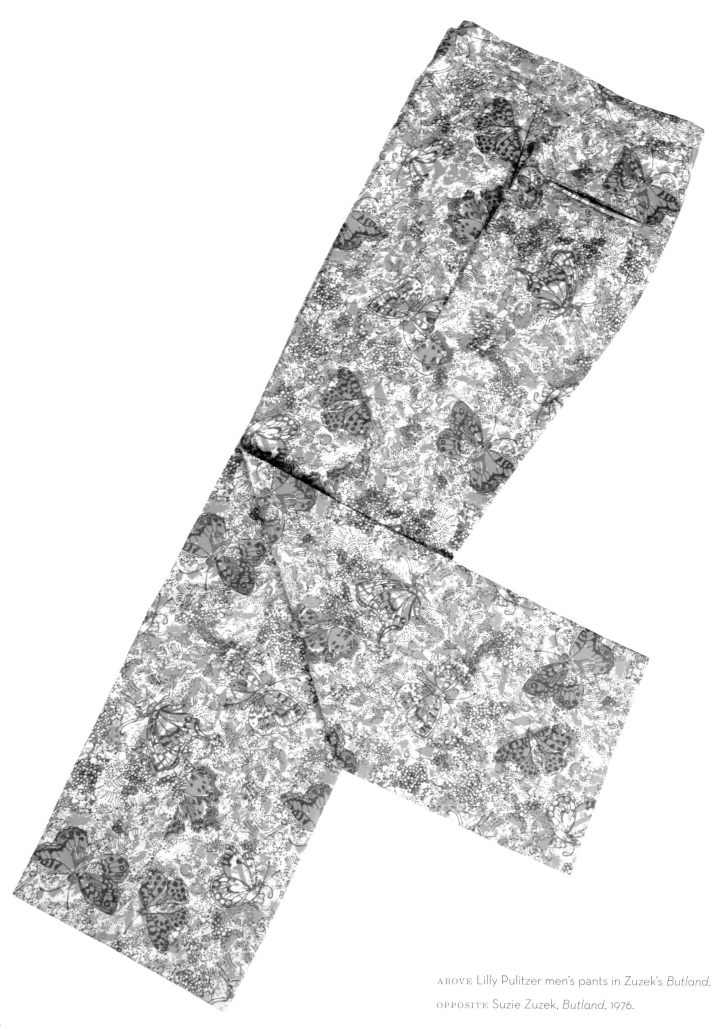

ABOVE Lilly Pulitzer men's pants in Zuzek's *Butland*.

OPPOSITE Suzie Zuzek, *Butland*, 1976.

146

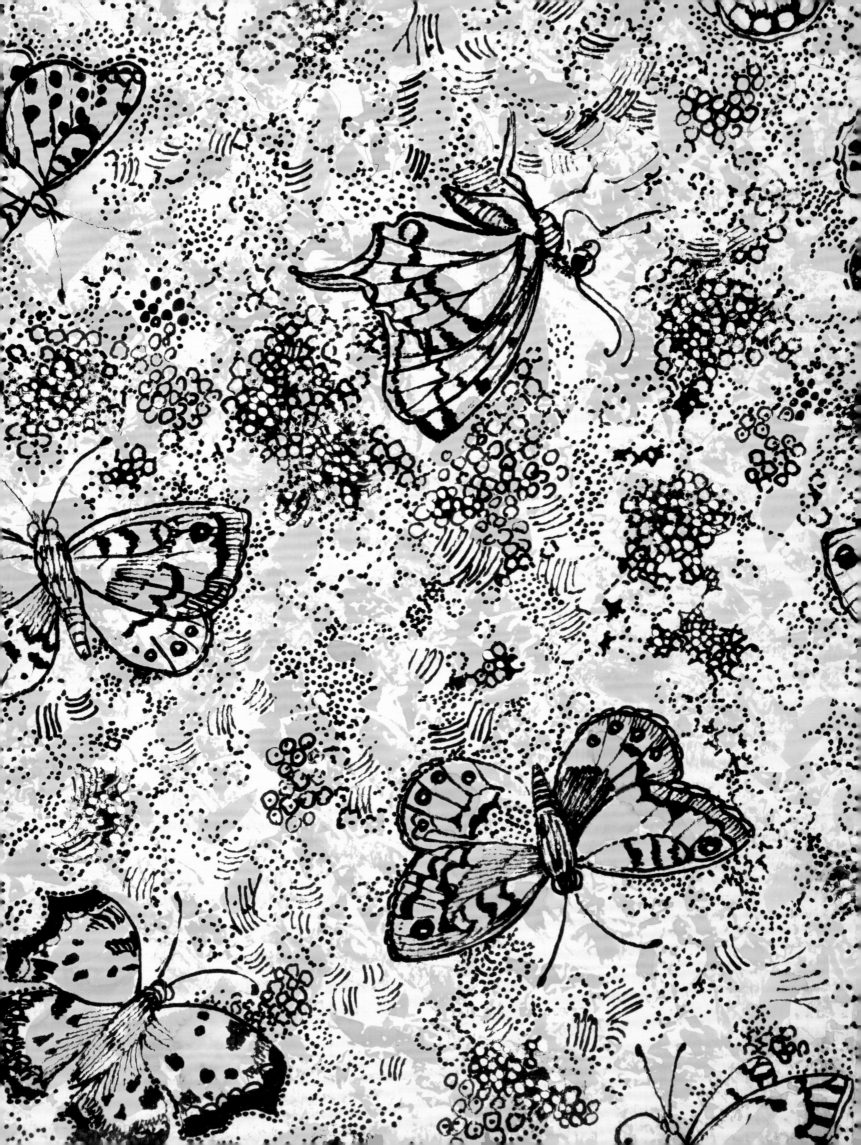

CLOCKWISE FROM TOP LEFT *Nocturne*, 1969; *Hippo*, 1979;
Gatlin Bears, 1972; and *Nairobi*, 1974. All drawings by Suzie Zuzek.

CLOCKWISE FROM TOP LEFT *More About Penguins*, 1968; *Lilly's Llamas*, 1967;
Pandas, 1972; and *Coquette*, 1974. All drawings by Suzie Zuzek. The artist
was able to imbue her designs with a unique sense of humor and an emotional
appeal—note the individual personalities of the penguins (upper left).

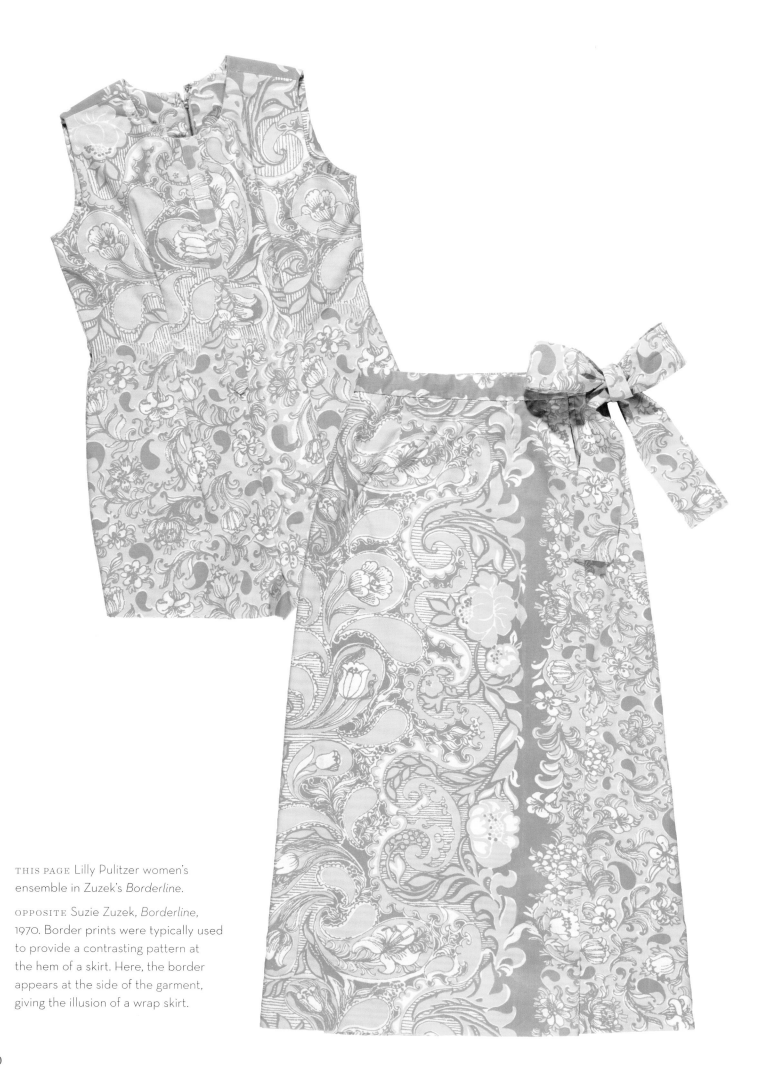

THIS PAGE Lilly Pulitzer women's
ensemble in Zuzek's *Borderline*.

OPPOSITE Suzie Zuzek, *Borderline*,
1970. Border prints were typically used
to provide a contrasting pattern at
the hem of a skirt. Here, the border
appears at the side of the garment,
giving the illusion of a wrap skirt.

ABOVE Model Rosie Vela wearing a Lilly Pulitzer dress in Zuzek's *Doggy*.
Photographed by Albert Watson for the May 1977 issue of *Vogue*.

ABOVE Suzie Zuzek, *Doggy* textile swatches, 1976.

OPPOSITE Suzie Zuzek, *Sweet Corn*, 1972.

ABOVE, CLOCKWISE FROM TOP LEFT *Squash*, 1972; *Sour Sop*, 1973; *Cole Slaw*, 1972;
and *Beets*, 1972. All drawings by Suzie Zuzek. In the artist's imagination,
homely vegetables such as cabbages and squash were transformed into lively and colorful
patterns. *Beets* and *Cole Slaw* appeared on men's swim trunks and shorts.

155

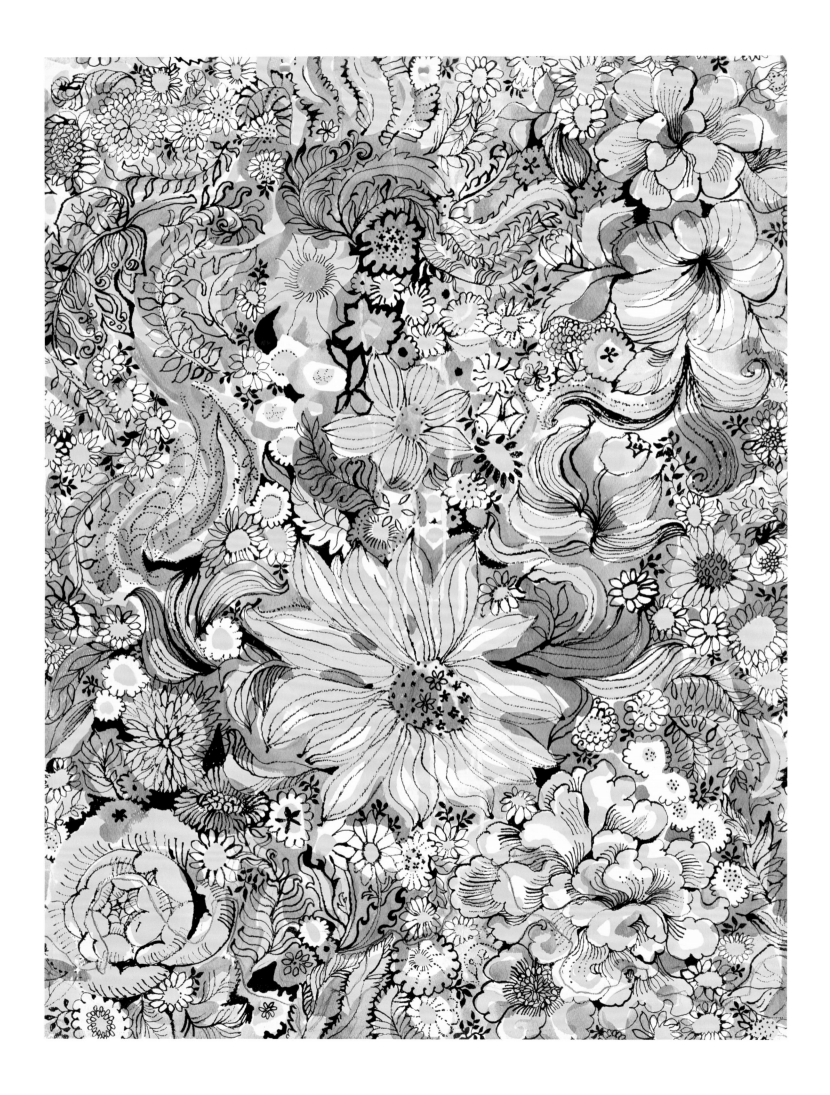

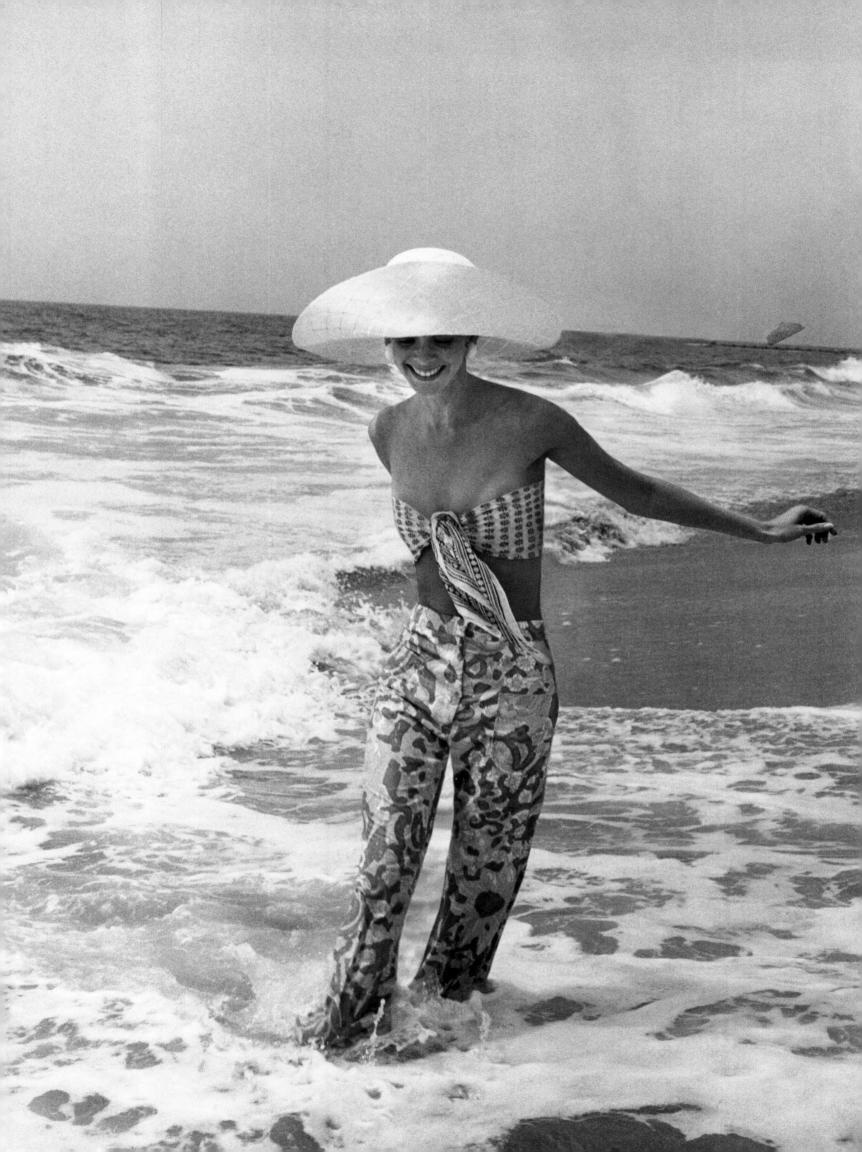

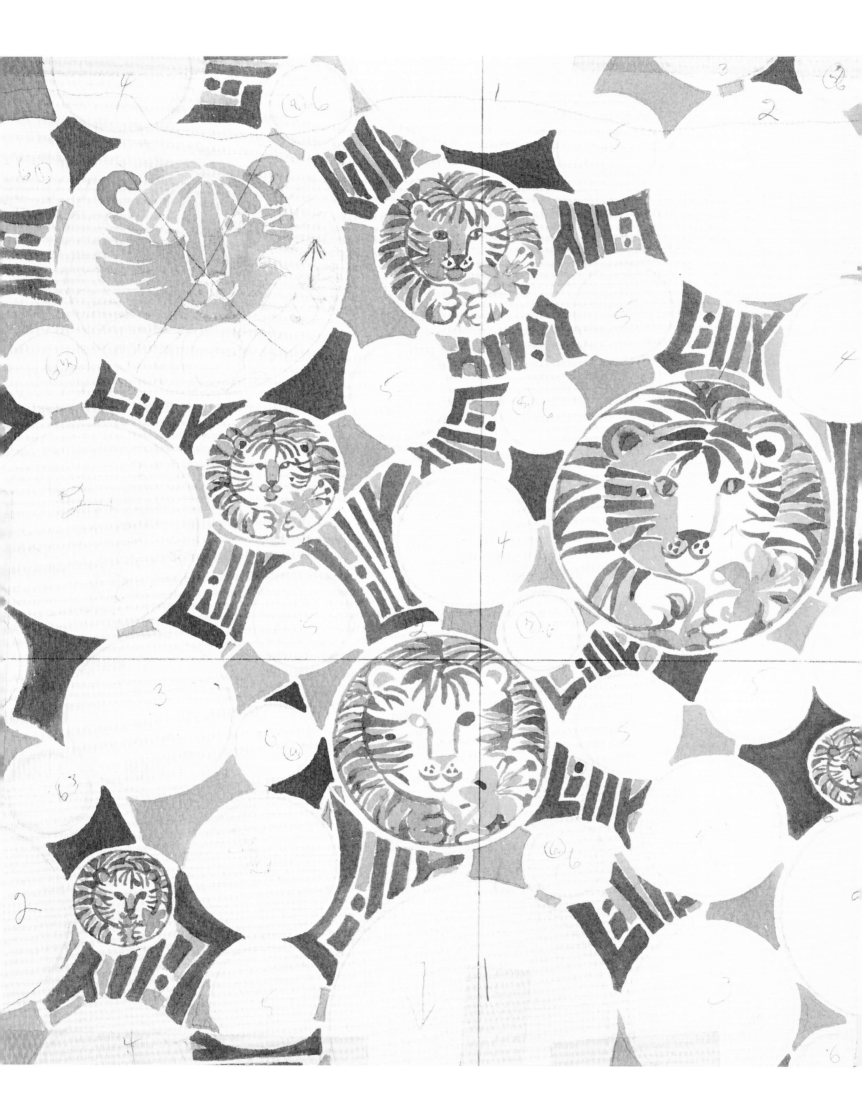

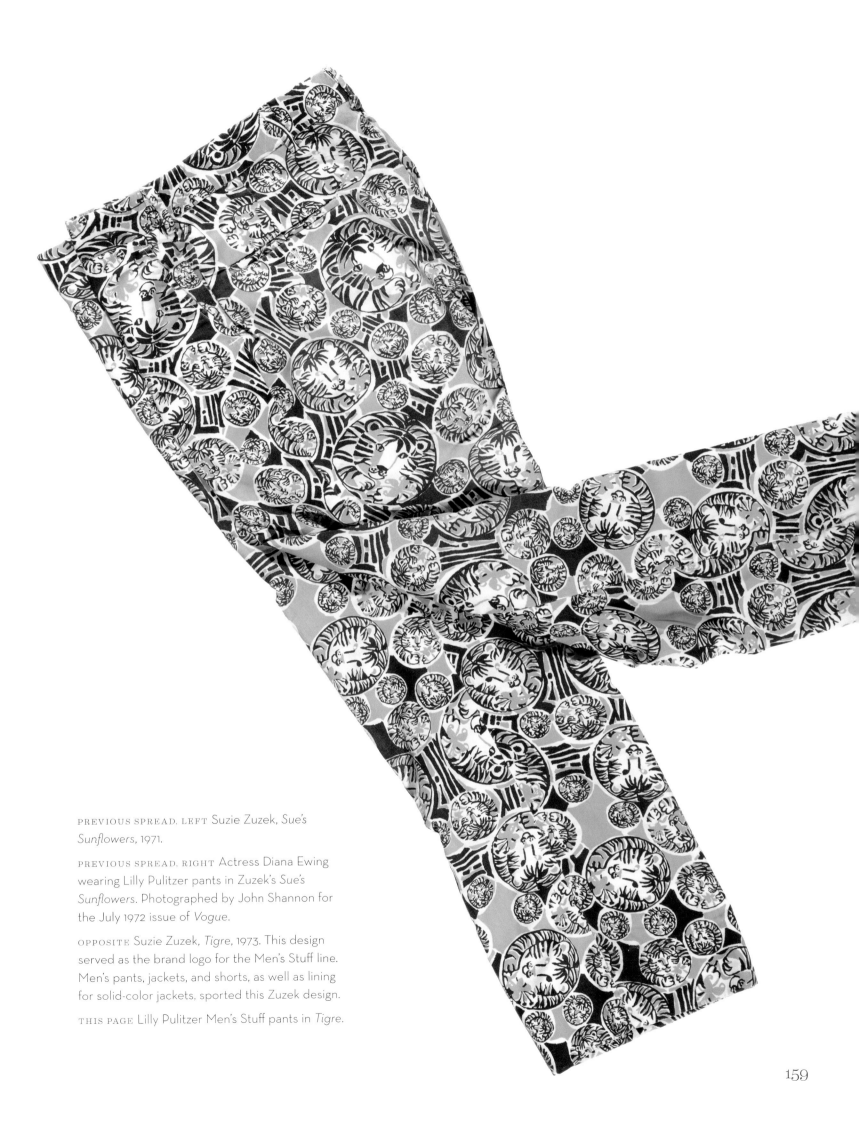

PREVIOUS SPREAD, LEFT Suzie Zuzek, *Sue's Sunflowers*, 1971.

PREVIOUS SPREAD, RIGHT Actress Diana Ewing wearing Lilly Pulitzer pants in Zuzek's *Sue's Sunflowers*. Photographed by John Shannon for the July 1972 issue of *Vogue*.

OPPOSITE Suzie Zuzek, *Tigre*, 1973. This design served as the brand logo for the Men's Stuff line. Men's pants, jackets, and shorts, as well as lining for solid-color jackets, sported this Zuzek design.

THIS PAGE Lilly Pulitzer Men's Stuff pants in *Tigre*.

159

ABOVE Lilly Pulitzer harem pants and top in Zuzek's *Lillies*. Photographed by Francesco
Scavullo for the May 1969 issue of *Harper's Bazaar*. The original caption reads:
"Wild flowers scrawled on pink cotton . . . ballooning into a parchment-crisp pantaloon.
The airy, sleeveless bodice traced in crossings of frail white batiste."

OPPOSITE Suzie Zuzek, *Lillies*, 1968.

160

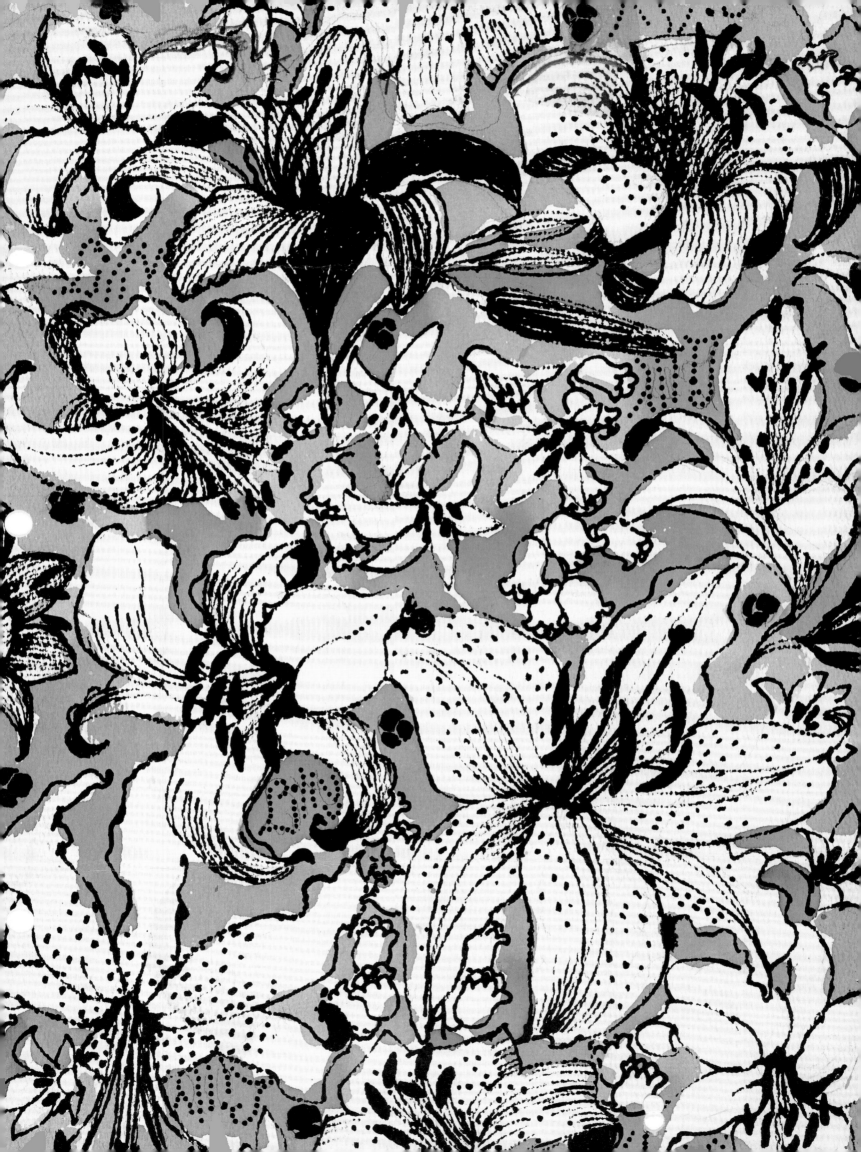

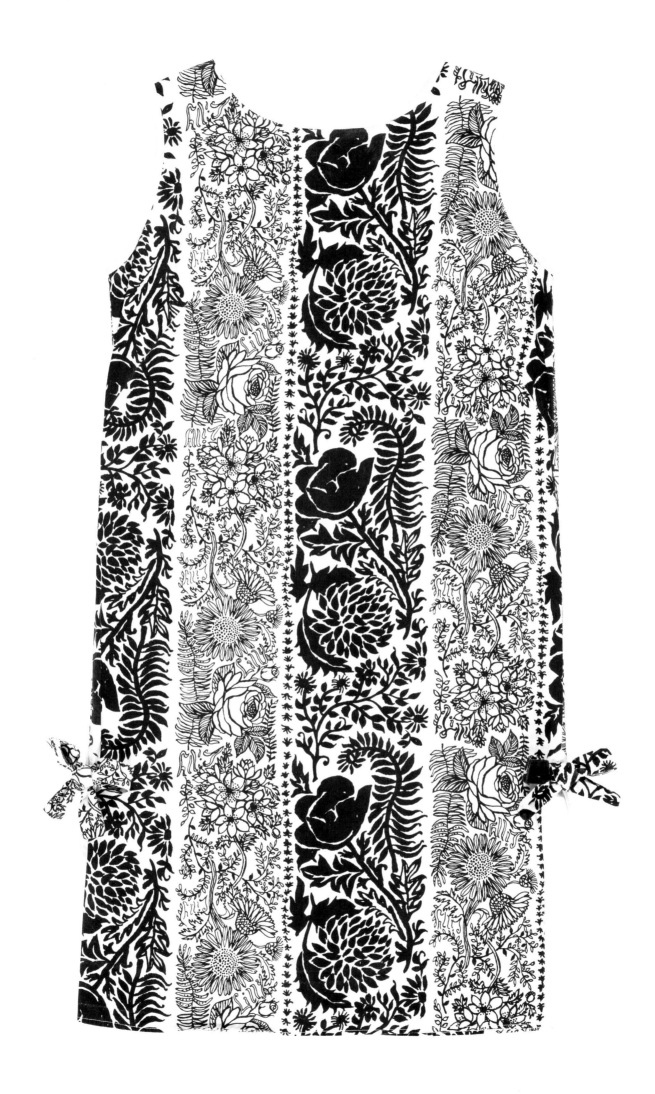

SUZIE ZUZEK FOR LILLY PULITZER

OPPOSITE Lilly Pulitzer shift in Zuzek's *Block Stripe*.

ABOVE Suzie Zuzek, *Block Stripe* textile swatches, 1965.

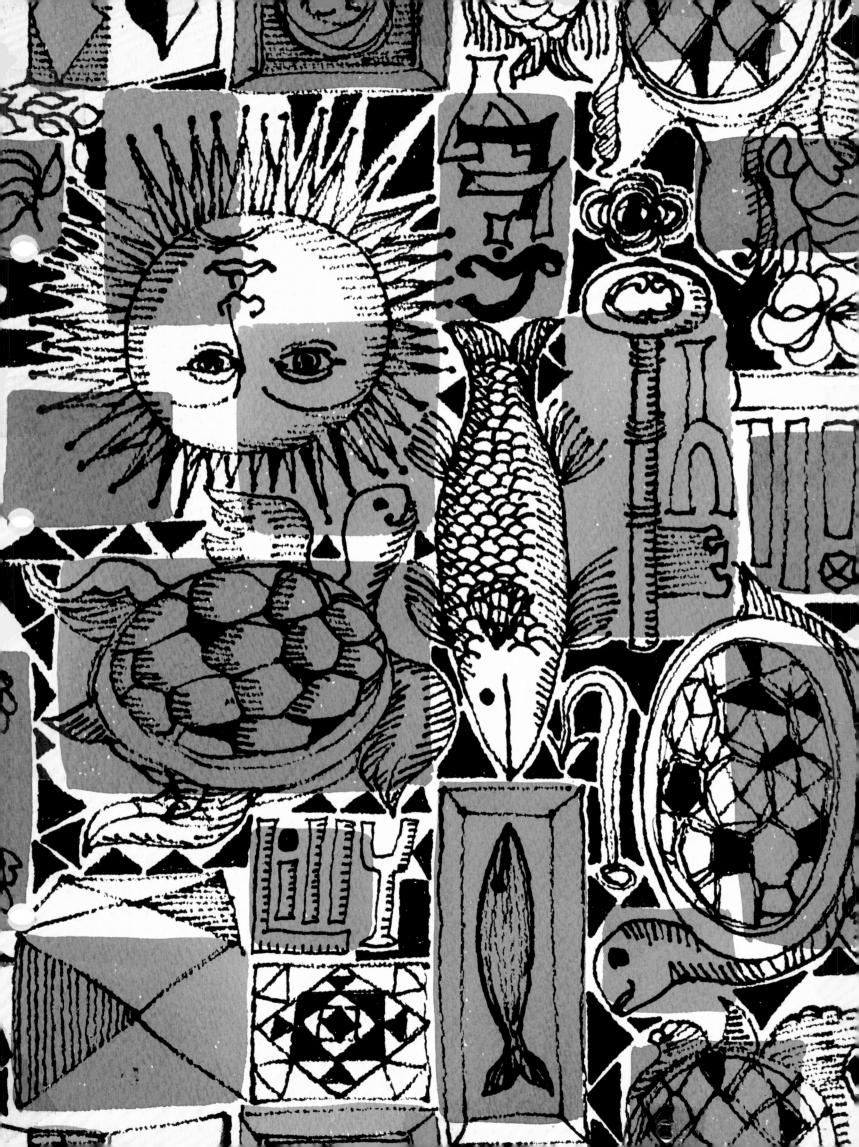

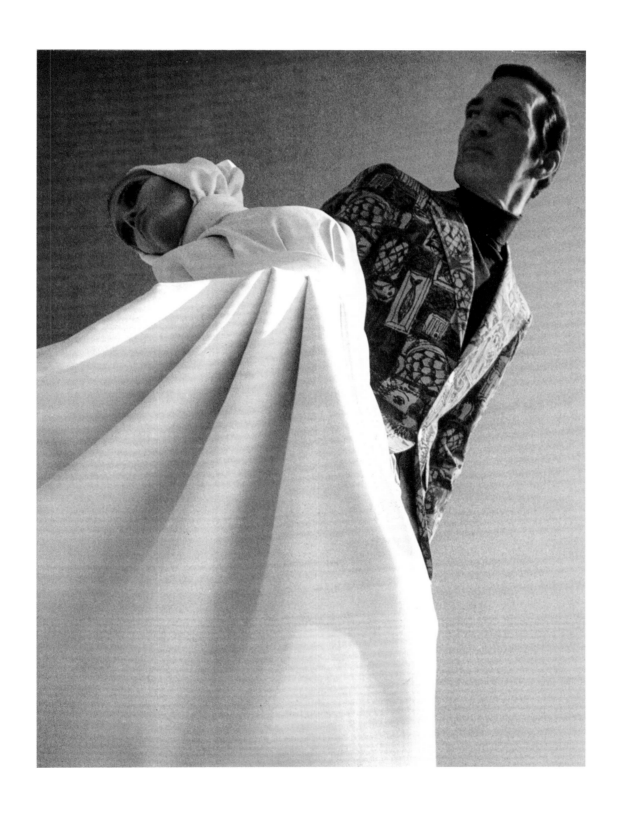

OPPOSITE Suzie Zuzek, *Harlillyquin*, 1968. The print was described in Lilly Pulitzer advertisements in 1969 as nonconformist, simmering, and sophisticated.

ABOVE Lilly Pulitzer men's jacket in Zuzek's *Harlillyquin*. This design was printed in forty-five different colorways on pima, on velvet, on canvas, and on corduroy. Photographed by Alan Ira Kaplan for the February 1969 issue of *Gentleman's Quarterly*.

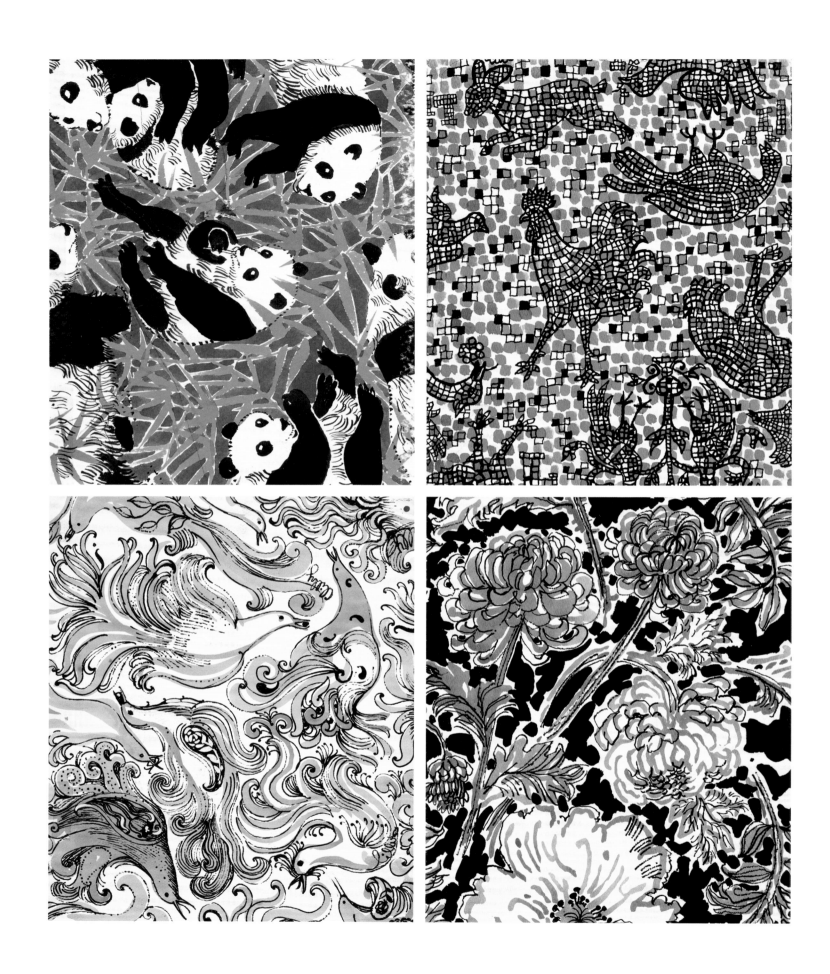

ABOVE, CLOCKWISE FROM TOP LEFT *Allen*, 1978; *San Marco Mosaic*, 1970;
Pop-Your-Lilly, 1968; and *Lilly-Birds*, 1967. All drawings by Suzie Zuzek.

OPPOSITE Suzie Zuzek, *Butter Lilly's No. 2*, 1966.

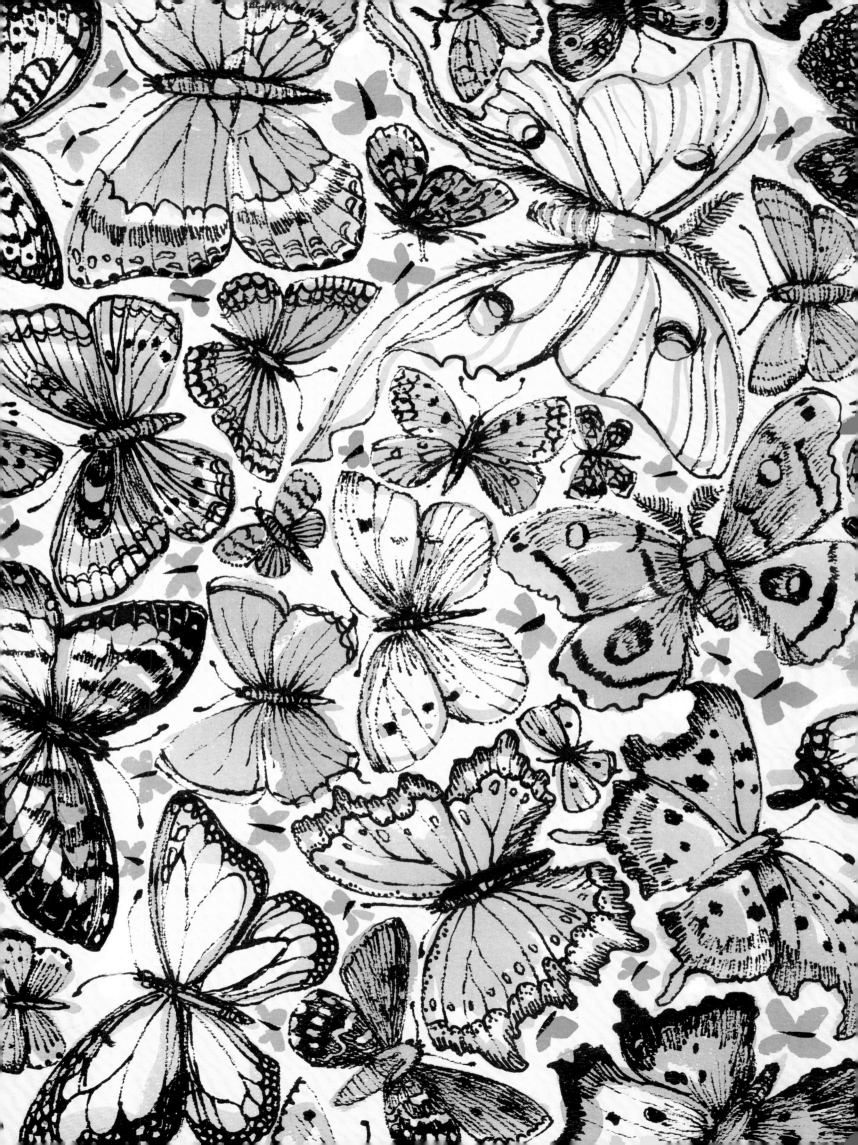

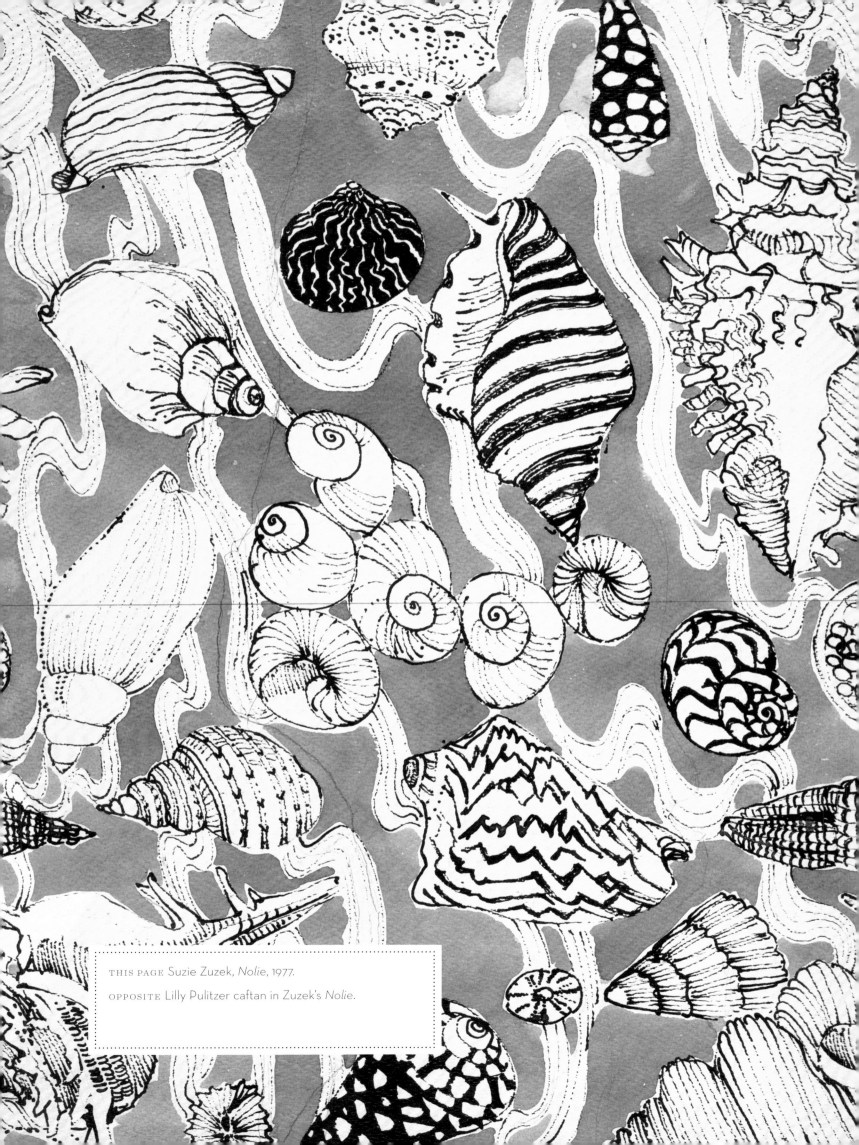

THIS PAGE Suzie Zuzek, *Nolie*, 1977.

OPPOSITE Lilly Pulitzer caftan in Zuzek's *Nolie*.

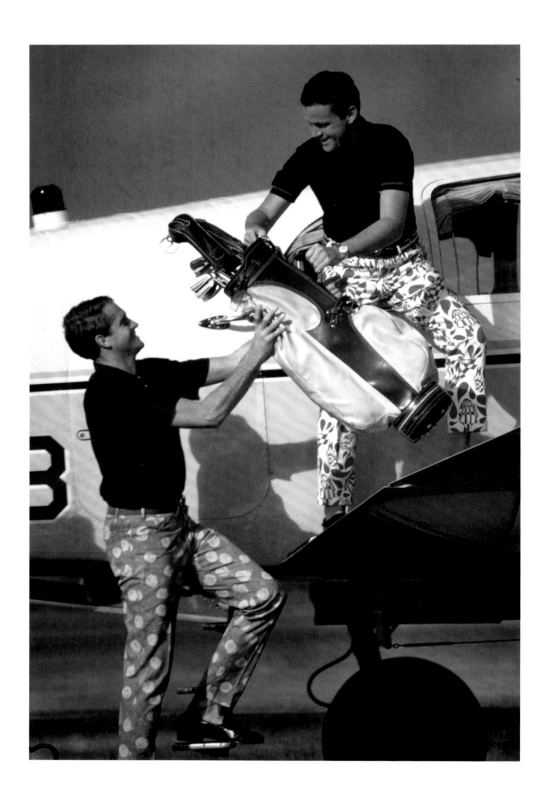

ABOVE Bob Leidy, on tarmac, wears PJs in Zuzek's *Lilly's Owls*; Phil Brady,
on the wing, wears PJs in Peter Pell's *Poisson a l'Armondo* (1967).
Photographed by Robert Phillips for the January 1968 issue of *Sports Illustrated*.

OPPOSITE Suzie Zuzek, *Lilly's Owls*, 1967. An overall polka-dot pattern is
cleverly combined with a linear drawing to create a print that can be read two ways—
as an abstract design or as a depiction of the wide-eyed birds.

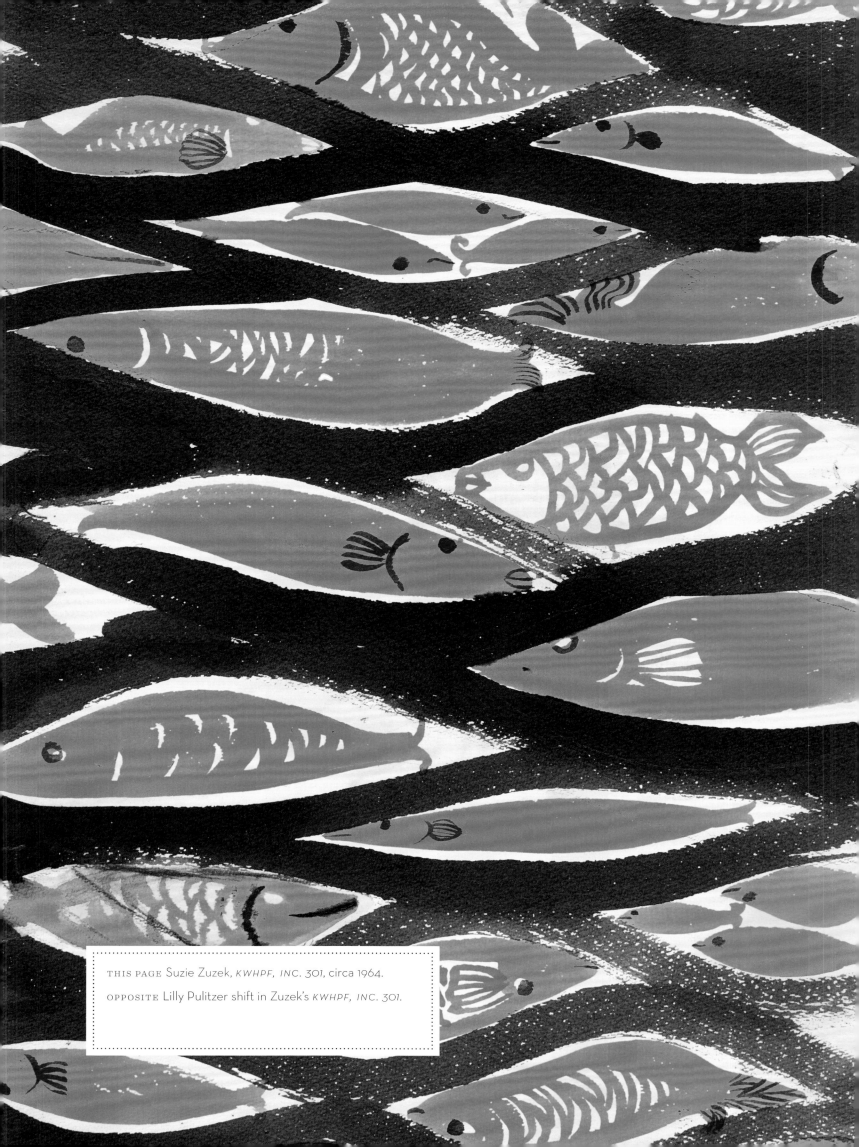

THIS PAGE Suzie Zuzek, *KWHPF, INC. 301*, circa 1964.

OPPOSITE Lilly Pulitzer shift in Zuzek's *KWHPF, INC. 301*.

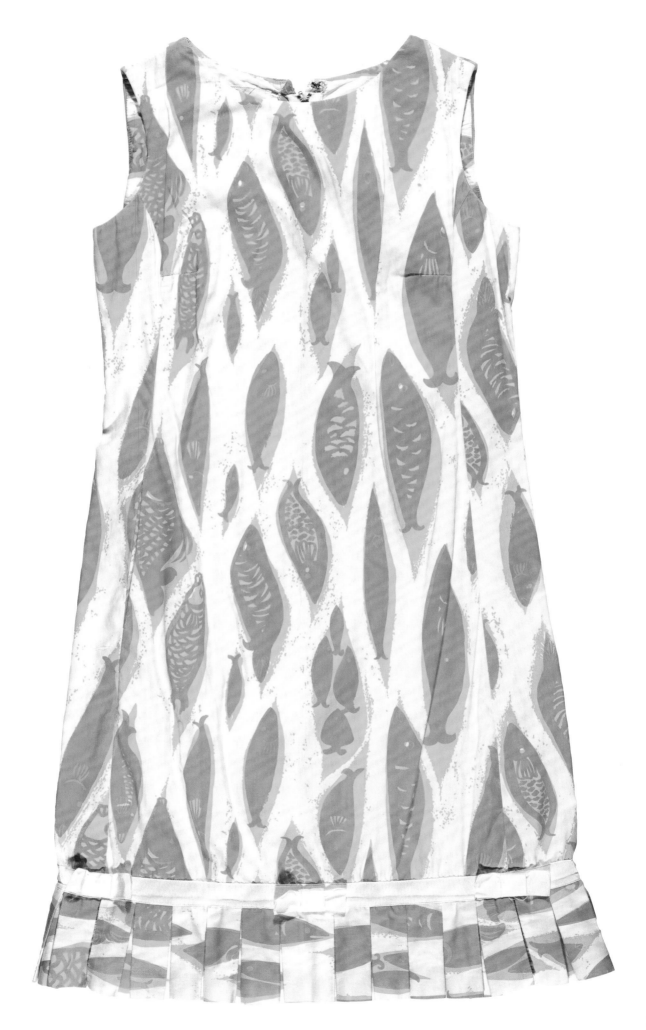

173

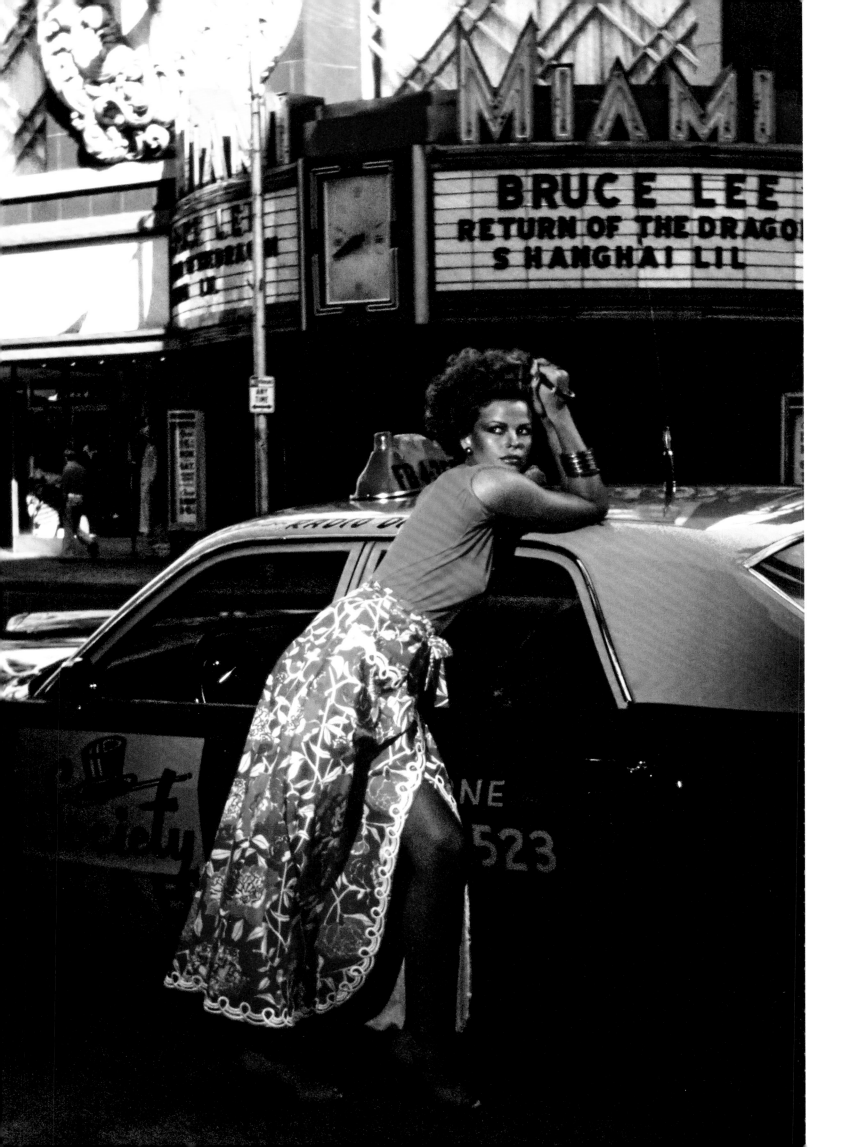

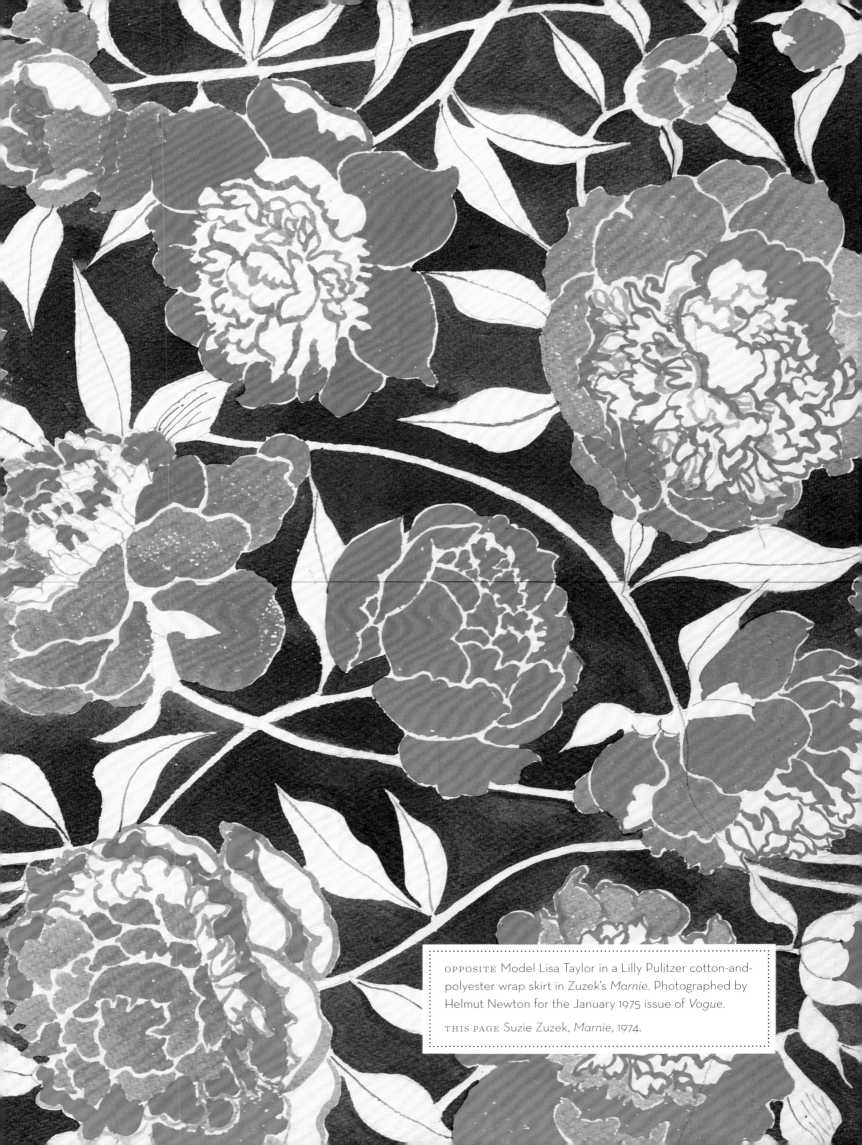

OPPOSITE Model Lisa Taylor in a Lilly Pulitzer cotton-and-polyester wrap skirt in Zuzek's *Marnie*. Photographed by Helmut Newton for the January 1975 issue of *Vogue*.

THIS PAGE Suzie Zuzek, *Marnie*, 1974.

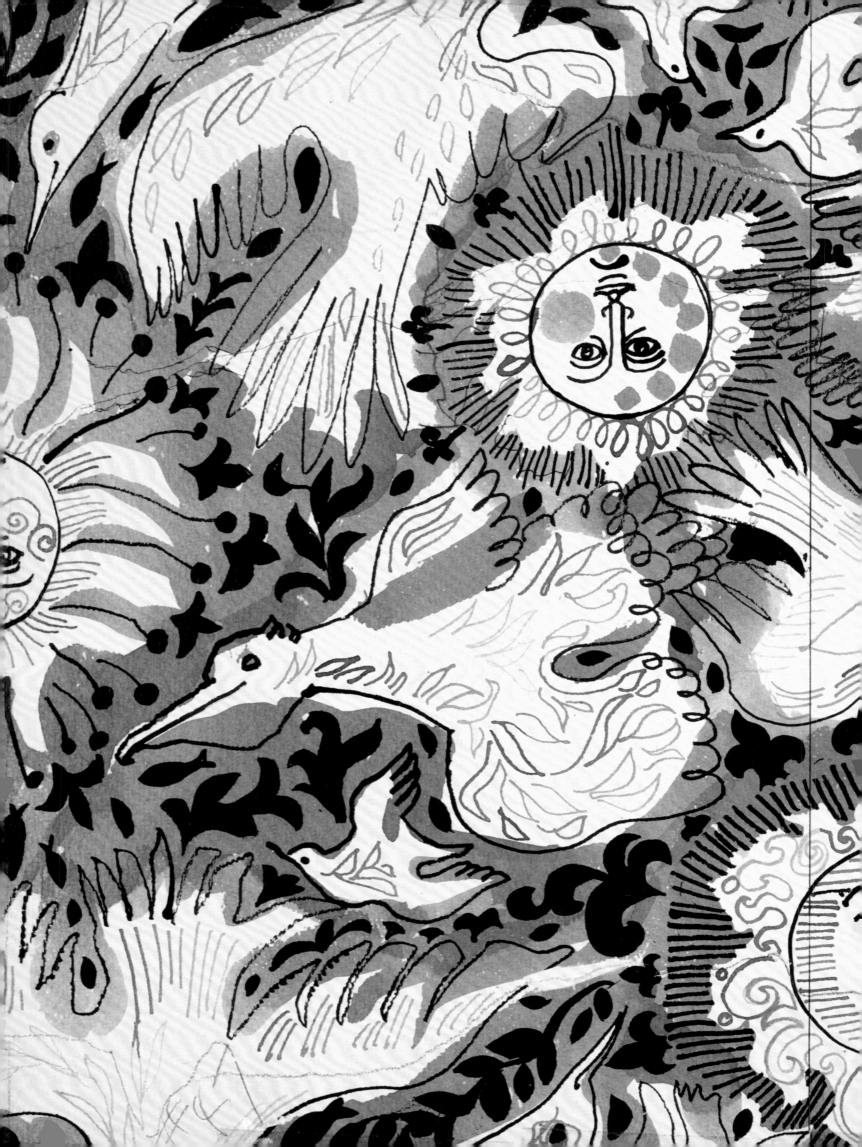

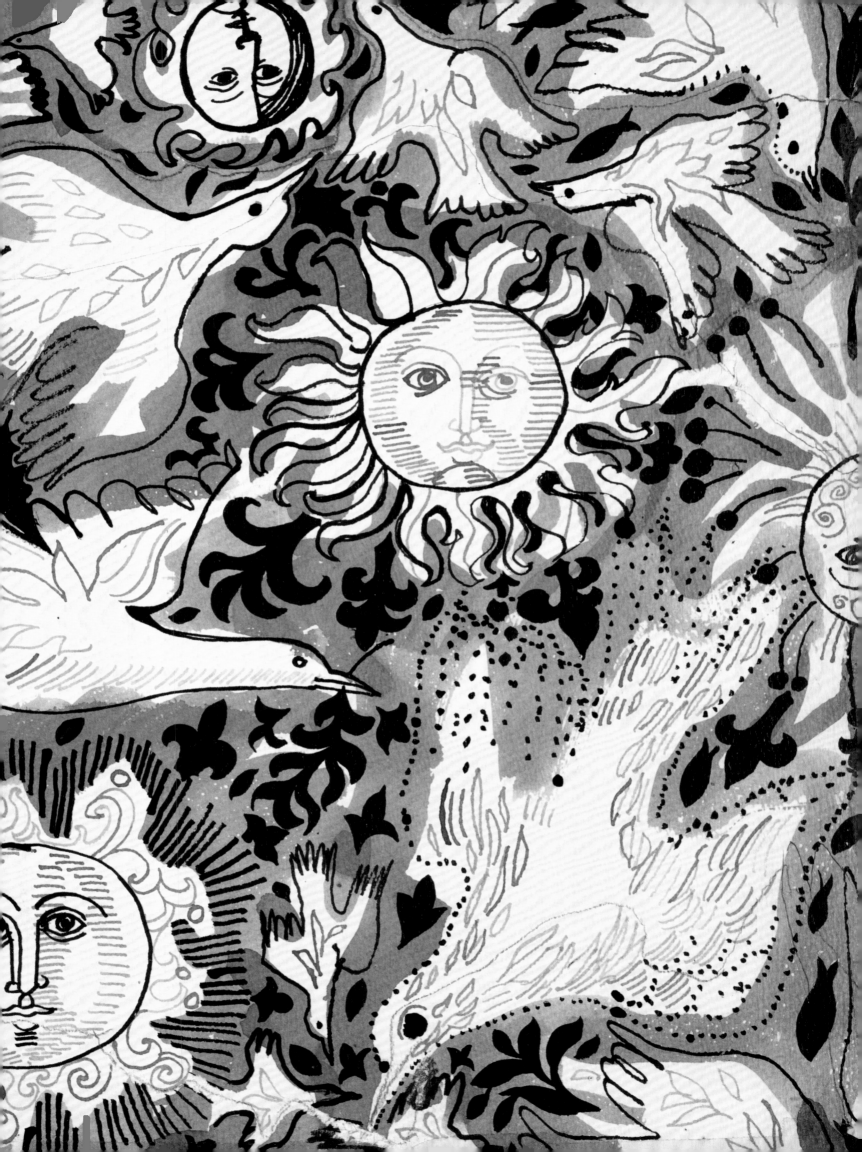

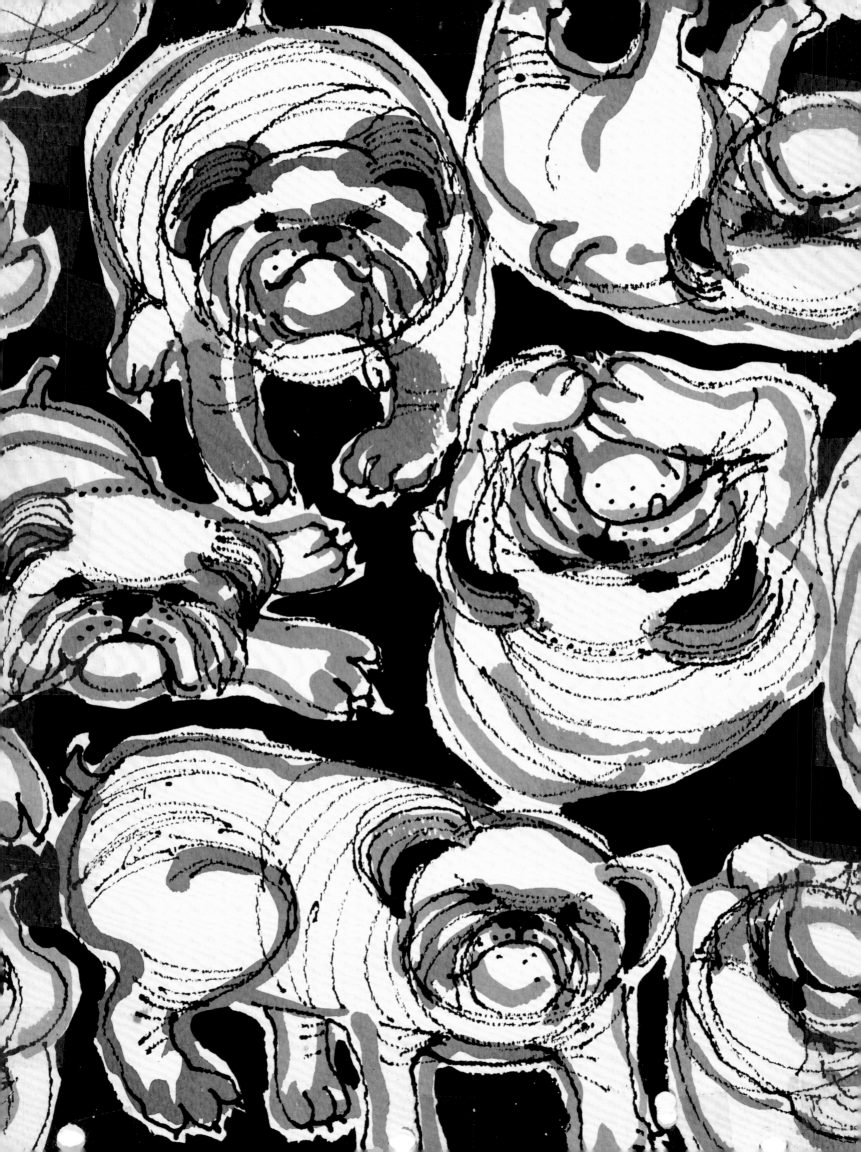

PREVIOUS SPREAD Suzie Zuzek, *Lilly Gulls*, 1972.

OPPOSITE Suzie Zuzek, *Bulldogs*, 1968. This design was printed in
twenty-three colorways, including a special order in turquoise, blue, and yellow
for the curtains at the Lilly Pulitzer shop in Southampton, New York.

ABOVE Donald Leas wears Lilly Pulitzer pants in Zuzek's *Bulldogs*. His wife is in a Lilly
Pulitzer caftan in Peter Pell's *Mumbletypell* (1967). Photographed by Slim Aarons, 1968.

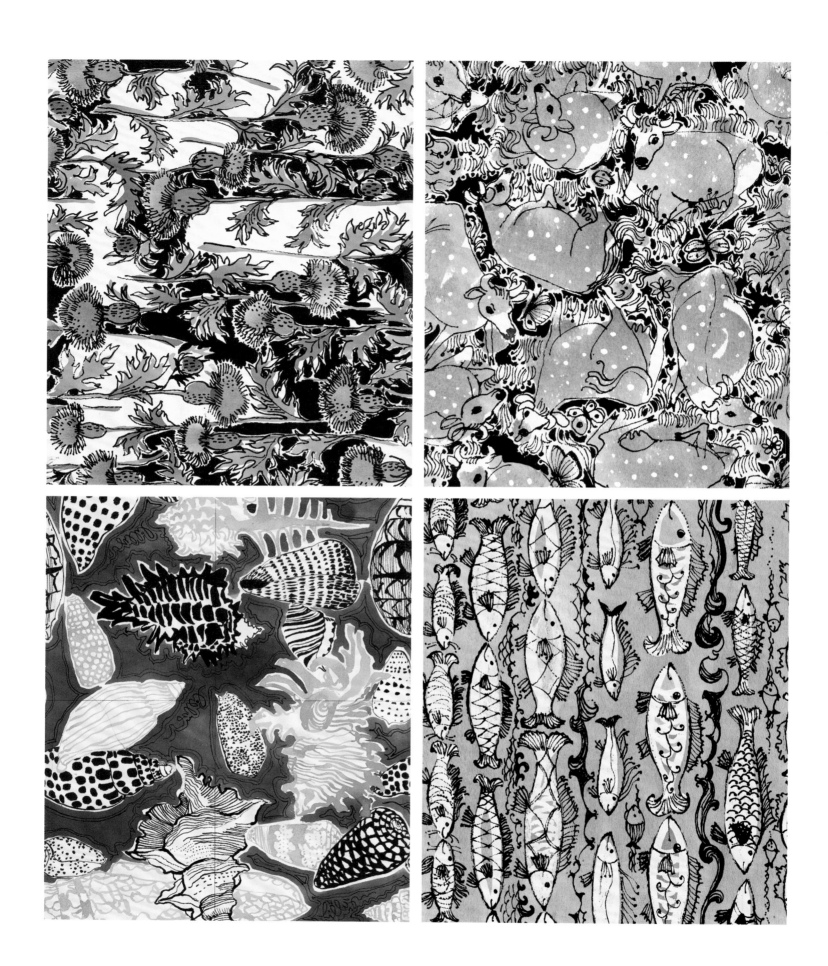

ABOVE, CLOCKWISE FROM TOP LEFT *Thistle Lilly*, 1968; *I Never Saw a Purple Cow*, 1969; *Pescados*, 1966; and *Lilly Shells*, 1972. All drawings by Suzie Zuzek.

OPPOSITE Suzie Zuzek, *Zodiac*, 1969.

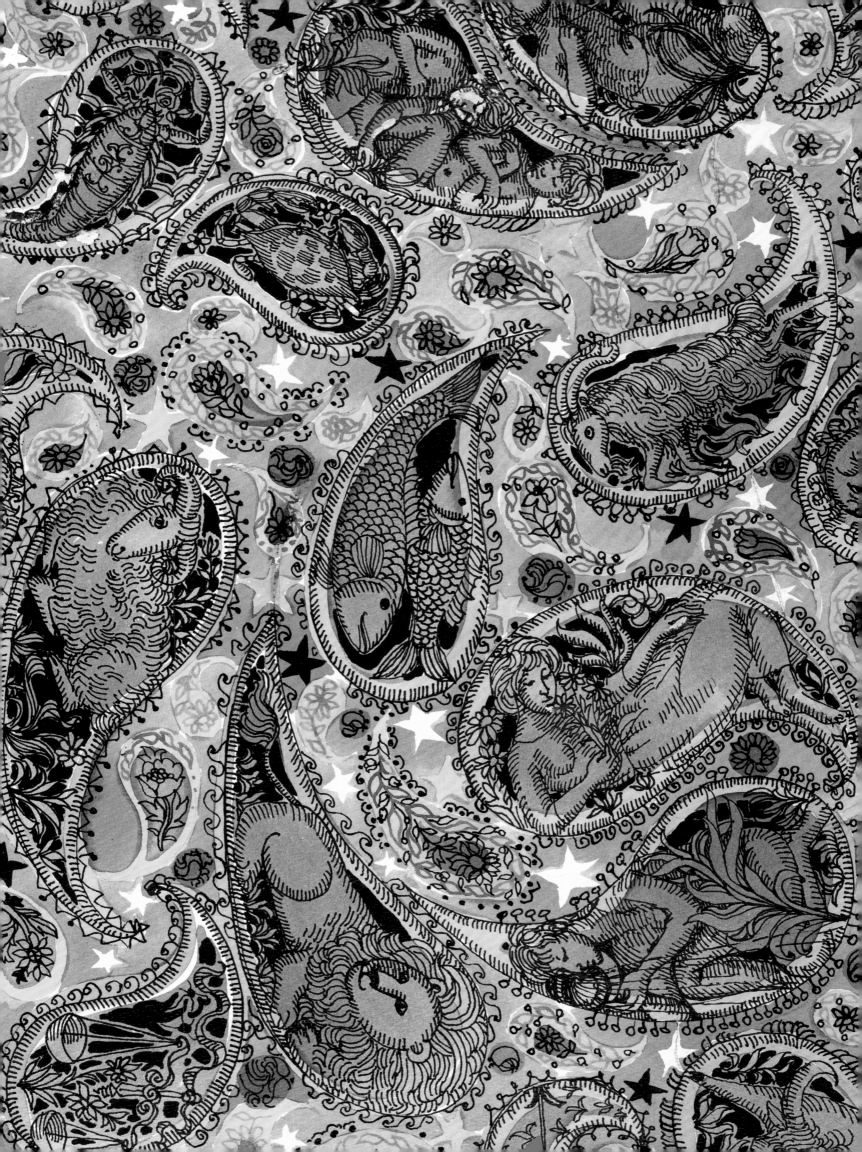

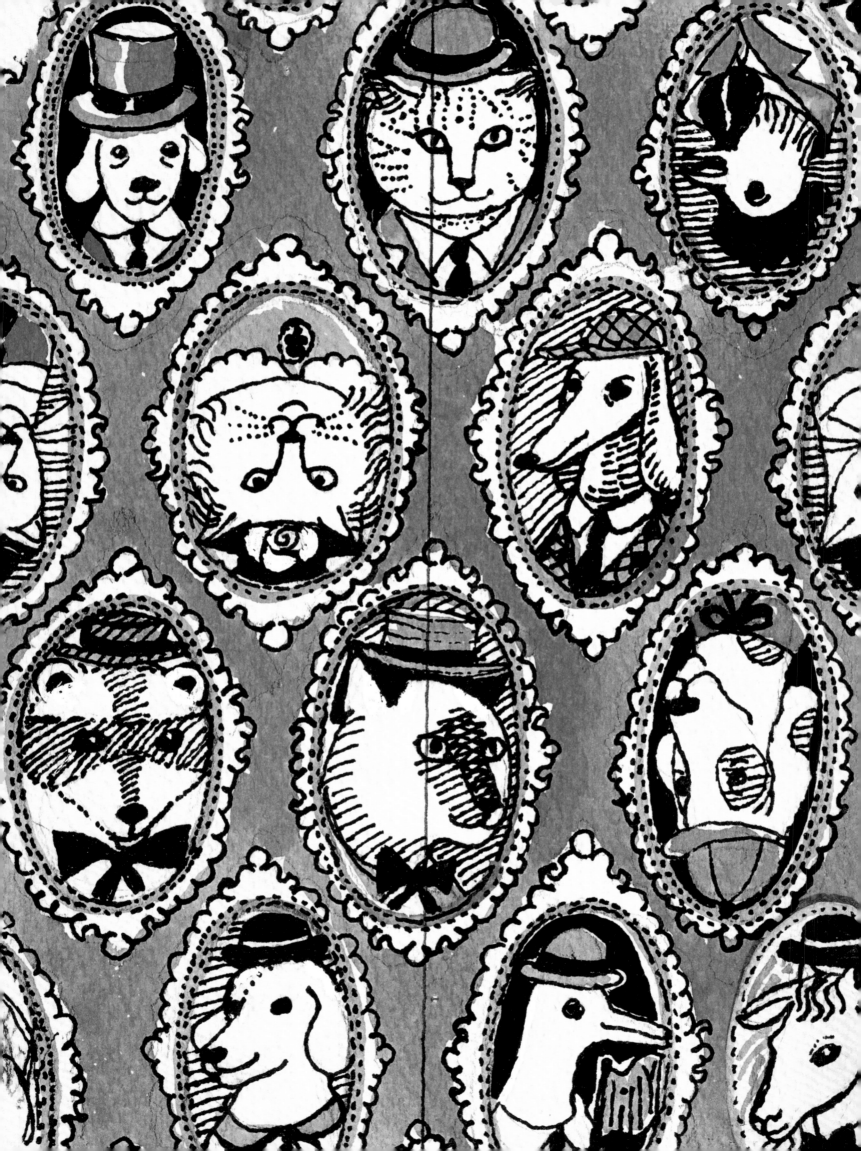

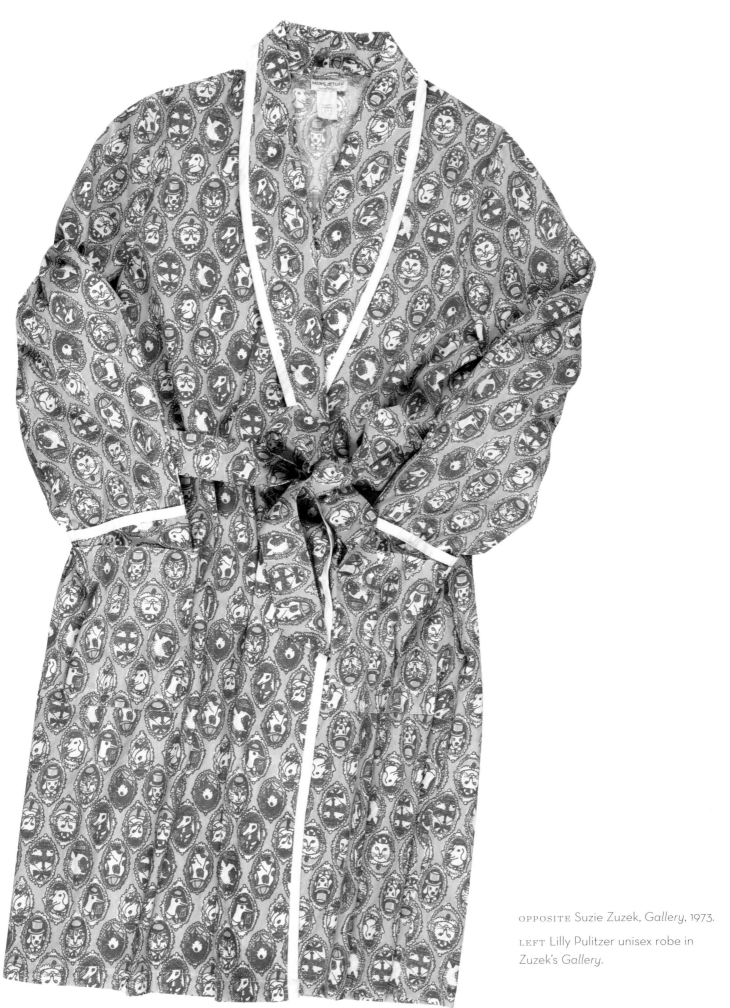

OPPOSITE Suzie Zuzek, *Gallery*, 1973.

LEFT Lilly Pulitzer unisex robe in
Zuzek's *Gallery*.

183

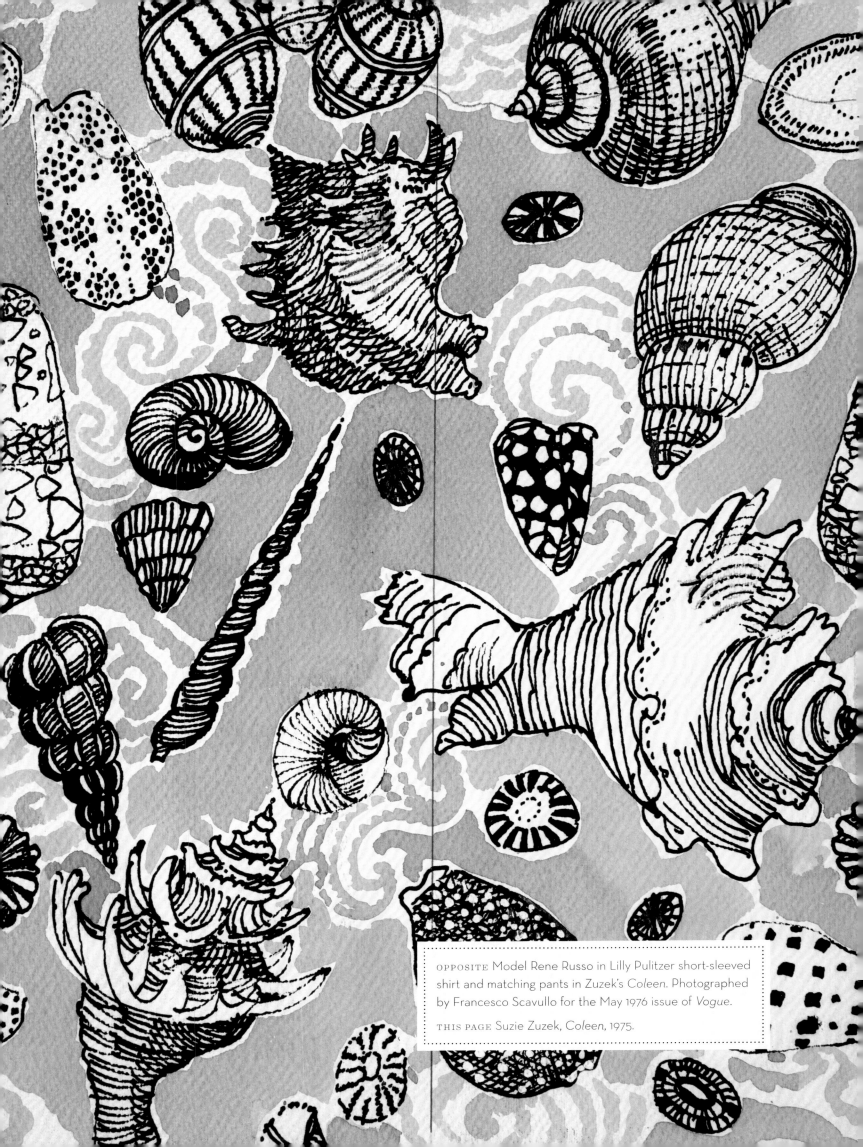

OPPOSITE Model Rene Russo in Lilly Pulitzer short-sleeved shirt and matching pants in Zuzek's *Coleen*. Photographed by Francesco Scavullo for the May 1976 issue of *Vogue*.

THIS PAGE Suzie Zuzek, *Coleen*, 1975.

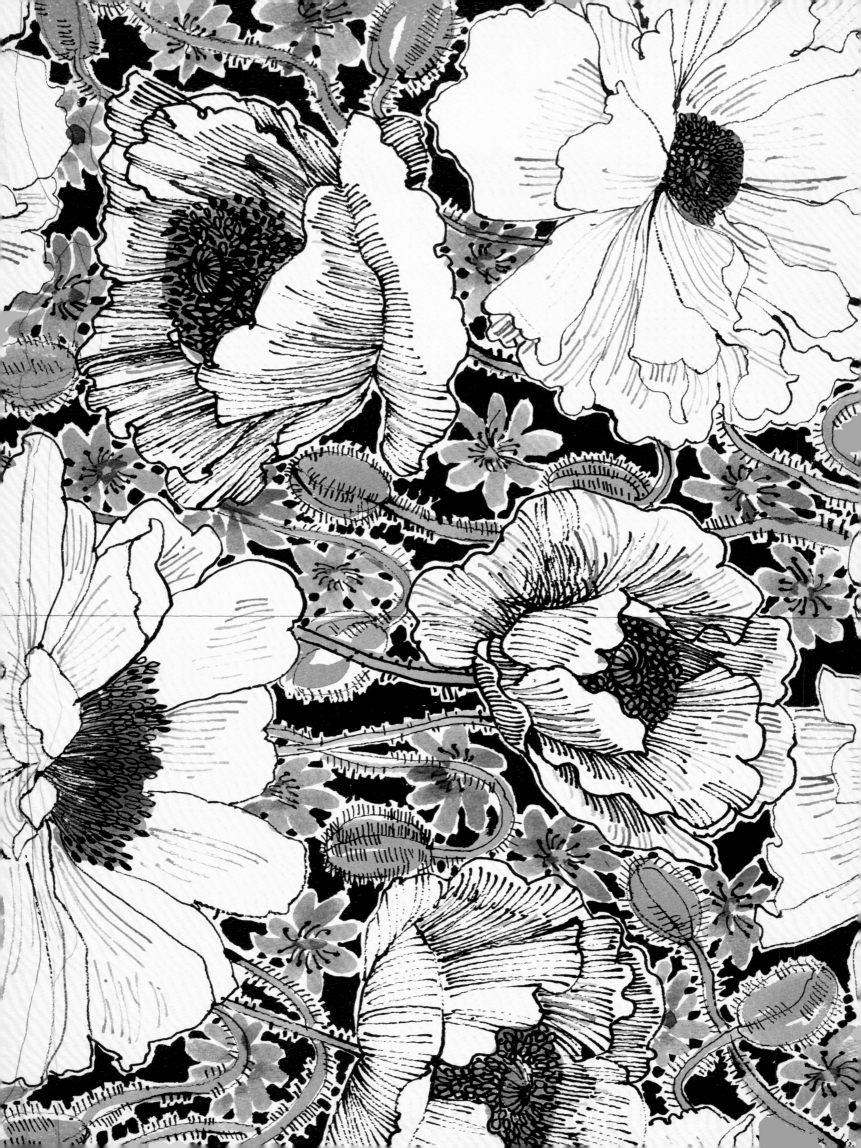

OPPOSITE Suzie Zuzek, *Poppyland*, 1971.

THIS PAGE Lilly Pulitzer skirt (front and back) in Zuzek's *Poppyland*.

FOLLOWING SPREAD, LEFT Suzie Zuzek, *Hi-Lowes*, 1971. Zuzek never visited Africa, but she studied animal life in such books as *Nature's Paradise: Africa* (1967) by Jen and Des Bartlett.

FOLLOWING SPREAD, RIGHT Suzie Zuzek, *Isabelle*, 1971.

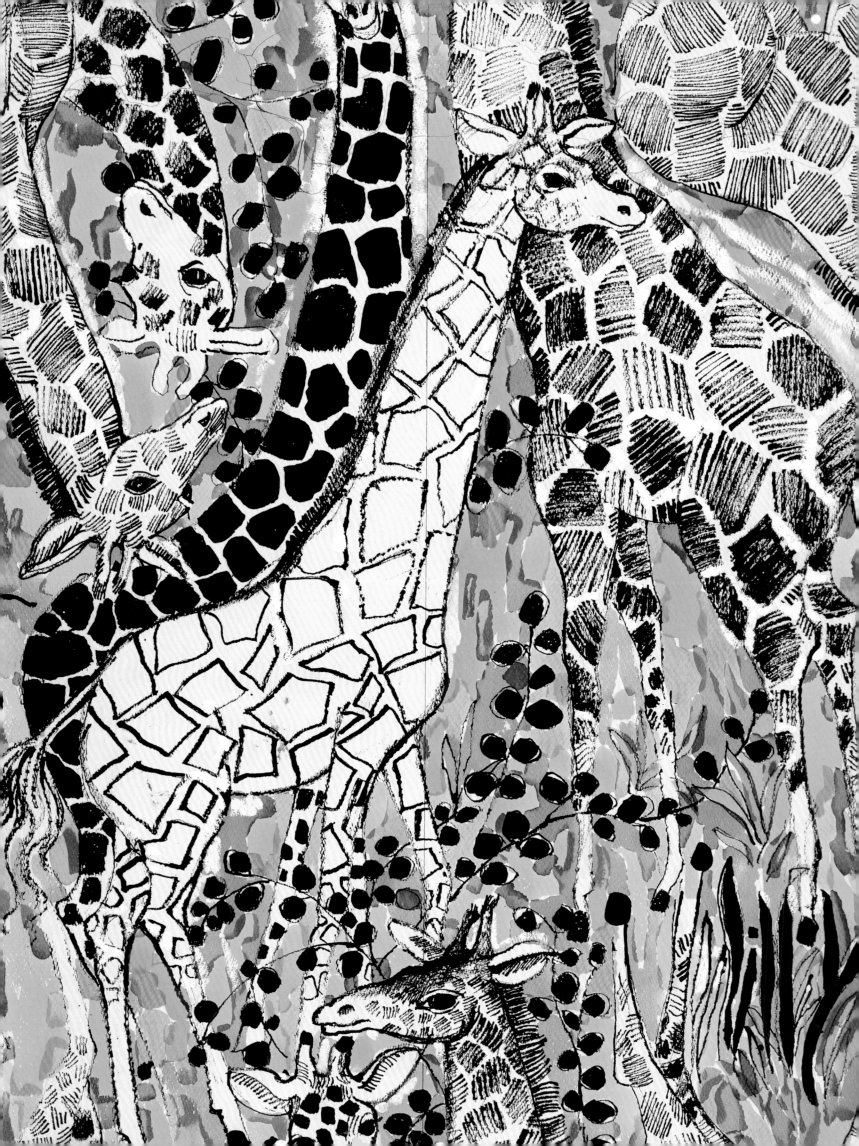

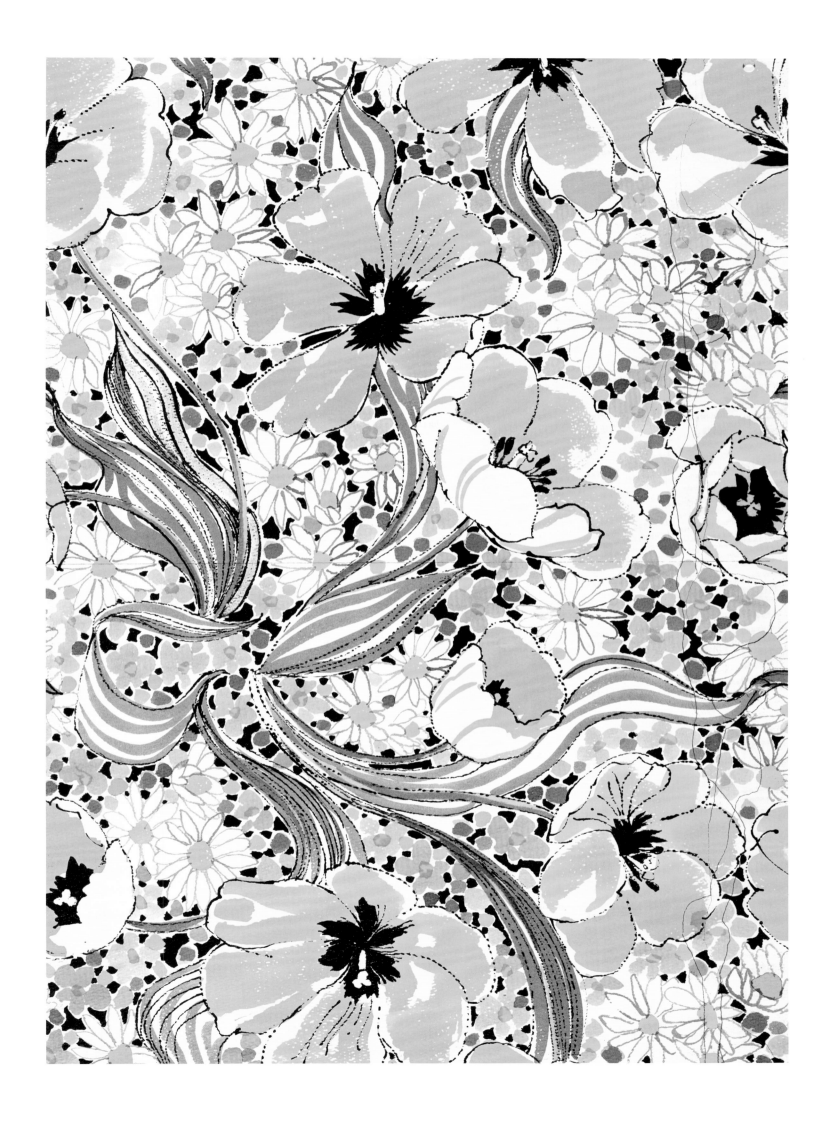

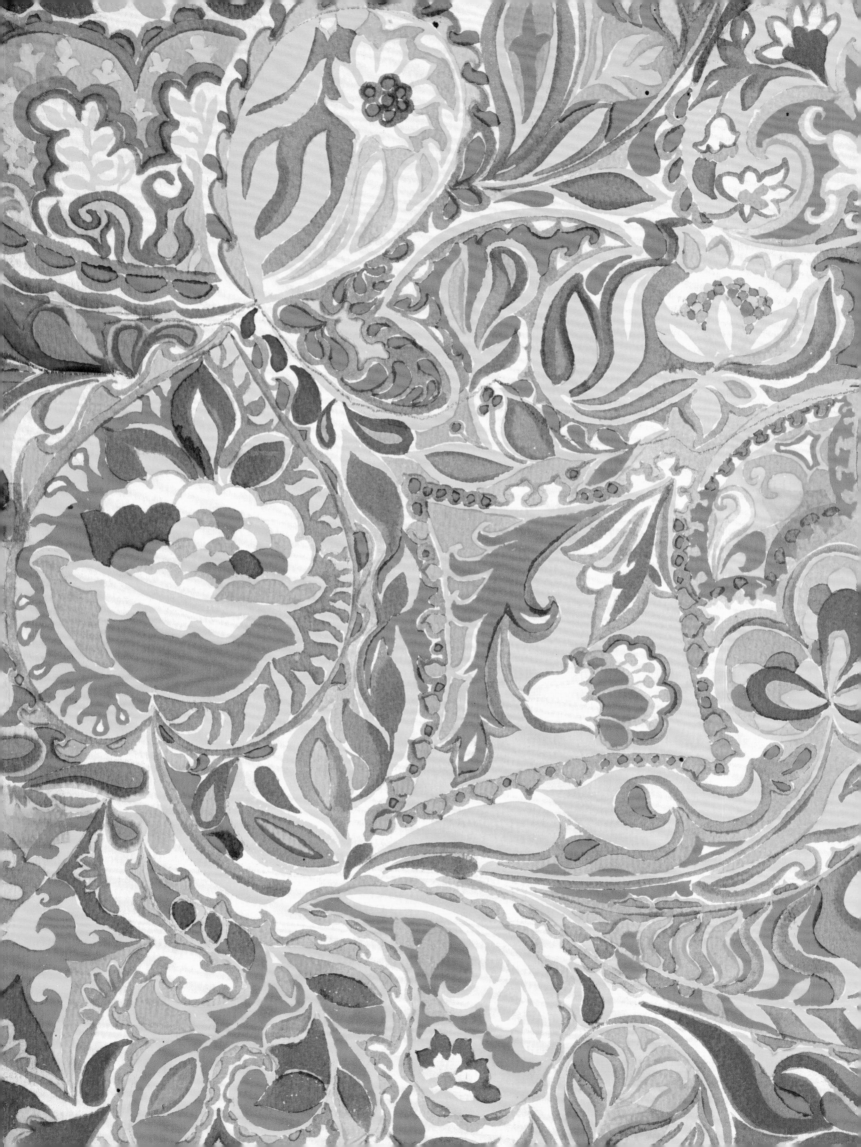

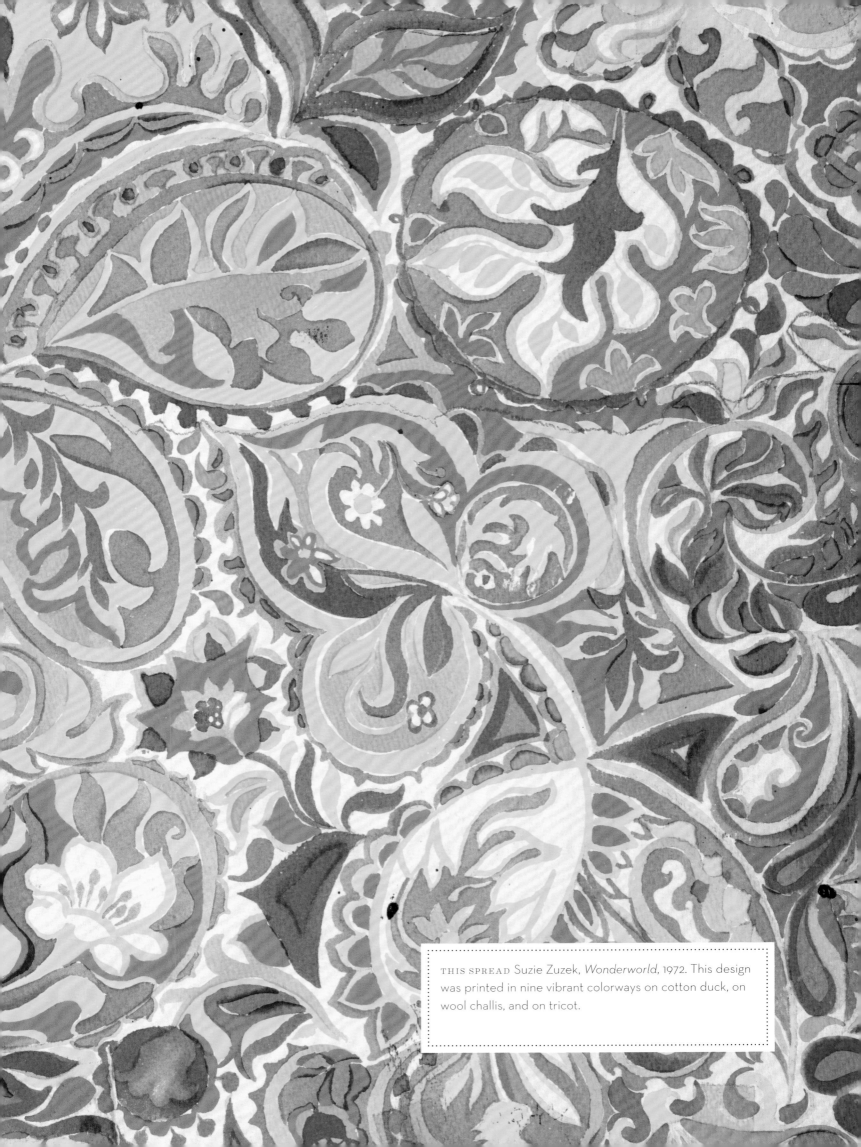

THIS SPREAD Suzie Zuzek, *Wonderworld*, 1972. This design was printed in nine vibrant colorways on cotton duck, on wool challis, and on tricot.

INDEX OF WORKS

Coquette, 1974. Brush and watercolor, pen and black ink, graphite on paper, 38.1 × 55.9 cm (15 × 22 in.). (149)

Borderline, 1970. Brush and watercolor, pen and black ink, graphite on paper, 76.2 × 78.7 cm (30 × 31 in.). (151)

Doggy, 1976. Twenty-one fabric samples printed on cotton, tricot knit, and ultressa polyester. (153)

Sweet Corn, 1972. Brush and watercolor, pen, graphite on paper, 27.9 × 38.1 cm (11 × 15 in.). (154)

Squash, 1972. Brush and watercolor, pen and black ink, graphite on paper, 38.1 × 55.9 cm (15 × 22 in.). (155)

Sour Sop, 1973. Brush and watercolor, pen and black ink, on paper, 27.9 × 38.1 cm (11 × 15 in.). (155)

Cole Slaw, 1972. Brush and watercolor, graphite on paper, 38.1 × 55.9 cm (15 × 22 in.). (155)

Beets, 1972. Brush and watercolor, pen and black ink, graphite on paper, 27.9 × 38.1 cm (11 × 15 in.). (155)

Sue's Sunflowers, 1971. Brush and watercolor, pen and black ink, graphite on paper, 55.9 × 76.2 cm (22 × 30 in.). (156)

Tigre, 1973. Brush and watercolor, pen, graphite on paper, 27.9 × 31.8 cm (11 × 12½ in.). (158)

Lillies, 1968. Brush and watercolor, pen and black ink, graphite on paper, 27.9 × 38.1 cm (11 × 15 in.). (161)

Block Stripe, 1965. Ten fabric samples printed on cotton. (163)

Harlillyquin, 1968. Brush and watercolor, pen and black ink on paper, 27.9 × 38.1 cm (11 × 15 in.). (164)

Allen, 1978. Brush and watercolor, pen and black ink, graphite on paper, 19.1 × 27.9 cm (7½ × 11 in.). (166)

San Marco Mosaic, 1970. Brush and watercolor, pen and black ink on paper, 27.9 × 38.1 cm (11 × 15 in.). (166)

Pop-Your-Lilly, 1968. Brush and watercolor, pen and black ink on paper, 27.9 × 38.1 cm (11 × 15 in.). (166)

Lilly-Birds, 1967. Brush and watercolor, white gouache, pen and black ink on paper, 38.1 × 55.9 cm (15 × 22 in.). (166)

Butter Lilly's No.2, 1966. Brush and watercolor, white gouache, pen and black ink on paper, 38.1 × 55.9 cm (15 × 22 in.). (167)

Nolie, 1977. Brush and watercolor, pen and black ink, graphite on paper, 38.1 × 55.9 cm (15 × 22 in.). (168)

Lilly's Owls, 1967. Brush and watercolor, pen and black ink on paper, 27.9 × 38.1 cm (11 × 15 in.). (171)

KWHPF, INC. 301, circa 1964. Brush and watercolor on paper, 38.1 × 55.9 cm (15 × 22 in.). (172)

Marnie, 1974. Brush and watercolor, pen and black ink on paper, 38.1 × 55.9 cm (15 × 22 in.). (175)

Lilly Gulls, 1972. Brush and watercolor, pen and black ink, graphite on paper, 38.1 × 55.9 cm (15 × 22 in.). (176–177)

Bulldogs, 1968. Brush and watercolor, pen and black ink, graphite on paper, 27.9 × 38.1 cm (11 × 15 in.). (178)

Thistle Lilly, 1968. Brush and watercolor, pen and black ink, graphite on paper, 38.1 × 55.9 cm (15 × 22 in.). (180)

I Never Saw A Purple Cow, 1969. Brush and watercolor, pen and black ink, 27.9 × 38.1 cm (11 × 15 in.). (180)

Pescados, 1966. Brush and watercolor, pen and black ink on paper, 27.9 × 38.1 cm (11 × 15 in.). (180)

Lilly Shells, 1972. Brush and watercolor, pen and black ink, graphite on paper, 38.1 × 55.9 cm (15 × 22 in.). (180)

Zodiac, 1969. Brush and watercolor, pen and black ink, graphite on paper, 38.1 × 55.9 cm (15 × 22 in.). (181)

Gallery, 1973. Brush and watercolor, white gouache, pen and black ink, graphite on paper, 22.9 × 37.5 cm (9 × 14¾ in.). (182)

Coleen, 1975. Brush and watercolor, pen and black ink, graphite on paper, 27.9 × 38.1 cm (11 × 15 in.). (185)

Poppyland, 1971. Brush and watercolor, pen and black ink, graphite on paper, 38.1 × 55.9 cm (15 × 22 in.). (186)

Hi-Lowes, 1971. Brush and watercolor, white gouache, pen and black ink, graphite on paper, 55.9 × 76.2 cm (22 × 30 in.). (188)

Isabelle, 1971. Brush and watercolor, pen and black ink, graphite on paper, 38.1 × 55.9 cm (15 × 22 in.). (189)

Wonderworld, 1972. Brush and watercolor, graphite on paper, 38.1 × 55.9 cm (15 × 22 in.). (190–191)

Kiki's Karnival, 1967. Brush and watercolor on paper, 27.9 × 38.1 cm (11 × 15 in.). (196)

Peace, 1969. Pen and black ink on paper, 12.7 × 17.8 cm (5 × 7 in.). (199)

OPPOSITE Lilly Pulitzer women's top and pants in Zuzek's *Ponchita's Petunias* (1967), which is one of five of the artist's designs on Lilly Pulitzer garments in the permanent collection of the Metropolitan Museum of Art, The Costume Institute.

ENDNOTES

WILDNESS

1 Patti Bond, "Building the Lilly," *Women's Wear Daily*, May 2005.

2 Anne Steinert, "How Lilly Turned a Dress into a Business," *New York Journal-American*, October 5, 1962.

3 Peter Chew, "Consider the Lillies and How They Grew," *The National Observer* vol. 4, no. 10, March 8, 1965.

4 Margaret Warrington, "Goodbye to Broadway's a Hello for Hit Fabric," *Miami News*, December 14, 1962.

5 Bud Jacobson, "30 Years Young This Year," *Solares Hill*, circa 1981.

6 Suzie Zuzek, interview by Marcela Morgan, unpublished video recording, 2003.

7 "The Amazing Zuzek," Key West Custom House Newsletter, circa 2001.

8 Florida Development Commission, "Tropics Magic Captured at Key West," October 1966.

9 Bud Jacobson, "30 Years Young This Year," *Solares Hill*, ca. 1981.

10 Peggy Poor, "Behind the Silk Screen," *Orlando Sentinel Florida Magazine*, March 3, 1968.

11 See, for example, Peggy Poor, "Behind the Silk Screen," *Orlando Sentinel Florida Magazine*, March 3, 1968: Betty Williams, "Key West Hand Print's rags to riches story," *The Key West Citizen*, January 29, 1984: Bud Jacobson, "30 Years Young This Year," *Solares Hill*, ca. 1981.

12 Personal interview with Robert McKenzie, conducted in Key West, Florida, February 11, 2019. With special thanks throughout to former Key West Hand Print Fabrics employees Martha de Poo, Leigh Martin Hooten, June Klausing, Robert McKenzie, and Jacq Staubs for sharing their memories and insights about the company and Suzie Zuzek.

13 See, for example, Peggy Poor, "Behind the Silk Screen," *Orlando Sentinel Florida Magazine*, March 3, 1968: Betty Williams, "Key West Hand Print's rags to riches story," *The Key West Citizen*, January 29, 1984: Bud Jacobson "30 Years Young This Year," *Solares Hill*, circa 1981.

14 Peter Chew, "Consider the Lillies and How They Grew," *The National Observer* vol. 4, no. 10, March 8, 1965.

15 William H. Honan, "Claiborne Pell, Patrician Senator Behind College Grant Program, Dies at 90," *The New York Times*, January 1, 2009.

16 Jim Russell was James Rousseau's stage name.

17 Telephone interview with Jacq Staubs, July 9, 2019.

18 Ann Smith, "Give Local Designers a Hand, 'Lilly' Has Her Eye on 'em," *Miami Herald*, April 28, 1966.

19 Beverly Wilson, "Fresh from the Oven: See What's Cookin' in Hot New Fashion," *Miami Herald*, March 1, 1964.

20 "Key West Fabrics gains national attention," *The Key West Citizen*, November 20, 1966.

21 Personal interview with Robert McKenzie, conducted in Key West, Florida, February 11, 2019.

22 Joan Nielsen McHale, "Key West hand print fabrics are known all over the world," *Miami News*, January 19, 1970.

23 "New Uniforms Will Brighten Sunshine State," *Melbourne Times*, February 4, 1970.

24 Personal interview with June Klausing, conducted in Key West, Florida, February 12, 2019.

25 Suzie Zuzek, interview by Marcela Morgan, unpublished video recording, 2003.

26 The Unicorn Tapestries, South Netherlandish, 1495–1505, Gift of John D. Rockefeller Jr., Metropolitan Museum of Art 37.80.1-6 and 38.51.1,2.

27 Personal interview with Martha de Poo, conducted in Key West, Florida, February 11, 2019.

28 Personal interview with Leigh Martin Hooten, conducted in Key West, Florida, February 11, 2019.

29 "US Court Backs Dress Firm Ruling," *Miami Herald*, August 24, 1967. The lower court's decision stating that Serbin, Inc. had unlawfully copied the designs was later upheld by the Fifth District Court of Appeals, with the defendant Serbin Inc. ultimately having to pay $40,000 in damages and court costs.

30 Even after Lilly Pulitzer, Inc. purchased a controlling share in the screen-printing company in 1980, new designs continued to be copyrighted under Key West Hand Print Fabrics, Inc.

31 Personal interview with Martha de Poo and Leigh Martin Hooten, conducted in Key West, Florida, February 11, 2019.

32 Peggy Poor, "Behind the Silk Screen," *Orlando Sentinel Florida Magazine*, March 3, 1968.

33 251 designs list Peter Pell in the title, 86 list Martha de Poo, 73 list Leigh Martin Hooten, and 26 list James Fudge. See US Copyright Office for complete list of Key West Hand Print Fabrics copyrighted titles.

34 "Tropics Magic Captured at Key West," Florida Development Commission, October, 1966.

35 "Key West Fabrics gains national attention," *The Key West Citizen*, November 20, 1966.

36 "Key West Fabrics gains national attention," *The Key West Citizen*, November 20, 1966. Today, the building houses the Pier House Hotel. The strangler fig tree still stands beside it.

37 Betty Williams, "Key West Hand Print's rags to riches story," *The Key West Citizen*, January 29, 1984.

38 "Key West Fabrics gains national attention," *The Key West Citizen*, November 20, 1966.

39 "Lilly Pulitzer," *Miami Herald*, April 17, 1967.

40 Agnes Ash, "2,000 a Day Go to See Plant-Store in Key West," *Home Furnishings Daily*, July 7, 1970.

41 "Key West Hand Print Fabrics has thriving shop in Nantucket now," *The Key West Citizen*, July 14, 1968.

42 Agnes Ash, "2,000 a Day Go to See Plant-Store in Key West," *Home Furnishings Daily*, July 7, 1970.

43 Lilly Pulitzer also had approximately four hundred wholesale accounts. Key West Hand Print Fabrics supplied the textiles for products and yardage sold in boutiques and shops.

44 Personal interview with June Klausing, conducted in Key West, Florida, February 12, 2019.

45 Joan Nielsen McHale, "Key West hand print fabrics are known all over the world," *Miami News*, January 19, 1970.

46 "The Lilly Look at Home," *House & Garden*, June, 1969.

47 Agnes Ash, "2,000 a Day Go to See Plant-Store in Key West," *Home Furnishings Daily*, July 7, 1970.

48 Bud Jacobson, "30 Years Young This Year," *Solares Hill*, circa 1981.

49 The design, created by Zuzek in 1964, was titled *Florida Fair*, and featured Florida flora and fauna, with the words "World's Fair" written in Zuzek's own block letters.

50 "Fabrics Publicize Key West," *The Key West Citizen*, November 15, 1964.

51 Photo caption, *Miami Herald*, May 18, 1968.

52 "New Uniforms Will Brighten Sunshine State," *Melbourne Times*, February 4, 1970.

53 Margaria Fitchner, "Making 'The Mansion' Florida's Finest," *Miami Herald*, October 4, 1980.

54 Betty Williams, "Key West Hand Print's rags to riches story," *The Key West Citizen*, January 29, 1984.

55 Dell Lockwood, "Factory is Tourist Attraction?" *The Key West Citizen*, November 19, 1972.

56 Margaria Fichtner, "Color Shapes Up and Ships Out," *Miami Herald*, February 14, 1973.

57 "'Marquesa' to fill handprint sails with stylish airs!" *The Key West Citizen*, February 11, 1973.

58 Personal interview with June Klausing, conducted in Key West, Florida, February 12, 2019.

59 Suzie Zuzek, interview by Marcela Morgan, unpublished video recording, 2003.

60 Betty Williams, "Key West Hand Print Fabrics: The demise of a grand lady," *The Key West Citizen*, ca. 1985

61 Rosalind Resnick, "Pulitzer Stores are deep in debt," *Miami Herald*, November 28, 1984.

62 Betty Williams, "Key West Hand Print Fabrics: The demise of a grand lady," *The Key West Citizen*, ca. 1985.

63 Personal interviews with Robert McKenzie, June Klausing, Leigh Martin Hooten, and Martha de Poo, February 11 and 12, 2019.

64 "Pulitzer Dress Shops to be Liquidated," UPI, May 23, 1985. In 1993 Lilly Pulitzer licensed her trademark name to Sugartown Worldwide. In 1997, she sold her trademark name to Sugartown Worldwide. In 2010, Sugartown Worldwide was purchased by Oxford Industries, the current owners. See Michael J. de las Merced, "Prep Stays Hot as Lilly Pulitzer is Sold for $60 Million," *The New York Times*, December 21, 2010.

65 Susan Ornstein, "Fabrics firm: Business as usual, tours to come," *Miami Herald*, June 1986.

66 "Hand Print Fabrics is Back in Business," *The Key West Citizen*, September 30, 1985; Susan Ornstein, "Fabrics firm: Business as usual, tours to come," *Miami Herald*, June 1986.

67 In 2010, Sugartown Worldwide was purchased by Oxford Industries. See Michael J. de las Merced, "Prep Stays Hot as Lilly Pulitzer is Sold for $60 Million," *The New York Times*, December 21, 2010; "Pulitzer Dress Shops to be Liquidated," UPI, May 23, 1985.

68 Eric Wilson, "Lilly, 50, Hasn't Aged a Day," *The New York Times*, November 5, 2008.

69 *Suzie de Poo: The Art of Hand Printing*, Key West Art and Historical Society, September 12, 2014 to January 2, 2015. Organized by Cori Convertito, Curator.

70 Tamison O'Connor, "Lilly Pulitzer Print Archive Rediscovered," *Business of Fashion*, July 9, 2018.

71 *Suzie Zuzek for Lilly Pulitzer: The Prints that Made the Fashion Brand*, Cooper Hewitt, Smithsonian Design Museum, May 15 – December 7, 2020. Organized by Susan Brown, Associate Curator, Textiles.

72 Lilly Pulitzer written statement to Becky Smith and Martha de Poo, 2012.

OPPOSITE Suzie Zuzek, *Kiki's Karnival*, 1967.

ACKNOWLEDGMENTS

The following people have been integral to the making of this publication:

Daniela López Amézquita
Barbara, Steve, and Kristin Archer
Peter Barlow
Billy Bitting, aka happyfunfree
Susan Brown, associate curator, Textiles,
 Cooper Hewitt, Smithsonian Design Museum
Victoria Brown
April Calahan, Special Collections,
 Fashion Institute of Technology
Cynthia Cathcart
Kip Chace
Margaret Chace
Natalie Chardonnet
Mary and Robert Ciapiak
Aaron Clendening
Cori Convertito, curator, Key West Art
 and Historical Society
Jennifer Cox
Kathryn de Poo
Martha de Poo
Margot Dockrell
David Donahue
Chris Donnellan
Emily Evans Eerdmans
Alyn Evans
Matt Flynn, photographer, Cooper Hewitt,
 Smithsonian Design Museum
Stan Friedman
Allison Galland and Danielle Uchitelle,
 TMS / Gallery Systems
Sarah Gifford
Martha Vietor Glass
Holt Haynsworth
Leigh Martin Hooten
James H. Howe IV
Janice Hussain, digital imaging specialist,
 Cooper Hewitt, Smithsonian Design Museum
Suzanne Lawless Johnson

Alan Ira Kaplan
Mark Katzman and Hilary Skirboll
Alan Kennish
June Klausing
Nadia Klausing-Hall
Kate Kuhner
Dorota Liczbinska
Christiane Mack
Marcus Mader
Alice D. Mattison
Robert McKenzie
Charles Miers
Caroline Rennolds Milbank
Jeremiah Milbank
Nicolas Moore
Deirdre McCabe Nolan
Richard Noble
Bill Ohlemeyer
Mark O'Neil
Philip Reeser
Dr. Alex J. Rosenberg
Andrea Ross
Nina Rumbough
Olivia Russin
Lindsey Schifko
Peter Shinkle
Greg Smith
Jacq Staubs
Steven Stolman
Stephen Watt
Louis Webre and Kathy Doyle
 of Doyle Auctioneers & Appraisers
John Woodworth
Donn Zaretsky
Roger Zissu

OPPOSITE Suzie Zuzek, *Peace*, 1969.

198

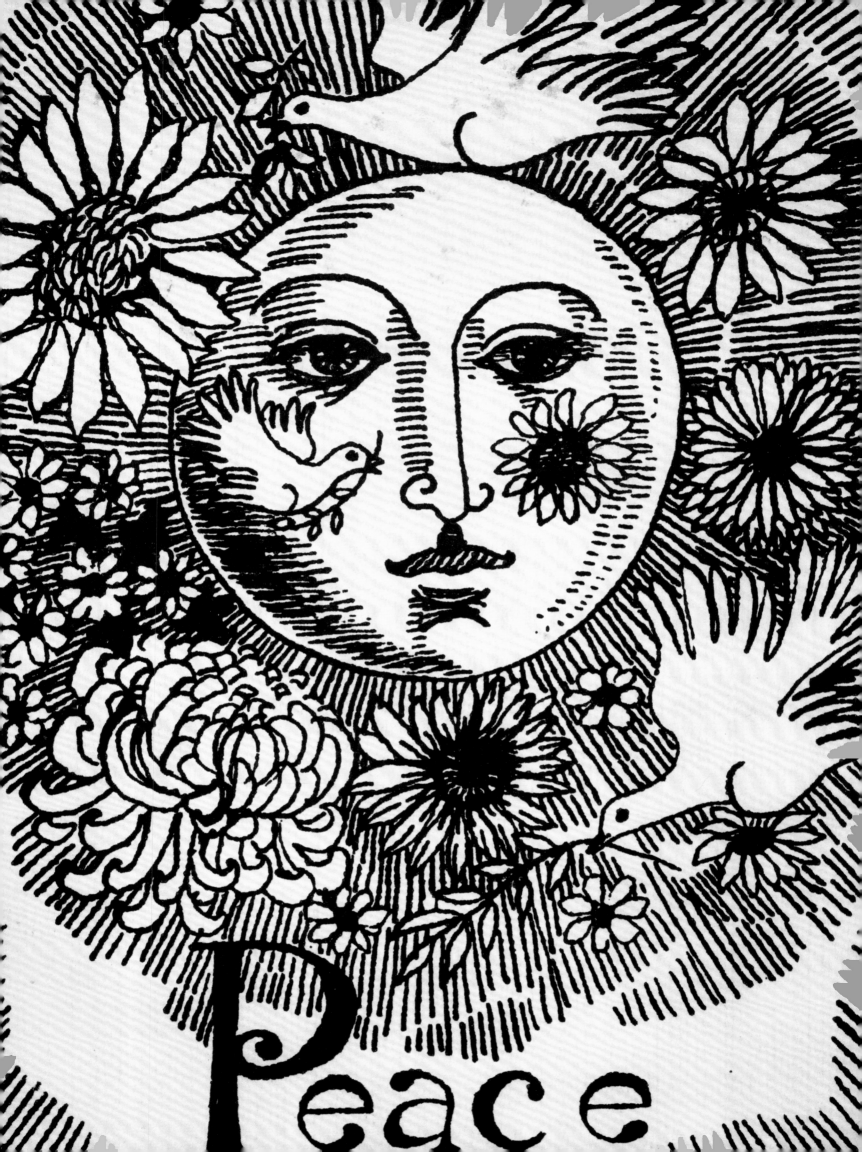

ENDPAPERS Suzie Zuzek, *Southmost Suns*, 1972.

PAGE 1 Suzie Zuzek, *Rhino*, 1977.

PAGES 2–3 Suzie Zuzek, *Wildness*, 1972.

PAGE 4 Suzie Zuzek, *The Reef*, 1979.

PAGES 68–69 Suzie Zuzek, *Astrolilly*, 1968.

FRONT OF CASE Suzie Zuzek, *Claudia*, 1971.

BACK OF CASE Suzie Zuzek, *Floretta*, 1974.

First published in the United States of America in 2020 by

Rizzoli Electa, a division of
Rizzoli International Publications, Inc.
300 Park Avenue South
New York, New York 10010
www.rizzoliusa.com

Copyright © 2020 by The Original I. P. LLC
The Original I. P. LLC and the authors of this book are not affiliated with LILLY PULITZER® or Sugartown Worldwide LLC in any way. LILLY PULITZER® is a registered trademark of Sugartown Worldwide LLC.

Essay by Susan Brown © 2020 Smithsonian Institution

For Rizzoli International Publications, Inc.:
PUBLISHER Charles Miers
ASSOCIATE PUBLISHER, RIZZOLI ELECTA Margaret Chace
SENIOR EDITOR Philip Reeser
DESIGNER Sarah Gifford
PRODUCTION MANAGER Alyn Evans
COPY EDITOR Cindy Trickel
MANAGING EDITOR Lynn Scrabis

Printed in Italy
2020 2021 2022 2023 / 10 9 8 7 6 5 4 3 2 1

ISBN: 978-0-8478-6764-6
Library of Congress Control Number: 2019951965

Facebook.com/RizzoliNewYork
Twitter: @Rizzoli_Books
Instagram.com/RizzoliBooks
Pinterest.com/RizzoliBooks
Youtube.com/user/RizzoliNY
Issuu.com/Rizzoli